The V&A Guide to Period Styles

The V&A Guide to

Period Styles

400 YEARS OF BRITISH ART AND DESIGN

ANNA JACKSON

with MORNA HINTON

V&A PUBLICATIONS

First published by V&A Publications, 2002

Reprinted 2005

V&A Publications
160 Brompton Road
London SW3 1HW

© The Board of Trustees of the Victoria and Albert
Museum 2002

Anna Jackson and Morna Hinton assert their moral
right to be identified as the authors of this book

ISBN: 1 85177 353 3

Designed by Broadbase

Jacket illustrations, front: details from images featured
on pages 43, 52, 126 and 129, *back:* details from
images on pages 60, 79, 144 and 153

Half title page: detail of earthenware vase, page 125

Frontispiece: detail of embroidery, page 132

Right: detail of engraving, page 12

Printed in Hong Kong

V&A Publications
160 Brompton Road
London SW3 1HW
www.vam.ac.uk

Contents

6 Introduction

8 Renaissance

16 Jacobean

24 Restoration

32 Baroque

42 Palladianism

50 Rococo

58 Chinoiserie

66 Neoclassicism

74 Medieval Revival

82 Regency Classicism

92 Chinese & Indian Styles

100 Gothic Revival

110 French Style

120 Classical & Renaissance Revival

128 Influences from beyond Europe

142 Influence of Japan

150 Aestheticism

158 Arts and Crafts

166 Scottish School

176 Acknowledgements

Introduction

This book provides an introduction to styles of British art and design in the period from 1500 to 1900. The key characteristics of nearly 20 styles are explored, beginning with the introduction of European Renaissance ornament in the 16th century, through the exuberance of Rococo, the elegance of Neoclassicism and the romance of the Medieval Revival, to the innovative and striking work of the Scottish School at the end of the 19th century.

Although a very commonly used word, 'style' describes what is in fact a rather complex concept that has been the focus of much art historical debate. Essentially style gives cohesion and meaning to groups of objects. The basic, dictionary definition of style is 'the manner in which a work of art is executed, regarded as characteristic of the individual artist, or of his time and place'. During the period covered here this 'manner' relates principally to form and decoration. This book therefore focuses on the origin, development and use of the shapes and motifs that were the chief indicators of particular styles.

Style has not always meant the same thing, however. The perception and understanding of the concept shifted significantly during the 400 years covered here. In 1500 people had little consciousness of style, but by 1900 there was great awareness of its meaning and significance. Style is, in reality, far more than just a matter of what things look like. It is intimately connected with social, economic and political factors.

The 16th and 17th centuries saw a marked increase in the number of objects made in recognisable styles as Britain's growing wealth provided ever expanding sectors of society with surplus income. The characteristic forms and motifs of particular styles also became apparent across a wider range of objects, from furniture and furnishings to dinner services and cutlery. From the end of the 17th century there was a move towards 'total design' as objects of all types, and the settings in which they were used, were designed in the same style.

The forms and motifs of a particular style generally built on what had gone

before, but it was not a simple linear development. The styles examined here often overlapped or, from about 1700, developed in opposition to one another. As the dominant position of classical styles was increasingly challenged, the range of other options began to grow. Style became a matter of choice and attitudes towards it began to change. Particular styles became indicators not only of wealth, but of taste, status and political affiliation, thus the style of objects began to reflect the desires and social aspirations of customers in a far more profound way than ever before.

In the 18th century a growing middle class opened up new markets for styled goods while the advent of semi-mechanical means of production made such objects easier and cheaper to produce. By the time Victoria came to the throne in 1837 a plethora of styles was available to her subjects. Many of these had their roots in historical forms and motifs, but as British trade and empire expanded so did the sources for design. Many artists and designers began to look to the art of countries outside Europe for inspiration. The use of alternative sources was encouraged by design reformers concerned that their age lacked any style it could call its own. The great style debate that ensued led only to more variety, however, making the 19th century the most eclectic and visually complex period in the history of British design. Style also became a question of ethics, for it was argued – and refuted – that style embodied the moral condition of the society that produced it. By the end of the century those involved in the Arts and Crafts Movement had taken such debates even further, as style came to encompass an entire philosophy of making and living.

The Victoria and Albert Museum has a superlative collection of British art and design through which it is possible to explore the history of style in all its richness and diversity. The majority of objects illustrated in this book are drawn from displays in the newly refurbished British Galleries that opened in 2001. Important exponents and proponents of the styles are also featured and sections on major buildings and interiors allow an exploration of the physical contexts in which the objects were originally used.

Renaissance
1500–1600

Renaissance means 'rebirth' and is the term used to describe the period of European cultural history that marked the transition from the Middle Ages to the modern age. This era saw a revival of classical art, architecture and design inspired by that of ancient Rome. The Renaissance style originated in Italy in the 14th century and gradually spread across the whole of Europe. Its new styles of ornament came to England in the 16th century where they were used alongside existing Gothic ones. Foreign artists and artisans working in London helped introduce the style, but the most important source for English designers was engraved books of Renaissance motifs.

One of the most distinctive elements of the new style was the **grotesque** which became the basis of most European flat ornament until the beginning of the 19th century. This was a form of decoration based on ancient Roman wall paintings discovered in Italy in the late 15th century. It featured a combination of scrolling plants, figures, fantastic creatures, masks and vases. **Strapwork** was also an essential feature of English design in the 16th century. This resembled flat strips of leather, bent to suggest bold, three-dimensional shapes. Strapwork was often used to frame other motifs or architectural features. Another important type of ornament was the **moresque**, associated with the Moors of north Africa and southern Spain, which was characterised by interlacing designs of stems, leaves and tendrils. **Figure busts in roundels**, a motif that had originated on ancient Roman coins, were also incorporated into designs. The arrival of Renaissance culture in England created a renewed interest in the stories and characters of **classical mythology**. These were often depicted in prints and paintings and used as motifs on objects.

This stoneware jug has been embellished with silver-gilt mounts that show many elements of the new Renaissance style. On the lid the classical hero Hercules captures the monstrous dog, Cerberus, guardian of the underworld. Grotesque masks, fruit swags and moresque motifs are also featured.

Stoneware with silver-gilt mounts. Jug made in Germany and mounts in England, 1550–60. V&A: 2119-1855

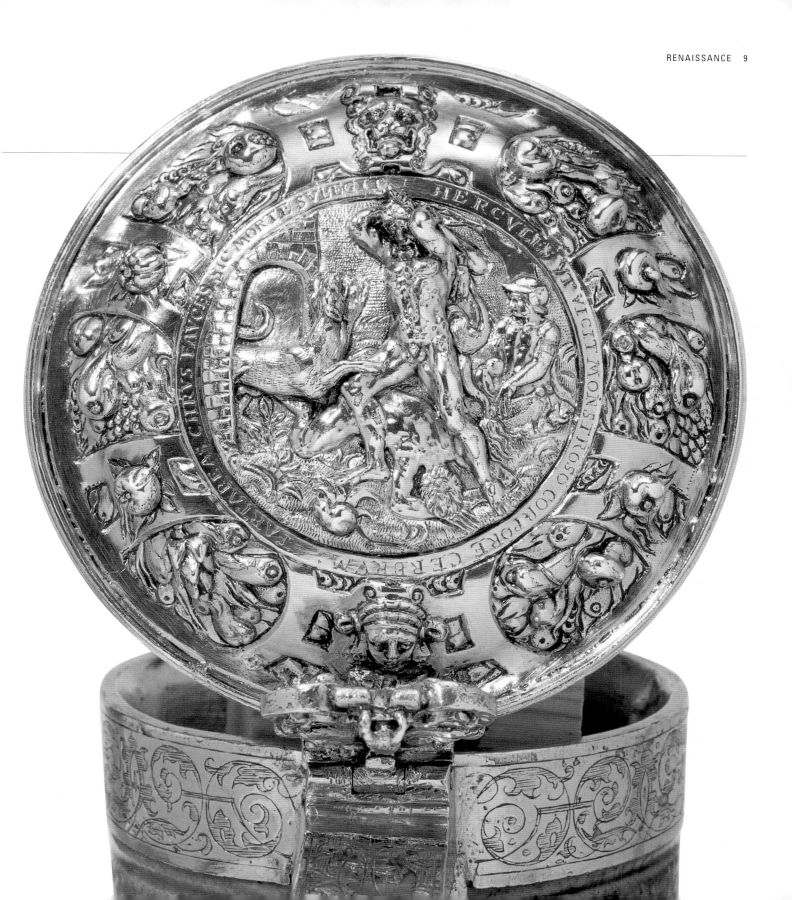

The Grotesque

This cushion cover is a rare survivor of English 'grotesque' work and features fantastic birds, cherubs, masks and flowers.

Woven silk satin ground, with applied work in velvet, cloth of silver and silk; embroidered details in silk, metal thread and sequins. Probably made in London in 1550–60. V&A: T.22-1947

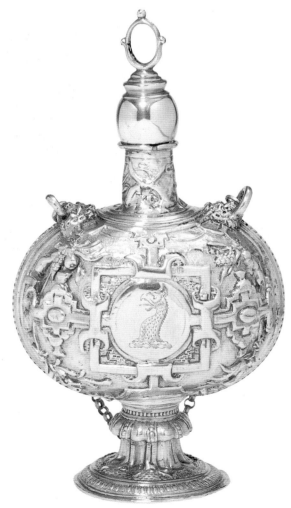

Strapwork

This bottle was designed to hold perfumed water and is decorated with strapwork ornament. Such objects were luxury accessories for the fashion conscious aristocracy and often reflected current European stylistic trends.

Chased, embossed and engraved silver, with applied shaped and punched wires, 1540–50. V&A: 451-1865

The Moresque

This edition of The Koran was published in Switzerland in 1543. The leather binding, probably created in France, has prominent Moresque ornament of angular, interlacing bands. Silver and black have been applied at the centre to reproduce the correct contrasts in the heraldry. The arms of the noted English 16th-century book collector Thomas Wotton are stamped on the cover.

Brown calf skin, with gold tooling and black paint; the arms stamped in silver. Probably bound in France about 1550 and stamped in England. National Art Library: L.1593-1948

Figure Busts in Roundels

A female head in profile has been incorporated into the back of this oak chair. The posts of the chair are in the older Gothic style, but in fact probably date from the 19th century.

Carved oak. Roundel probably made in Scotland around 1540. V&A: W.59-1950

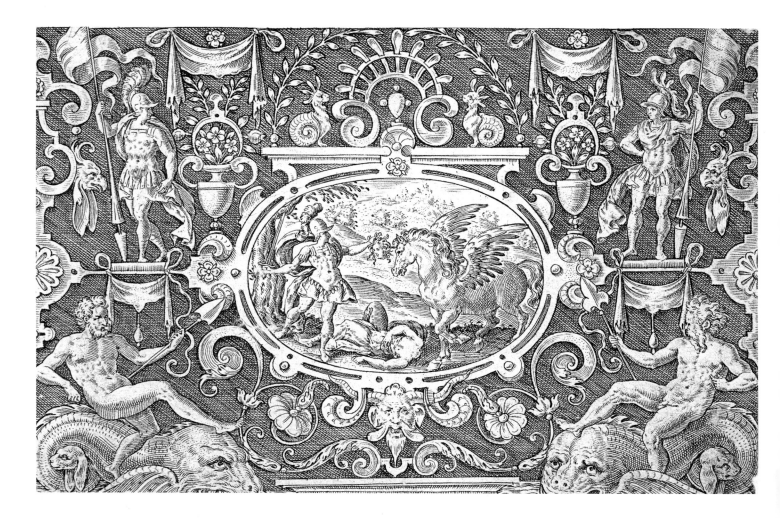

Classical Mythology

This print illustrates the classical hero Perseus. He has just killed Medusa and the winged horse Pegasus has sprung from her body. The image is surrounded by fantastical decoration. Prints such as this would have provided designs for overmantles, silverware, tapestries or wall paintings.

Engraving, ink on paper. Designed by Abraham de Bruyn, probably in Cologne, and published in 1584. V&A: E.830-1927

People & Places

Henry VIII
(1491–1547)

Henry VIII became King of England in 1509. He was a great patron of the arts and his court was one of the richest and most magnificent in Europe, rivalling those of other monarchs. Many of the luxury objects made for Henry and his court show the influence of new ideas from Renaissance Europe. The king also employed many foreign artists for the building and decoration of more than 50 royal palaces. Henry VIII used the splendour of his court to assert his cultural and political authority on the country.

▼ Henry VIII, oil on panel by an unknown artist of the Anglo-Flemish school, 1535–40. Courtesy of the National Portrait Gallery, London.

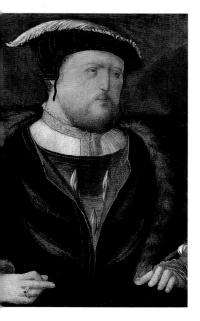

Sebastiano Serlio
(1475–1554)

Sebastiano Serlio was an Italian architect, painter and theorist. He wrote some of the most influential architectural treatises of the Renaissance. The books, published in a series from 1537, recorded the structures of antiquity and promoted the classical style for exteriors and interior features such as ceilings and fireplaces. The bold illustrations meant that Serlio's volumes could easily be used as pattern books by artisans working across Europe. In England they had an enormous influence on a wide range of architects and designers.

◤ The interior of the Pantheon, Rome, from Sebastiano Serlio's *Third Book of Architecture,* English translation (London, 1611). National Art Library RC.BB.25

Jan Vredeman de Vries
(1527–1604)

Jan Vredeman de Vries was a Flemish designer, architect and painter whose work became widely known in Europe through published engravings. His architectural designs had a great influence on the buildings and urban planning of Northern Europe. He also produced numerous exuberant designs for Renaissance style ornament. These provided a vast repertoire of motifs for designers working in many media. In England Vredeman de Vries's strapwork designs were used for doorways, decorative panels, overmantels and gables.

▶ Carved and painted oak strapwork panel from a design by Vredeman de Vries, 1590–1610. V&A: 404-1872

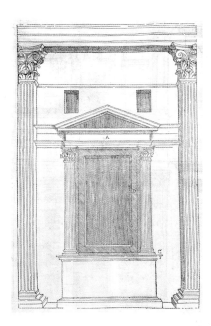

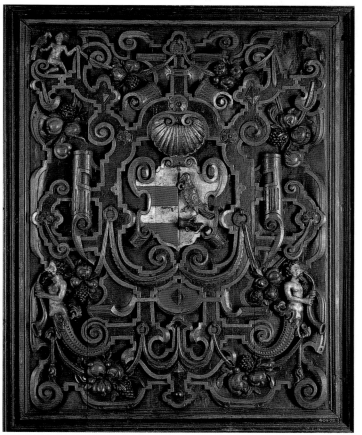

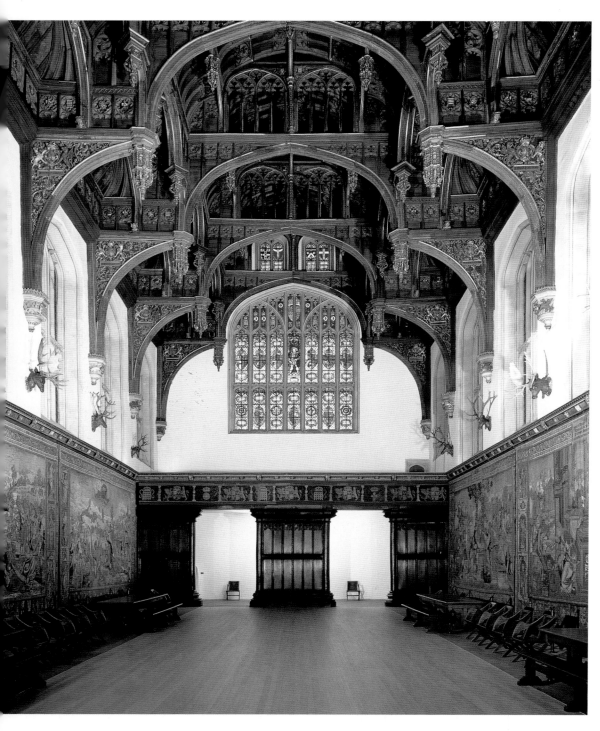

Hampton Court Palace

Hampton Court in Surrey was one of Henry VIII's favourite palaces and he spent a great deal of money on it. The king's royal apartments were largely demolished in the late 17th century, but a few of the magnificent public rooms, including the Great Hall and the Chapel Royal, remain. Henry's palace was constructed in a traditional style, but many of the details reveal the influence of the new Renaissance ornament. The splendid hammerbeam ceiling of the Great Hall, completed in 1536–7, incorporates the royal arms within rich grotesque decoration.

◄ The Great Hall, Hampton Court Palace. Courtesy of Historic Royal Palaces.

Kirby Hall

Kirby Hall in Northamptonshire was built in 1570–5 for Sir Humphrey Stafford. He was a fairly minor figure at the court of Queen Elizabeth I, but his house was very grand. It was one of the first buildings in England to employ Renaissance principles of classical architecture. This is seen in the symmetry of the plan and in the ornament. The richly decorated porch features two of the classical orders: Ionic on the ground floor and Corinthian above. Kirby Hall was altered and enlarged in the 17th century.

▶ Kirby Hall. Courtesy of English Heritage Photographic Library, photograph by John Critchley.

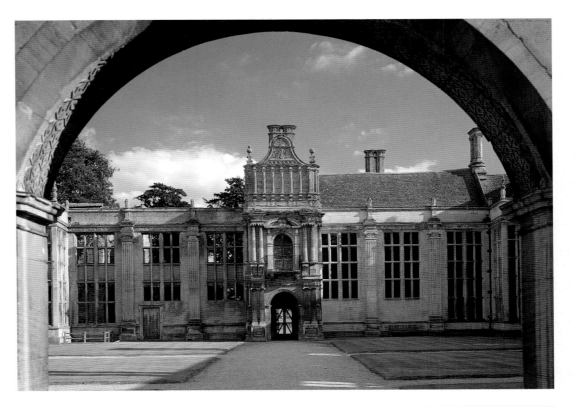

Wollaton Hall

Wollaton Hall in Nottinghamshire, designed by Robert Smythson, is one of the great houses of Elizabethan England. It was built in the 1580s for Sir Francis Willoughby, who had made his money in coal. Both the exterior and interior of the house are richly decorated with Renaissance ornament. The plan, with its central hall and chamber above, was taken from one of Serlio's books on architecture. To this Smythson added a mass of other details. Many of these, such as the strapwork gables, were inspired by the work of Vredeman de Vries.

▶ Wollaton Hall. Courtesy of A.F. Kersting.

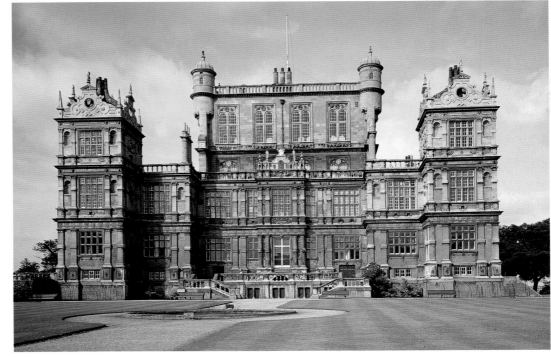

Jacobean
1603–1625

The reign of James I of England (VI of Scotland) is known as the Jacobean period. At this time printed sources of designs and motifs from Europe were plentiful and imports from as far away as Asia fired the imagination of designers. Luxury goods were rich in design and extravagant in material, while court architecture reflected a move towards a new, more restrained classical style.

The Jacobean style was noted for the **3-dimensional fullness** of its design. Wood was deeply carved and silver strongly modelled. Particular elements were accentuated, such as baluster shapes which became very bulbous. **Marine motifs** were popular and used especially on silver. Objects were shaped like mermaids or giant shells and decorated with waves, dolphins, and seahorses.

In the Jacobean period trade with Asia was established. **Exotic materials** such as mother-of-pearl were brought to England and used to embellish objects. Wood was also painted black to imitate Asian lacquer.

Furniture was sometimes brightly painted although often only small traces of these colours remain today. Textiles and clothing were particularly **rich in colour**, exemplifying the exuberance of the Jacobean style. Indeed, **luxurious clothes** and accessories were essential items for the wealthy and powerful members of Jacobean society. Both men and women wore richly embroidered and trimmed garments.

Basins were used for the ceremonial washing of hands, though this example is so large that perhaps it was only meant for display. The silver has been boldly modelled with fruit, strapwork and marine motifs.

Silver gilt, chased and embossed.
Made in London, maker's mark 'R.S.', 1607–8.
V&A: M.6-1961

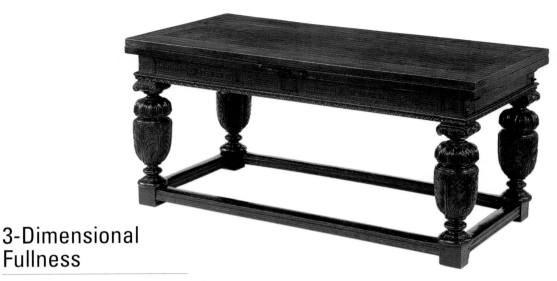

3-Dimensional Fullness

The bulbous legs of this draw-table were derived from Flemish and German examples. The style was introduced to England by immigrant craftsmen and through continental pattern books.

Inlaid and carved oak, sycamore, holly and bog-oak. Probably made in Southwark, London around 1600. V&A: 384-1898

Marine Motifs

Sets of silver like this were used for the ceremonial washing of hands after a meal. The basin is in the shape of a scallop shell and the ewer of a mermaid. Her tail unscrews for pouring in rosewater, which flows from her nipples when tilted. The engraved coat of arms on the basin is probably that of Sir Thomas Wilson, a diplomat, scholar and the prosecutor of Sir Walter Raleigh in 1618. Such heraldic devices were important symbols of loyalty and status and were often incorporated into designs.

Embossed and engraved silver. Made in London, maker's mark 'T.B.', 1610–11. V&A: M.10-1974

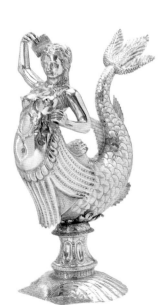

Exotic Materials

This cabinet would have been used for jewels or personal items. Its design was inspired by lacquer cabinets imported from Japan and India by the East India Company. The decoration is composed of mother-of-pearl which at this time came mainly from the shell of a marine mollusc that lived only in the Western Pacific. It was therefore a rare and exotic material.

Painted pine inlaid with mother-of-pearl.
Probably made in London around 1620.
V&A: W.37-1927

Rich Colours

In the Jacobean period trimmings
of expensive materials were applied
to elaborate suites of furniture,
particularly beds and the seats
that went with them. Deeper
fringes hung from valences and
the bottoms of curtains.

Silk, gold and silver thread.
Made in 1600–10. V&A: T.270-1965

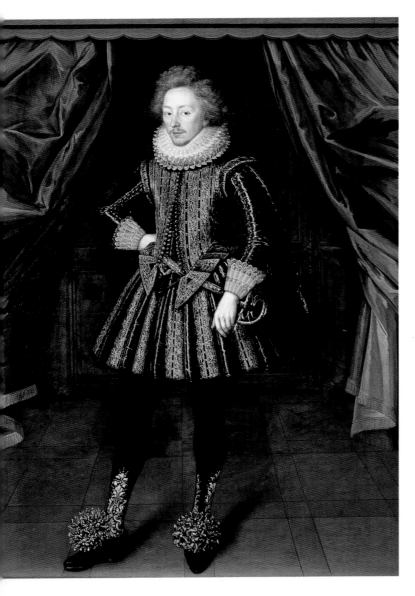

Luxurious Clothes

This portrait is of Dudley North
(1581–1666) a leading figure at the
court of James I. He is shown
dressed in a luxurious costume of
black and silver jerkin, doublet and
hose with lace ruff and cuffs, and
elaborately trimmed shoes.

Oil on canvas by an unknown English artist,
around 1630. V&A: P.4-1948

People & Places

James I
(1566–1625)

In 1603 James VI of Scotland became King of England, joining together the crowns of the two countries for the first time. His court in London was noted for its extravagance. The most luxurious of clothes were worn and spectacular masques, or musical dramas, were staged. James's queen, Anne of Denmark, was a major collector and patron of the arts while the sophisticated group of courtiers in the circle of James's son, Prince Henry, encouraged a renewed interest in the latest European designs for buildings, interiors and gardens.

▼ Locket with a portrait miniature of James I painted in the London studio of Nicholas Hilliard around 1610. V&A: M.92-1975

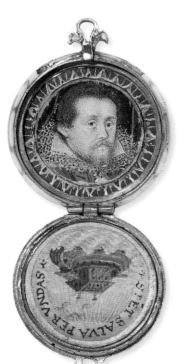

Richard Sackville, 3rd Earl of Dorset
(1590–1624)

Richard Sackville succeeded as Earl of Dorset in 1609. He was described as 'a man of spirit and talent, but a licentious spendthrift'. The sumptuous clothes he wore can be seen in this portrait of 1616. An inventory of the following year recorded these, down to the 'paire of Roeses edged with gold and silver lace' on his shoes. The earl continued the interior decoration of the family home at Knole begun by his grandfather. However, his lavish spending habits meant that the house had been mortgaged by the time of his death.

▶ Richard Sackville, watercolour on vellum by Isaac Oliver, 1616. V&A: 721-1882

Inigo Jones
(1573–1652)

Inigo Jones was the major architect and designer of the Jacobean period. He was renowned for the innovative stage designs and costumes he created for the elaborate entertainments held at the court of James I and his successor Charles I. From 1615 Inigo Jones was in charge of royal buildings. He introduced to England the fundamental principles of classical architecture, having studied them at first hand in Italy. His most famous works were Banqueting House in the Palace of Whitehall, London, built in 1619–22, and the Queen's House at Greenwich, completed in 1638. Both buildings were stylistically well ahead of their time.

▶ Banqueting House by Inigo Jones. Courtesy of Historic Royal Palaces.

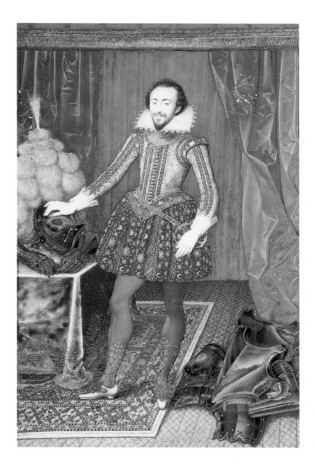

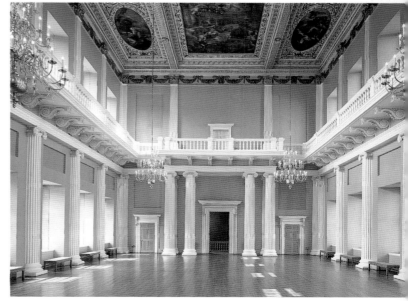

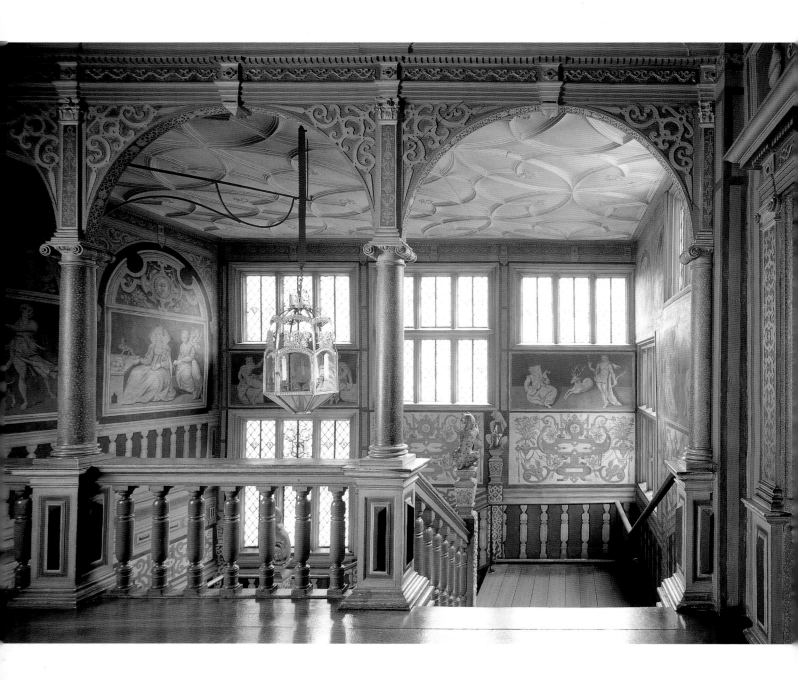

Sir Paul Pindar's House

Sir Paul Pindar was a successful London merchant who in 1611 became ambassador to the Sultan of Turkey. On his return he took up a lucrative appointment as customs collector and was later knighted by James I. His house, built in about 1624, was in Bishopsgate Without in the City of London. With its elaborate two-storey bay windows and rich carving, it typified the magnificent style of Jacobean town houses. The building was demolished in 1890, but part of the façade was saved and is now preserved in the Victoria and Albert Museum.

▶ Façade of Sir Paul Pindar's House. V&A: 846-1890

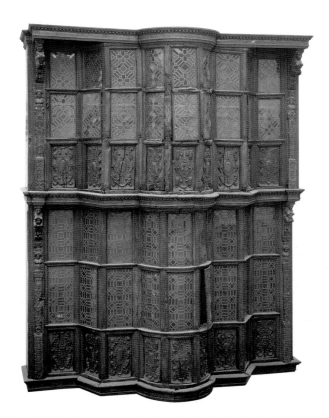

Knole

The vast house at Knole in Kent was built in the late 15th century. It subsequently came into royal hands and in 1566 Elizabeth I presented it to her cousin Thomas Sackville, later 1st Earl of Dorset. Between 1603 and 1608 the earl made extensive alterations and additions. One dramatic feature of the new Jacobean style interior was the Great Staircase, which featured the heraldic Sackville leopards on the newel posts. The painted decoration that covered the walls of the staircase was adapted from Flemish prints.

◀ The Great Staircase at Knole. Courtesy of the National Trust Photographic Library, photograph by Andreas von Einsiede.

Hatfield House

Hatfield House in Hertfordshire was built in 1607–11 by Robert Cecil, 1st Earl of Salisbury and chief minister to James I. Some of the extravagant Jacobean elements of the interior remain, including the grand black and white marble fireplace overmantle which incorporates a statue of the king The loggia on the south front of the house originally served as the grand entrance. It may have been designed by Inigo Jones and reveals the new interest in classical architecture that developed in the Jacobean period.

▶ Loggia of Hatfield House. Courtesy of the Marquess of Salisbury.

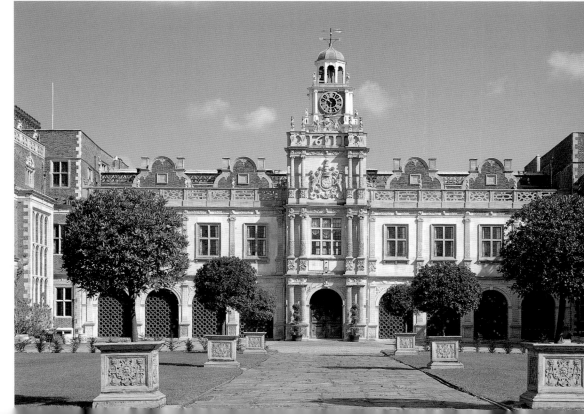

Restoration
1660–1685

The restoration of the monarchy in 1660 ushered in a period of great opulence in English art, architecture and design. Charles II and his followers had spent the years of exile in France and the Netherlands and on their return brought with them a taste for the latest European styles. Foreign-trained artists and craftspeople working in England also used flamboyant designs and rich materials.

Flowing, **curvaceous forms** characterised the Restoration style. Elaborate carving and high relief decoration created a sense of movement that was gracefully contained within the symmetry of the overall design. Ornate, **rich finishes** were also a major feature of the period with gold and silver being used to embellish wood and leather panels.

Fruit, flowers and leaves had long been used to decorate objects. In the 17th century, however, a growing interest in botany led to the creation of increasingly realistic **natural motifs**. The scrolling growth of the **acanthus leaf**, a motif that features in many styles, made it particularly popular in the Restoration period. The leaves were used as a band of ornament around objects, as an architectural feature or to create flowing decorative forms.

An interest in technical developments promoted the use of the new style. From the mid 17th century a technique of producing **spirally twisted forms** by turning wood on a lathe was used to create supports for furniture and architectural woodwork.

This large and elaborate shield was presented by Charles II's wife, Queen Catherine of Braganza, to the Marshall of the Fraternity of Oxford, an archery club associated with the court. It bears the coat of arms of the king and queen. The curvaceous form of the object has been enhanced by the flowing acanthus leaves that surround the figures. The skilled work of the shield suggests that the maker was trained abroad.

Chased silver. Made in London, possibly by John Cooqus, around 1670. Courtesy of the Royal Toxophilite Society.

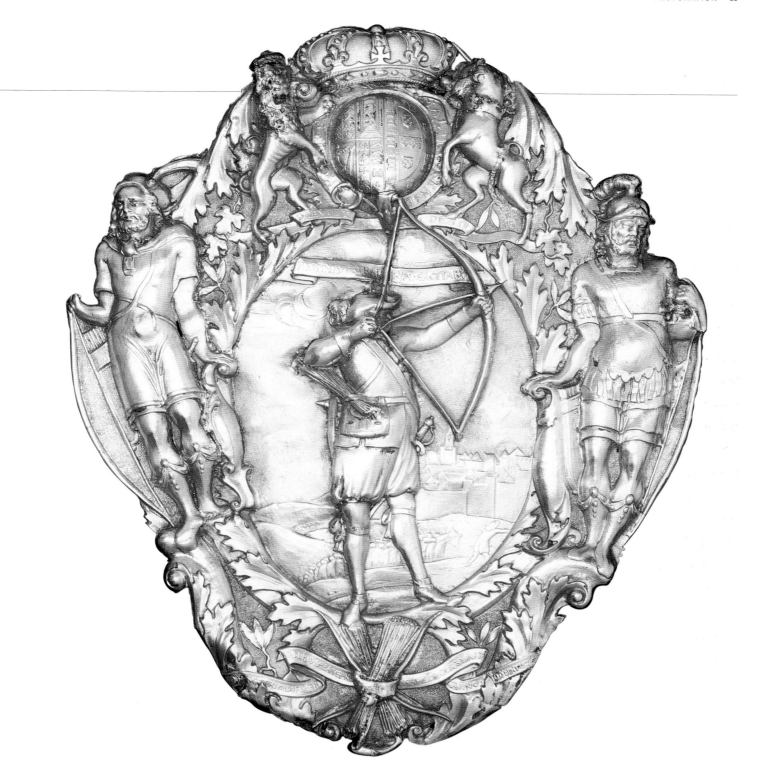

Curvaceous Forms

Caned chairs such as this were introduced to England in the 1660s and were inspired by Indian ebony examples. With its carved scrollwork and turned uprights and stretchers, this chair is typical of the kind made from the late 1680s.

Carved and turned walnut with caned panels in seat and back. Made in 1685–95.
V&A: 702-1899

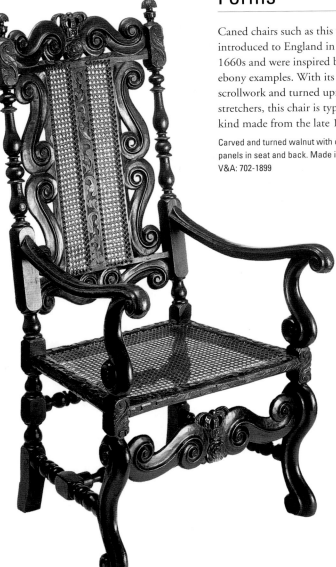

Rich Finishes

The scrolling foliage that surrounds this looking glass has been decorated with silver leaf to imitate solid metal.

Carved pine, decorated with gesso and silver leaf. Frame possibly made by a Dutch or Flemish carver in London in 1665–72.
V&A: W.37-1949

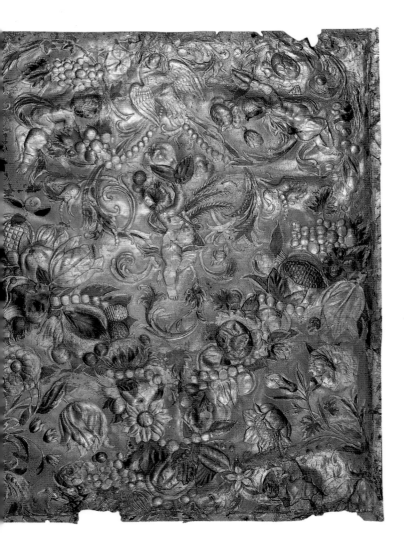

Natural Motifs

Leather panels, imported to England from the Netherlands, were hung on the walls of dining rooms as they did not absorb the smell of the food. This example is decorated with an abundance of fruit and flowers.

Embossed leather with silver leaf, red and green glazes and overall yellow glaze. Made in Amsterdam around 1670. V&A: W.67-1911

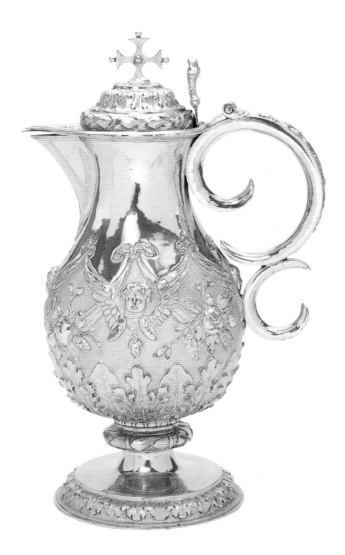

Acanthus Leaves

This flagon for communion wine was given to St James' Church, Piccadilly, at the time of its consecration in 1683. The pear-shaped body and bold decoration, of acanthus leaves, cherub heads and fruit swags, are influenced by the work of French Protestant refugee goldsmiths who had settled in London.

Silver gilt; repoussé, chased and modelled. Made in London, possibly by Ralph Leeke, in 1683. Courtesy of St James' Church, Piccadilly.

Spirally Twisted Forms

The table and candlestands date from the 1670s when their spirally twisted supports and delicate silhouette would have been newly fashionable. The bowls and cups are for wassail, a spiced ale served at Christmas and on other feast days.

Carved and turned lignum vitae (from the West Indies) and ivory (probably from Africa). Made in 1640–80. V&A: W.8-1976

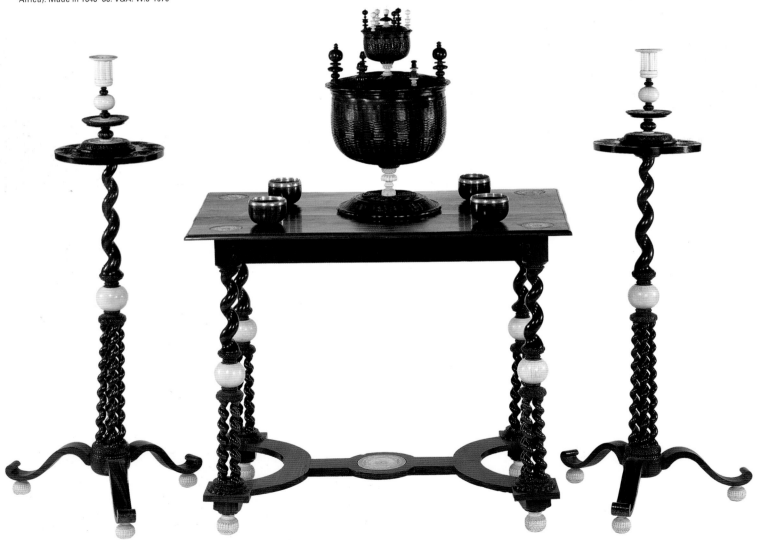

People & Places

Charles II
(1630–1685)

As heir to the throne, Charles II spent 12 years in exile in Europe where he was able to absorb new developments in continental style. On his Restoration in 1660 he set about refurbishing his royal palaces, particularly Windsor Castle. Charles valued the arts as a way to assert the renewed power of the Stuart dynasty. He actively encouraged foreign artists and craftspeople to come to England and was a great supporter of the architects Christopher Wren and Hugh May. The king's patronage ensured that the new Restoration style flourished.

▼ Charles II, marble bust by Honoré Pelle, 1684. V&A: 239-1881

John Evelyn
(1620–1706)

John Evelyn was a diarist, writer and collector. Between 1643 and 1652 he travelled extensively in France and Italy. He stayed in all the major cities, studying languages, art, antiquities and gardening. After the Restoration he served Charles II and James II and wrote a number of books. Evelyn was an avid collector, particularly of prints and medals, but his most famous possession was a cabinet that he had made to incorporate the *pietra dura* (hardstone) panels he had acquired in Florence in 1644. The cabinet was then extended to accommodate bronze plaques which were probably made by Franceso Fanelli. The cabinet was embellished further in the early 19th century when the manuscript of Evelyn's diary was published.

◢ The Evelyn Cabinet. V&A: W.24-1977

Sir Christopher Wren
(1632–1723)

Sir Christopher Wren is one of the most famous architects in British history. He was also a renowned scientist and mathematician and it was his study of structure and geometry that led to an interest in architecture. In 1665 Wren travelled to Paris where he was able to study the new, sophisticated styles of classical architecture that were developing in Europe. His big opportunity came after the Fire of London of 1666 when he was appointed to rebuild numerous city churches. The dramatic buildings Wren created transformed the London skyline.

▶ Sir Christopher Wren, oil on canvas by Sir Godfrey Kneller, 1711. Courtesy of the National Portrait Gallery, London.

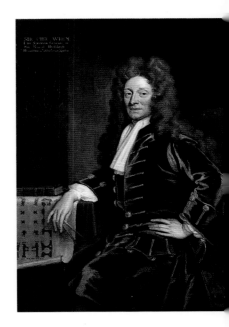

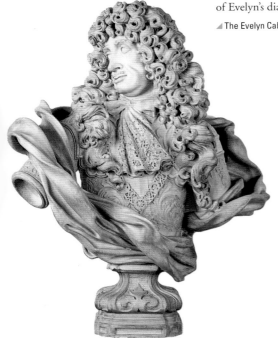

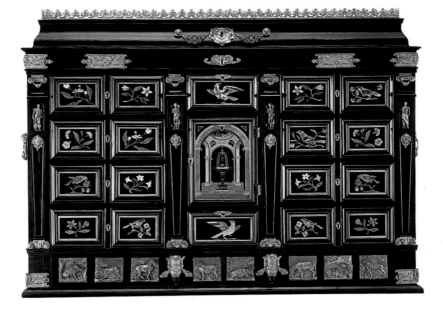

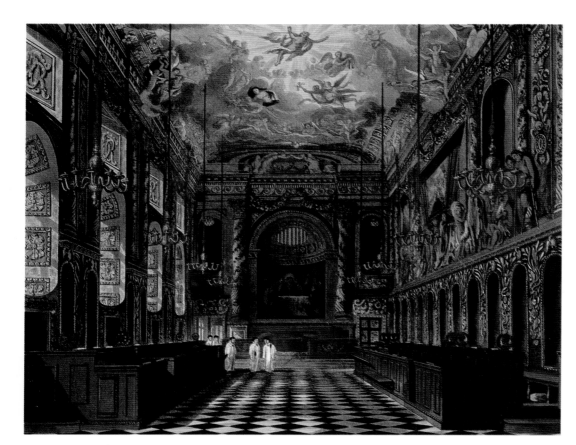

The Royal Chapel, Windsor Castle.

On his Restoration Charles II set about remodelling Windsor Castle in a style that would match the magnificence of the palaces he had seen in Europe. The architect Hugh May was responsible for the designs of the new state rooms which were created between 1675 and 1685. The Royal Chapel was one of most spectacular Restoration interiors in the country. The elaborate colonnade, ornate twisted columns and vast floral swags framed scenes of Christ's miracles and the Last Supper by the Italian painter Antonio Verrio. Above, a cloud-filled ceiling showed the Resurrection. The interior of the Royal Chapel did not survive the remodelling of Windsor that took place in the early 19th century.

◤ The Royal Chapel illustrated by W.H. Pyne in *The History of the Royal Residences of Windsor Castle, St James Palace, Carlton House, Kensington Palace, Hampton Court, Buckingham Palace and Frogmore*, 1819. National Art Library, RC.LL.70

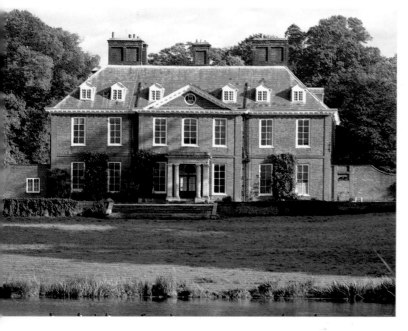

Squerryes Court

Squerryes Court in Westerham, Kent, was built in 1680 by Sir Nicholas Crisp, a loyal and active supporter of the Stuart throne. It is not as opulent as many of the residences built for the nobility, but is typical of the kind of manor house that developed in the Restoration period. The relatively simple, yet refined style was influenced by Dutch architecture. Squerryes Court is a perfectly symmetrical building, two storeys high with an attic in the hipped roof. Constructed of brick, it has a classical pediment and columned portico.

◀ Squerryes Court. Courtesy of Squerryes Court.

The Queen's Closet, Ham House

Ham House, in Richmond near London, is one of the most perfectly preserved 17th century houses in Britain. It was built in 1610 by Sir Thomas Vavasor, but enlarged and refurbished in the 1670s by the Duke and Duchess of Lauderdale. John Evelyn described the sumptuous interior as being 'furnished like a Great Prince's'. The Queen's Closet has ornate gilt carving and walls hung with rich brocaded satin. The scrolling leaves and flowers that decorate the fireplace surround are executed in scagliola, a technique imported from Italy which imitates hardstone inlay.

▶ The Queen's Closet, Ham House. Courtesy of the National Trust Photographic Library, photograph by Andreas von Einsiede.

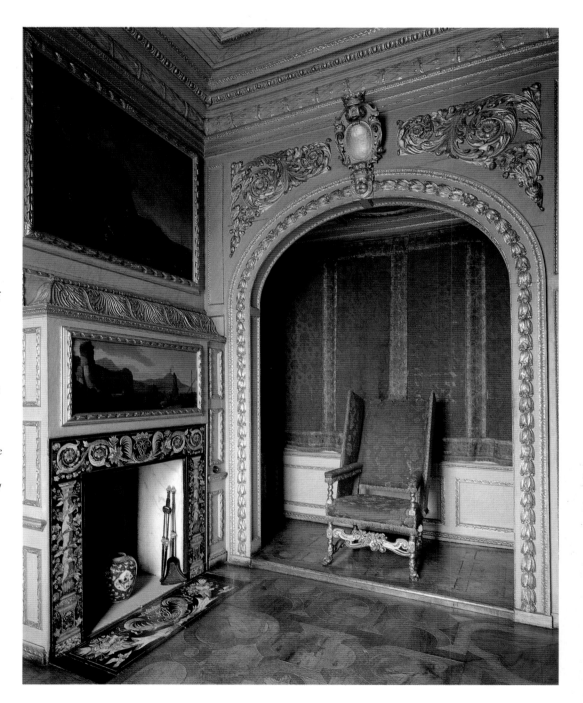

Baroque
1685–1725

The exuberant Baroque style originated in Italy and influenced the entire continent. English designers found new ideas in printed books of continental ornament. Foreign craftspeople who settled in England also had a great influence on the development of the style. They included Protestant Huguenot refugees, exiled from Catholic France as a result of the Revocation of the Edict of Nantes in 1685, who brought a range of new skills with them.

A sense of drama and a love of the ornate characterised the Baroque. Objects were decorated with a profusion of plant life. Chubby infants called 'putti', the Italian for 'boys', cavorted around the **scrolling foliage** and garlands of flowers. The decorative use of **monograms**, usually people's initials, was another feature of the style. Heraldic **crests** were also incorporated into designs as symbols of status and ownership.

Baroque interiors were luxurious. Walls were covered with tapestries, embossed leather or damask. Seat furniture was richly upholstered, giltwood furniture imitated gold, and silver vessels took on **sculptural forms**. One novel form of furniture decoration inspired by continental examples was **marquetry**, a technique that involved the use of veneers of different coloured woods.

The decoration on this silver waiter (or tray) exemplifies the extravagant Baroque style. The design of putti, scrolling acanthus and armorial cartouche is taken from French and Italian prints. The waiter was made by Benjamin Pyne, an English goldsmith who employed Huguenot craftsmen in his workshop.

Silver gilt, chased and engraved. Made in London in 1698–9. V&A: M.77-1947

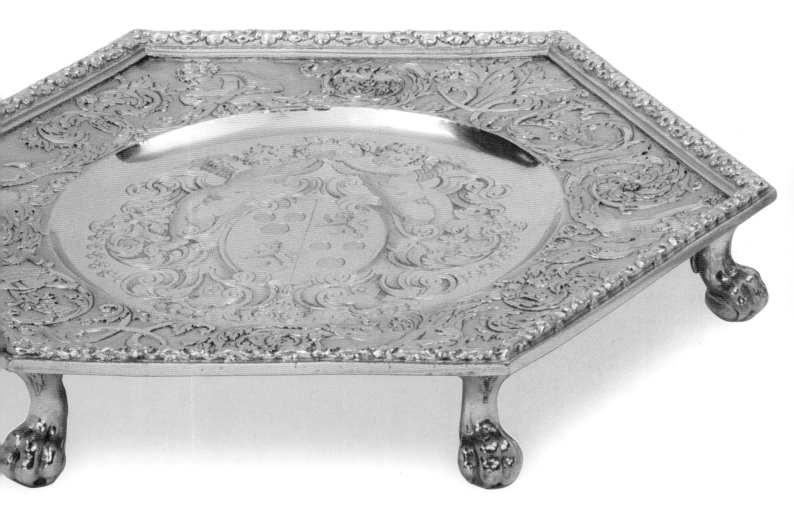

Putti

This looking glass is decorated with putti playing among garlands of flowers. Unlike textiles and wood of the period the glass retains the bright colours that are characteristic of the Baroque style.

Frame of stained wood, mirrored glass painted in oils. Probably made in London in 1710–20. V&A: W.36-1934

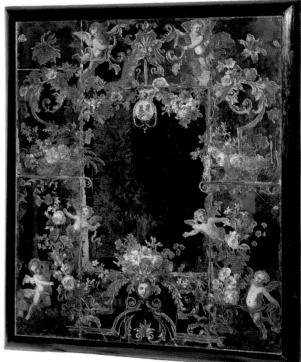

Scrolling Foliage

This settee has been richly upholstered with a pattern of scrolling foliage in embroidery of wool on silk.

Wood frame, walnut legs, embroidery of wool on silk. Made in England for Hampton Court, Herefordshire in 1690–1700. V&A: W.15-1945

Sculptural Forms

The handle of this ewer is in the
form of a water nymph, an
appropriate motif for a water jug.
The balance of plain and decorated
surfaces is typical of silver pieces
made by Huguenot craftsmen in
England.

Silver gilt, cast details and applied cut-card
work, ornamented in relief. Made in London
by David Willaume in 1700–1. V&A: 822-1890

Monograms and Crests

The initials 'RC', for Richard
Temple, Baron Cobham, form the
central part of the design of this
giltwood table. The scrollwork and
shells on the top recur on the apron
which also incorporates the patron's
crest.

Carved oak and pine, gessoed and gilded.
Made in Short's Garden, London around
1714. V&A: W.30-1947

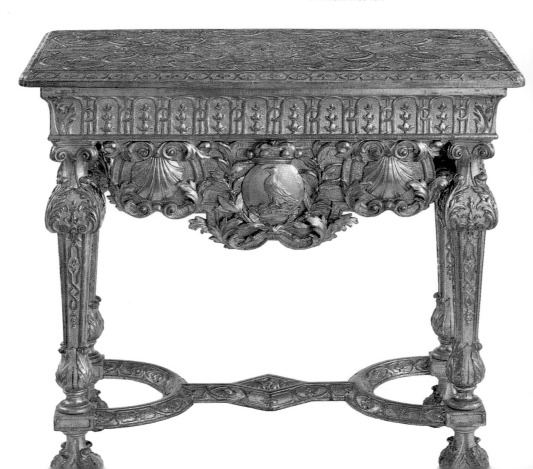

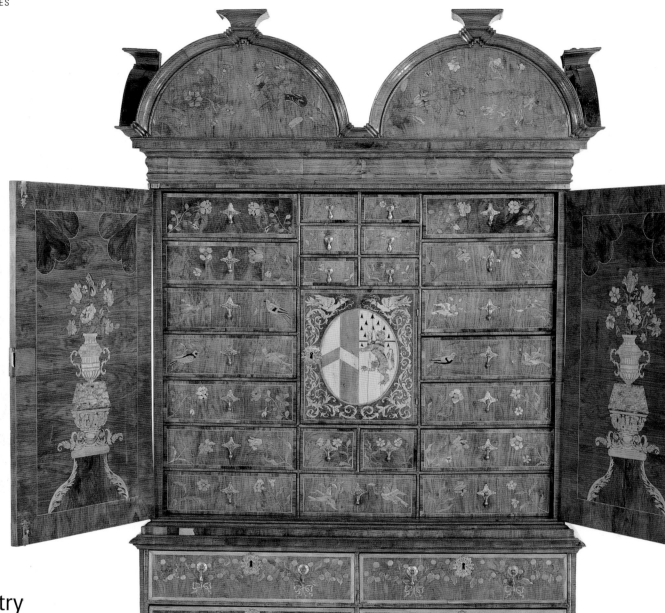

Marquetry

This cabinet was made for East Harlsey Castle, Yorkshire to commemorate the marriage of Margaret Trotter and George Lawson. The rich marquetry incorporates their monograms and combined arms.

Marquetry of walnut, burr walnut, sycamore, other woods and ivory on a pine and oak carcass. Probably made in London around 1700. V&A: W.136-1928

People & Places

Queen Mary II
(1662–1694)

The Baroque style dominated the court of William and Mary. The queen played an important role in the cultivation of the arts and influenced the development of an increasingly cosmopolitan style of design in England. Mary was involved in the architectural renovations of a number of royal residences including Hampton Court Palace. Here she adopted a small building, the Water Gallery, which she decorated with blue and white ceramics from Delft in the Netherlands. Her passion for delftware and blue and white porcelain from China started a craze for such ceramics in England.

◀ Mary II, mezzotint by John Smith, 1690. V&A: E.673-1910

▼ Delftware tile from the Water Gallery after a design by Daniel Marot, around 1694. V&A: C.12-1956

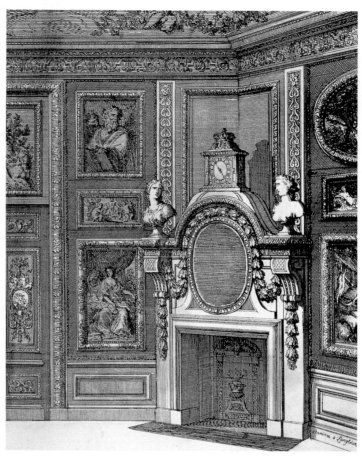

Daniel Marot
(1661–1752)

The French designer Daniel Marot was one of thousands of Huguenot Protestants forced to leave France after 1685. He emigrated to the Netherlands where he entered the service of Prince William of Orange. William became King of England and Scotland in 1688 and the designer later followed his master to London. Marot's numerous engraved designs contributed greatly to the development of the Baroque style in Britain. He established the idea of a unified interior, in which the decoration, furniture and furnishings were all created in a co-ordinated style.

▲ Etched design for a chimneypiece by Daniel Marot, around 1700. V&A: 13857.1

Grinling Gibbons
(1648–1721)

The celebrated woodcarver and sculptor Grinling Gibbons was born in Rotterdam and settled in London in 1671. Gibbons was famous for his extremely intricate limewood carvings of flowers, fruit, foliage, birds and fish which were created to embellish private houses and churches. In 1693 he was appointed Master Carver to the Crown. He worked at various royal residences including Windsor Castle where he created spectacular carvings for panelling, overdoors, chimney pieces and picture frames. Gibbons' artistic virtuosity, exuberant style and naturalistic subject-matter made him the master of Baroque interior detail.

▲ Grinling Gibbons, oil on canvas by Sir Godfrey Kneller, around 1690. Courtesy of the National Portrait Gallery, London.

◥ The Stoning of St Stephen. Lime and lancewood carving by Grinling Gibbons, 1680-1710. V&A: 446-1898

St Paul's Cathedral

The centrepiece of Sir Christopher Wren's plan to remodel London after the Great Fire of 1666 was the new St Paul's Cathedral. Constructed between 1675 and 1709 it is one of the masterpieces of Baroque architecture. The most famous feature of St Paul's is the huge dome, the first ever to be constructed in Britain. The scale and drama of the exterior of the building is echoed by Wren's grand interior. Its ornate choir-stalls, screen and bishop's throne were carved by Grinling Gibbons.

▶ St Paul's Cathedral. Courtesy of A.F. Kersting.

▼ The choir of St Paul's Cathedral, with stalls carved by Grinling Gibbons. © Pitkin Unichrome Ltd.

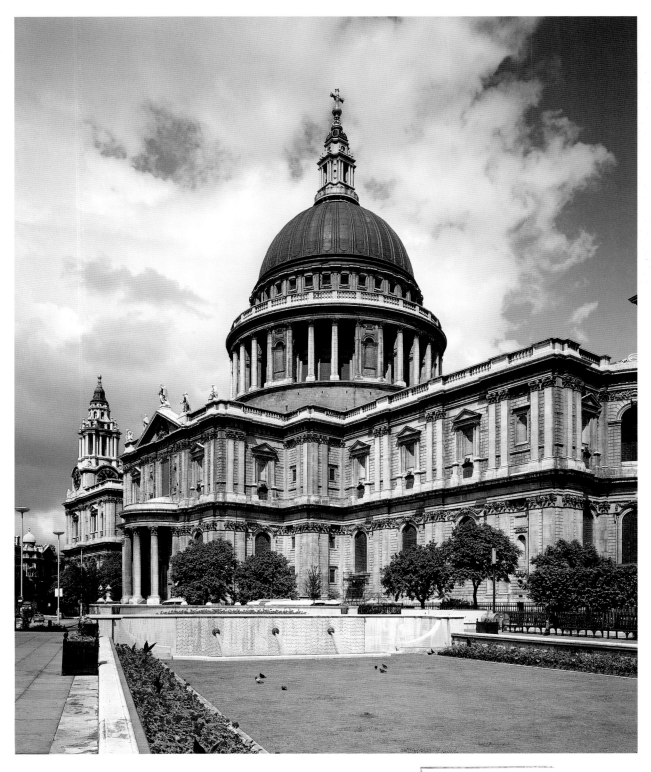

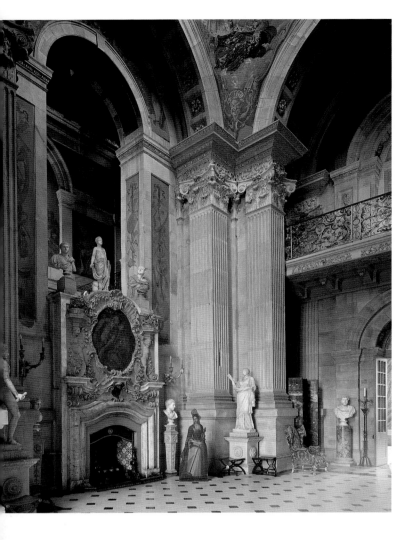

Castle Howard

Castle Howard, Yorkshire, is one of the grandest houses in Britain. It was built in 1701–x24 by John Vanbrugh, one of the great masters of the Baroque style. Castle Howard was the first building designed by Vanbrugh and he was assisted by Nicholas Hawksmoor, another celebrated Baroque architect. This partnership created the imposing classical exterior, its central block surmounted by a dome. On the inside, the Great Hall is equally majestic with grand pillars, an ornate chimneypiece and wall paintings by the Italian artist Giovanni Antonio Pellegrini.

◀ The Great Hall, Castle Howard. Courtesy of A.F. Kersting.

▼ Castle Howard. Courtesy of A.F. Kersting.

The Heaven Room, Burghley House

Burghley House in Lincolnshire was built in the 16th century by William Cecil, later Lord Burghley. The interior was remodelled by Burghley's descendant, the 5th Earl of Exeter, in the late 17th century. The earl spent a vast amount of money on the project and employed the finest of craftsmen including the virtuoso woodcarver Grinling Gibbons. The most magnificent of the Baroque rooms is the Heaven Room, named after the painted decorations by the Italian artist Antonio Verrio which depict classical deities in an architectural setting.

▶ The Heaven Room, Burghley House. Courtesy of The Burghley House Collection/ Heritage House Group Ltd.

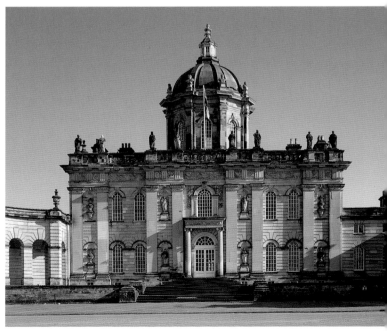

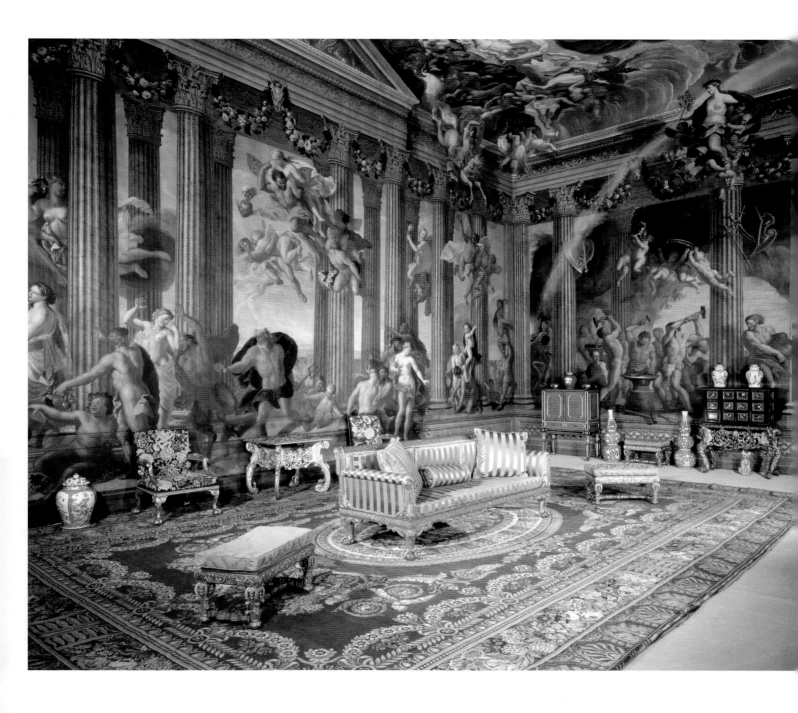

Palladianism
1715–1760

In the early 18th century there was a growing reaction against the extravagance of the Baroque style. A desire to return to the basic principles of classicism, with its emphasis on restraint, proportion, balance and the systematic use of the classical orders of architecture, led to the development of Palladianism. This uniquely British style was based on the forms and ornaments of ancient Roman buildings, transmitted through the work of the Italian Renaissance architect Andrea Palladio and the British 17th century architect Inigo Jones. It was the first widely applied classical style, with a set of rules that could be applied to any building from the grandest mansion to the smallest terrace house.

Palladian interiors were richly decorated in contrast to the exteriors which were quite plain and austere. Objects created for these interiors were based on classical forms. Designs were symmetrical with decorative features, such as **columns** and **pediments**, derived from architecture. **Terms** were another architectural element. The name of these bust- or half-length figures on the top of a pillar comes from Terminus, the Roman god of boundaries. **Masks** and **shells** were also common Palladian motifs, their forms again deriving from antique examples.

For the architects, designers and patrons who promoted Palladianism, these forms and motifs were imbued with special meaning, for their use linked the virtues and authority of Ancient Rome with the political system and growing power of the British nation.

This table is one of the earliest pieces of Palladian furniture. It was designed by William Kent for Chiswick House, the villa designed by Lord Burlington the great promoter of the Palladian style. The symmetrical form of the table is based on the capital of a Corinthian column with its distinctive acanthus leaf motif. The central mask echoes elements of the interior design of Chiswick House.

Carved and gilded softwood with Siena marble top. Made in London in 1727–32.
V&A: W.14-1971

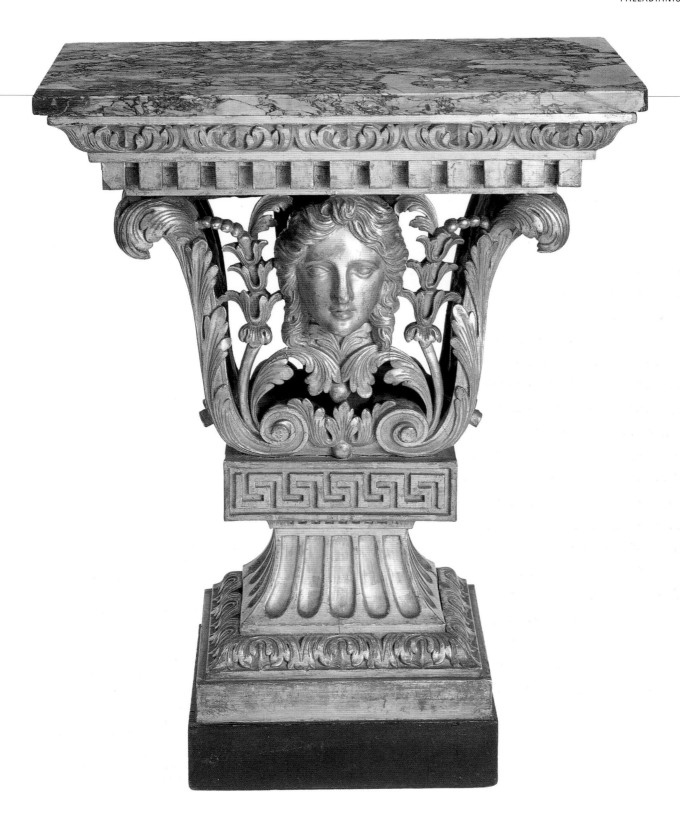

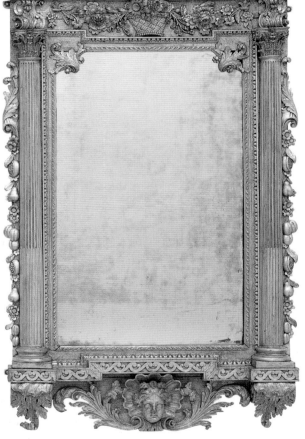

Columns

The influence of Palladianism spread rapidly to countries under British rule. In Ireland the style was strongly developed. This mirror was probably made in the workshops of Francis and John Booker in Dublin and features a number of Palladian stylistic elements, including three-quarter columns and elaborate capitals, a swan-neck pediment and a mask of the Roman goddess Venus set in a shell in the apron. However, the exuberant carving is more Baroque in style and the lion and eagle cartouche at the top and the foliage brackets beneath the columns suggest the influence of the flamboyant new Rococo style.

Carved and gilded wood. Made in Dublin in 1750–60. V&A: W.47-1928

Pediments

Prints of important Palladian architecture encouraged the spread of the style. This example shows the chimneypiece at Houghton Hall in Norfolk designed by William Kent and made by the sculptor John Michael Rysbrack in 1725. The grand pediment surmounting the overmantle and the terms on either side of the chimney show the architectural elements that formed the basis of Palladianism.

Etching, ink on paper. Drawn and published by Isaac Ware in 1735. V&A: 13095

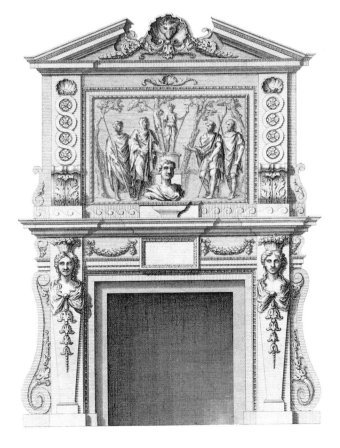

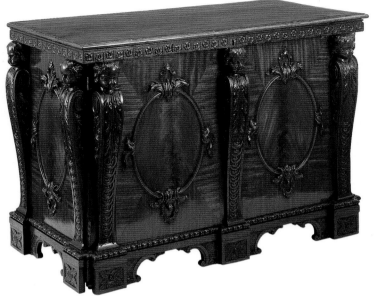

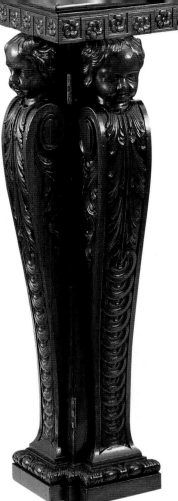

Terms

The heavy shape of this commode is divided by terms, here in the form of narrow scrolling pedestals with children's heads. The oval panels are not Palladian. Instead they reveal the influence of the new Rococo style developing in the 1740s.

Carved mahogany and pine. Possibly designed by Henry Flitcroft and made by William Hallett, London, the heads possibly carved by John Boson, 1740–6.
V&A: W.74-1962

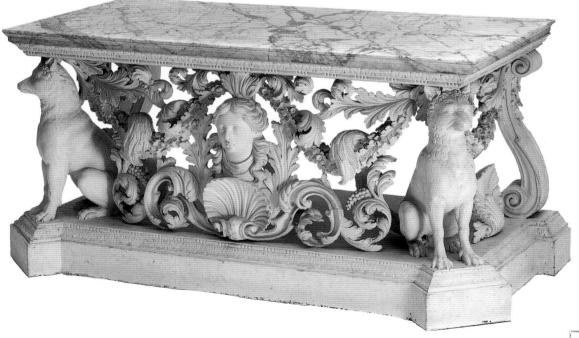

Masks

The central mask of this side table is of Diana, the Roman goddess of hunting. The use of foxes, rather than more traditional lions, for the supports continues this theme of the hunt.

Carved pine, painted white with grey-veined white marble. Probably made in London in the workshops of Benjamin Goodison around 1740, for Sir Jacob Bouverie, Longford Castle, Wiltshire. V&A: W.3-1953

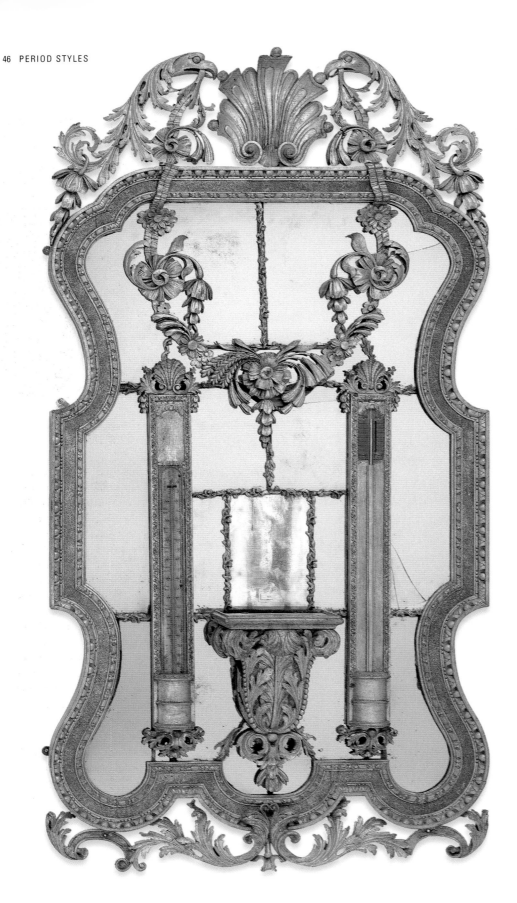

Shells

This mirror is unusual for it features a thermometer, barometer and bracket for a clock. The frame is carved with typical Palladian motifs of shells and acanthus leaves.

Carved pine, original oil gilding. Probably made in London around 1720.
V&A: W.44-1927

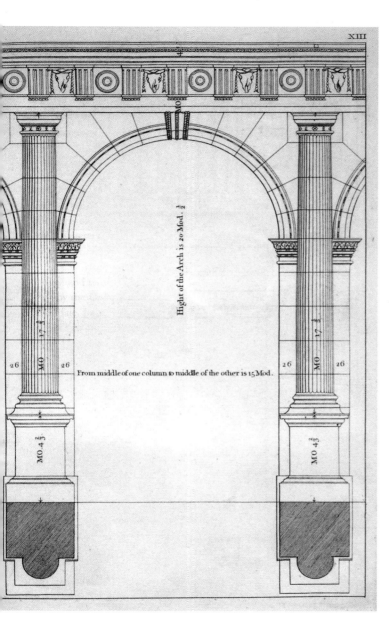

People & Places

Andrea Palladio
(1508–1580)

The work of the 16th century Italian architect, theorist and writer Andrea Palladio shaped the development of classical architecture in Europe. His enormous influence in Britain is apparent in Palladianism, the style that bears his name. Palladio's many palaces, villas, public buildings and churches were documented in his *Quattro libri dell'architettura*, first published in 1570. In the 18th century the books became a vital source of Palladian design. An English translation was sponsored by Lord Burlington.

◄ Page from *The Four Books of Andrea Palladio's Architecture*, published by Isaac Ware, London, 1738. National Art Library, 1.12.1864

▼ Andrea Palladio, oil on canvas by Giambattista Maganza, 1576. Courtesy of the Centro Internazionale di Studi di Architettura 'Andrea Palladio', Vicenza.

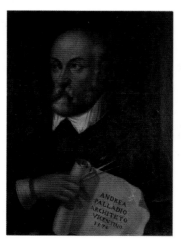

Richard Boyle
3rd Earl of Burlington
(1694–1753)

Lord Burlington was the great champion of the Palladian style. Heir to huge estates in Yorkshire and Ireland, Burlington used his vast fortune to become an important patron, an 'Apollo of the Arts' as the writer and antiquarian Horace Walpole called him. He studied classical architecture at first hand in Italy and became an avid collector of drawings by Palladio and Inigo Jones. Burlington's wealth and social position made him an important arbiter of taste. He disseminated the Palladian style through engravings, his translation of Palladio's treatise and his own architectural work, notably Chiswick House in London and the Assembly Rooms in York.

▲ Lord Burlington, mezzotint by J. Faber after a painting by Sir Godfrey Kneller, 1734. V&A: E.430-1898

William Kent

(1685–1748)

William Kent was trained as a
painter, but his true talents lay in
other directions. While studying in
Italy he met Lord Burlington and
on his return to Britain in 1720
became the earl's assistant and
protégé, initially working as an
interior decorator. Through
Burlington he gained many
commissions and became master
carpenter in the royal Office of
Works. He subsequently worked on
many large country houses, first on
interior decoration and then on
architecture and garden design.
Although most associated with
Palladianism, Kent worked in other
styles such as the Gothic. He was
also a brilliant designer of furniture
and silver.

◤ William Kent, oil on canvas by William
Aikman, 1723-5. Courtesy of the National
Portrait Gallery, London.

◀ Gold cup in the form of an ancient Roman
stone vase. Designed by William Kent for
Colonel James Pelham, private secretary to
the Prince of Wales, around 1736.
Anonymous loan.

Wanstead House

Vitruvius Britannicus was the first
architectural book to illustrate
modern British buildings. It was
published from 1715 by Colen
Campbell, an architect and pioneer
of the Palladian style. The book was
a plea for 'antique simplicity' and
Campbell included examples of his
own work including his design for
Wanstead House in Essex. Its grand
entrance portico, the alternately
arched and pedimented windows,
the great rough blocks of the
basement and the end pavilions lit
by Venetian windows were to
become key features of Palladian
architecture.

▼ Wanstead House illustrated in *Vitruvius
Britannicus*. National Art Library, L.4058-1961

The West Front of Wansted in Essex the Seat of St Richard Child Baronet Hereditary Warden of Waltham F.
Ca: Campbell Inv: et Delin
To whom this Plate is most humbly Inscrib'd

Chiswick House

Chiswick House, London, was built in 1725-9 for Lord Burlington to his own designs. The centralised structure and square plan of the villa were inspired by Andrea Palladio's Villa Rotonda near Vicenza in Italy. Burlington drew on other Palladian designs for the entrance portico on its high, rusticated podium, the double staircase, the windows and the internal arrangement of rooms. The lavishly gilded interior decoration was the work of William Kent. Burlington and Kent also remodelled the gardens at Chiswick, their small classical buildings and complicated paths being designed to recall those described in the literature of antiquity.

▶ Chiswick House. Courtesy of English Heritage Photographic Library.

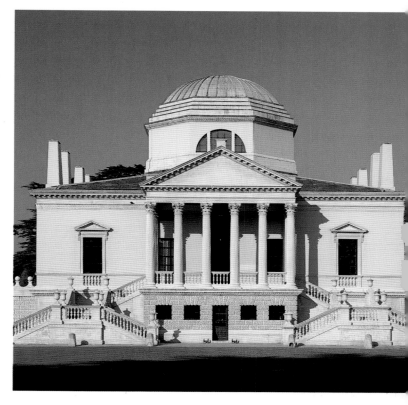

of 40 Feet. Extends 180. Elevation de L'Entrée du Chateau de WANSTED dans la Comté D'ESSEX appartenant a M.ʳ CHILD Chevalier.

Rococo
1730–1770

Rococo emerged as a distinct style in France in the 1720s and 1730s. By the following decade it was flourishing in Britain, with immigrant artists and craftsmen playing a key role in its introduction and dissemination. Some of the decorative ingredients of Rococo, such as the **acanthus leaf**, were already common elements of ornamental vocabulary, but the style itself was quite new. It was known in Britain as the 'modern' style, a term which signalled the break from the classical idiom.

While classicism was bound by the rules of the architectural orders, Rococo was free of such restrictions. It was a style of **extravagant forms** and marked **asymmetry**. The key elements were **C- and S- scrolls**, **naturalistic motifs**, such as fruit and flowers, and a form of ornament known as **rocaille**, which resembles the irregular edges of rocks and shells. Rococo was often used in combination with other anti-classical styles such as Chinoiserie and Gothic.

In Britain the chief promoters of Rococo were artists, craftspeople and entrepreneurs from the middle ranks of society rather than architects and their noble patrons. Thus the style was rarely taken up in architecture, though it played an important part in interior decoration. It was used for luxury goods such as grand furnishings and silver, and also for inexpensive pottery and ephemeral prints.

The Rococo style was often criticised for its immoderation. It was seen as a product of the French, who were viewed as frivolous, extravagant and effete. However, such anti-French attitudes sometimes served to promote Rococo, for the complexity of the style gave British craftspeople the chance to demonstrate that they were as skilled as their Gallic rivals.

Bees, moths, butterflies and beetles creep over the vine leaves that form the body of this sauceboat, while the handles and feet are cast as twigs and berries. Such 'organic naturalism', where the plant form provides the structure and the decoration, was much more common in France than Britain. The maker Paul Bruguier was a French Huguenot refugee which may explain his interest in such forms.

Cast and chased silver. Made in St Martin's Lane, London in 1755–6. V&A: M.94-1969

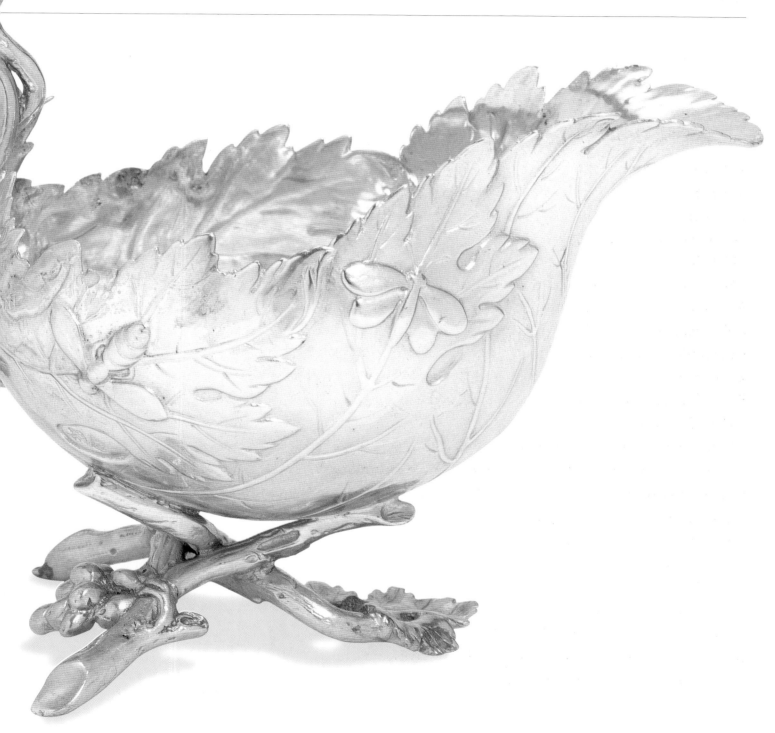

C- and S-scrolls

This elaborately decorated dressing-table mirror and stand, with its curving C- and S- scrolls, was made at the Chelsea porcelain factory. During the 1750s and 1760s pieces made at Chelsea imitated the luxury wares made at Sèvres, the French royal porcelain factory.

Soft-paste porcelain, painted in enamels, with gilt-metal mounts. Made in Chelsea, London around 1758. V&A: C.214-1935

Acanthus Leaves

The gilt bronze mounts of this commode are in the form of acanthus leaves. The mounts, the coloured floral marquetry and the elegant curvature of the front and sides of this piece of furniture are very Parisian in design reflecting the French origins of its maker.

Rosewood and marquetry of other woods, with pewter, gilt-bronze mounts and marble slab. Made in London by Pierre Langlois around 1765. V&A: W.8-1967

Asymmetry

Although asymmetry is a major characteristic of the Rococo style, it is unusual to find a design such as this in ceramics. This vase may have been made using a carved wooden casting model.

Soft-paste porcelain, painted in enamels. Made at the Derby porcelain factory in 1758–60. V&A: C.76-1967

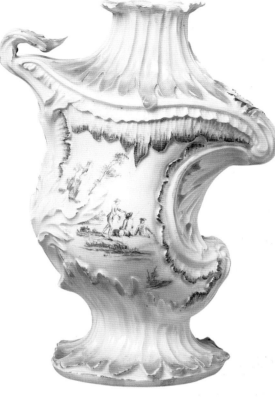

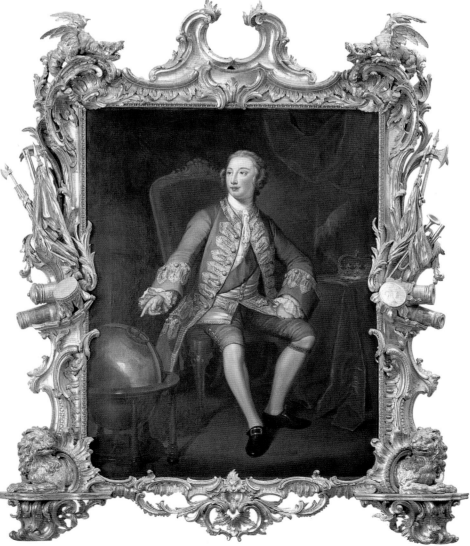

Extravagant Forms

This is one of the most elaborate English carved Rococo frames to survive. The bold carving of military trophies, animals, curving scrolls and foliage was probably carried out in the workshop of Paul Petit.

Frame of carved and gilded pine made in London around 1751. Portrait of George III when Prince of Wales, oil on canvas after George Knapton. V&A: W.35-1972

Naturalistic Motifs

This mantua and petticoat represent the grandest style of court dress. The width of the skirt made it necessary for the wearer to go sideways through doors, but had the advantage of displaying a large area of lavish decoration. Botanically accurate flowers were a feature of English Rococo embroidery, patterned silks and printed textiles of the 1740s and 1750s.

Silk embroidered with coloured silk and silver thread. Made in 1740–5.
V&A: T.260-1969

Rocaille

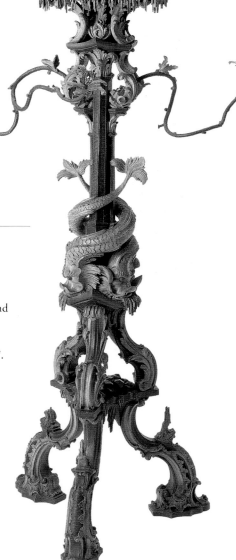

A range of Rococo forms and motifs have been used on this exuberant candlestand. The columns are entwined with naturalistically carved branches and dolphins, supported on a base of scrolls fringed with the shell-like ornamentation known as 'rocaille'. The stalactite forms extend the aquatic theme.

Carved and painted pine, iron candle branches, gilt-bronze nozzles. Probably designed by Thomas Johnson and made in his workshop in Soho, London in 1756–60. V&A: W.9-1950

People & Places

Hubert Gravelot
(1699–1773)

The French illustrator, engraver, painter and draughtsman Hubert Gravelot played a major role in the development of the Rococo style in Britain. He came to London in the 1730s where his skills brought him immediate success. During his 12 years in the country he taught at the St Martin's Lane Academy, where the new Rococo style was first nurtured, and illustrated over 50 works including Samuel Richardson's novel *Pamela*. He also collaborated with other artists such as Francis Hayman, with whom he worked on decorations for the supper-boxes at the Vauxhall Pleasure Gardens. A rise in anti-French feeling in 1754, following the French victory over Allied forces at the Battle of Fontenoy, forced Gravelot to return to Paris.

◀ Illustration from the sixth edition of *Pamela* designed by Francis Hayman and etched by Hubert Gravelot, 1742. V&A: 26614.53

▼ Border from a portrait engraving taken from a design by Hubert Gravelot, 1735. V&A: E.7283-1903

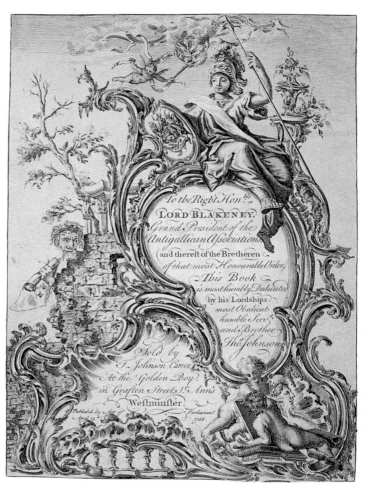

Thomas Johnson
(1714–?1778)

Thomas Johnson was an influential figure in British Rococo. He published numerous designs as well as working as a wood carver and teacher. In 1758 he published *One Hundred and Fifty New Designs* which he dedicated to his fellows in the Antigallican Association, a group hostile to new French fashions. The dedication page shows Britannia sitting astride a wildly asymmetrical Rococo cartouche and holding the Antigallican arms. Nearby Cupid sets fire to cheap French papier-mâché imports of the kind that were undercutting the prices of elaborate Rococo woodcarving produced by Johnson and others.

▲ Dedication page from *One Hundred and Fifty New Designs*. V&A: E.3780-1903

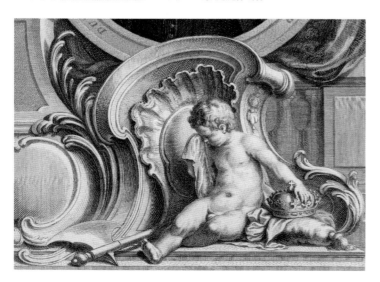

Paul de Lamerie
(1688–1751)

Paul de Lamerie was the son of
French Huguenot parents who
had emigrated to the Netherlands
before settling in London. In the
1730s he was one of the first
British silversmiths to work in the
new Rococo style. His exuberantly
modelled, naturalistic forms
brought him widespread fame and
a number of important aristocratic
clients. This elaborate centrepiece is
encrusted with Rococo ornament.
It has 14 different components
that can be assembled in different
combinations for the various stages
of a meal.

▼ The Newdigate Centrepiece, cast, chased
and engraved silver. Made in London in the
workshop of Paul de Lamerie in 1743–4.
V&A: M.149-1919

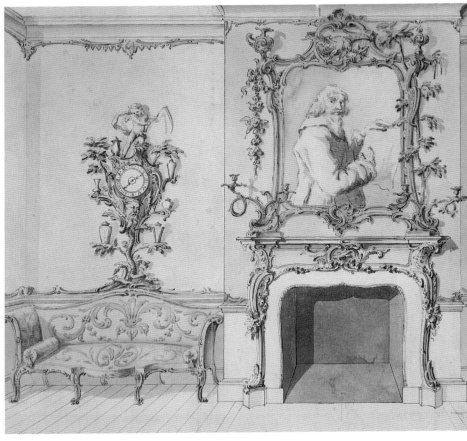

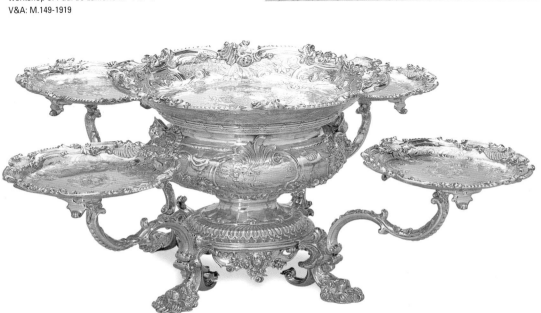

Design of an interior

This design, from about 1755, is
by John Linnell who, with his
father William, was one of the most
successful designers and cabinet
makers of the 18th century.
Linnell studied at St Martin's Lane
Academy and his training in the
Rococo style is evident in this
design which features a richly
carved chimneypiece, a highly
elaborate naturalistic overmantle, a
clock in the form of a tree and an
elegantly curved settee with an
upholstery design of scrolling
acanthus. The Linnells were also
famed for their Chinoiserie designs.

▲ Design in pencil, ink and wash by John
Linnell, late 18th century. V&A: E.263-1929

The Norfolk House Music Room

Norfolk House in St James's Square, London was designed in 1748-56 for the 9th Duke and Duchess of Norfolk by Matthew Brettingham. The lavish interiors of the house contrasted with the rather austere Palladian exterior and reflected the taste of the Francophile duchess. They illustrate the combined talents of a number of British and European craftsmen who worked on the building, including Italian designer Giovanni Battista Borra, French carver and gilder John Anthony Cuenot, sculptor James Lovell and plasterers Thomas Clark and William Collins. The proportions and overall symmetry of the Music Room, now preserved in the Victoria and Albert Museum, are classical, but the elaborate carvings are Rococo in style.

▼ Norfolk House Music Room.
V&A: W.70-1938

The Grand Staircase at Powderham Castle

Powderham Castle in Devon is the family home of the Earl of Devon. The oldest parts of the castle were built in 1390 to 1420, but the building was extensively altered and enlarged in the 18th and 19th centuries. The spectacular staircase, which dates from around 1755, features ornate, scrolling Rococo plasterwork.

▶ The Grand Staircase at Powderham Castle, courtesy of the Earl of Devon.

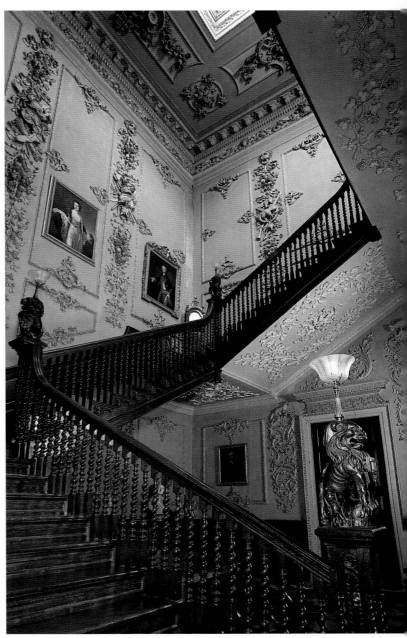

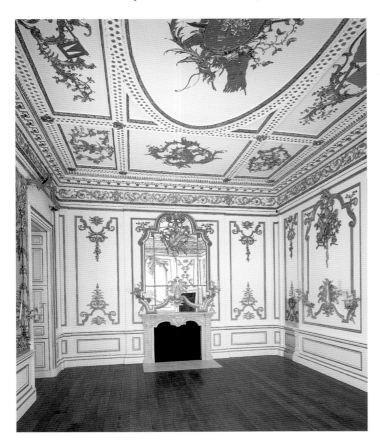

Chinoiserie
1750–1765

In the 18th century porcelain, silk and lacquer imported from China and Japan were extremely fashionable. This inspired many British designers and craftsmen to imitate Asian designs and to create their own fanciful versions of the East. The style was called Chinoiserie from 'chinois', the French for Chinese.

To people living in Britain in the 18th century China was a mysterious, far-away place. Chinoiserie drew on this exotic image. Objects featured **fantastic landscapes** with fanciful pavilions and fabulous birds. **Chinese figures** also appeared frequently. Such themes were sometimes inspired by those depicted on actual Asian objects, but often they originated in the designer's imagination.

Dragons were another common Chinoiserie motif. To British designers these mythical beasts summed up all that was strange and wonderful about Asia. The sweeping lines of the roofs of Chinese **pagodas** were also incorporated into a wide range of Chinoiserie objects.

British designers often combined Chinoiserie with the Rococo and Medieval Revival styles. Chinoiserie was used particularly for bedrooms and dressing rooms. Such interiors often featured genuine Asian objects such as Chinese porcelain and wallpaper. In architecture Chinoiserie was used for small garden buildings. The style was at its height of popularity in the mid 18th century, but continued to be used into the 19th century.

This elaborately carved mirror comes from Halnaby Hall, North Yorkshire, which was famed for its Rococo plasterwork. It features fanciful buildings, long-necked birds and figures in Chinese robes. It presents a fairy-tale image of Asia, created from the imagination rather than copied from an actual Chinese object.

Carved and gilded wood. Made in London, probably after a design by Thomas Johnson, in 1758–60. V&A: W.23-1949

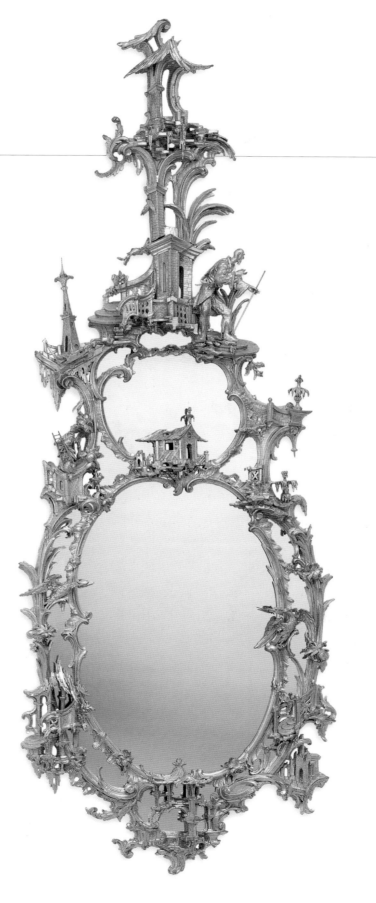

Fantastic Landscapes

This commode has been 'japanned' using layers of pigmented varnish, in imitation of Asian lacquer. The doors show two fishing scenes with pagoda-like buildings, rocks, trees and foliage.

Softwood carcass with drawers lined with oak; japanned in gold on a black ground with gilt bronze mounts. Made in 1760–5.
V&A: W.61-1931

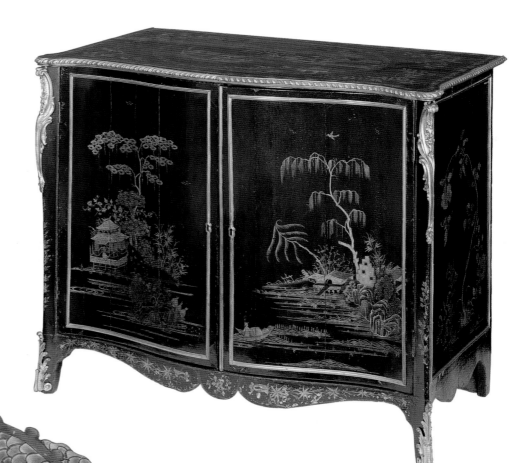

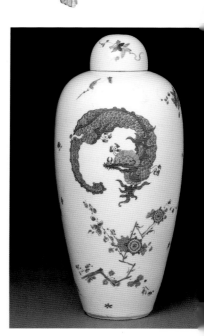

Dragons

The decoration and colours of this vase imitate Japanese Kakiemon porcelains, which were much admired in Europe in the 18th century.

Soft-paste porcelain, painted in enamels and gilt. Made in London at the Bow porcelain factory around 1755.
V&A: C.333-1926

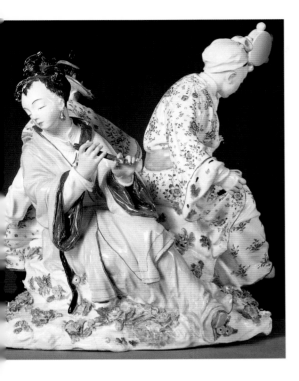

Pagodas

On this chair the pagoda-shaped cresting and the fretwork of the central spat derive from China, but the clustered columns of the legs are an element of the Medieval Revival style.

Carved mahogany, with modern damask upholstery. Made around 1760.
V&A: W.71-1962

Chinese Figures

This is the largest, most complex and most ambitious porcelain figure group made in 18th century Britain and features four richly dressed Chinese figures on a rocky base.

Soft-paste porcelain, painted in enamels and gilt. Modelled by Joseph Willems at the Chelsea porcelain factory in London around 1755. V&A: C.40-1974

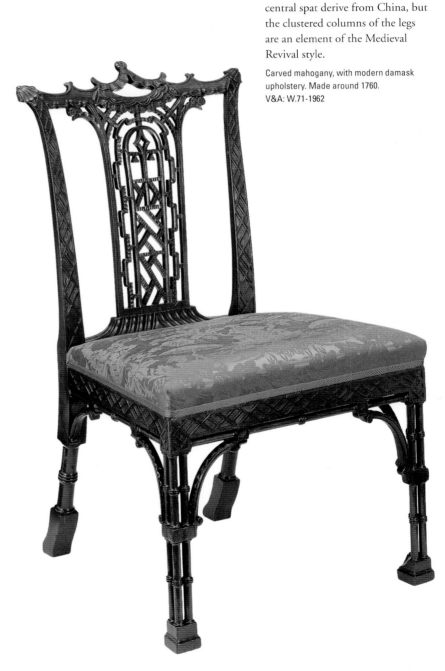

People & Places

Sir William Chambers

(1723–1796)

Sir William Chambers is best known as a classical architect, but in his garden buildings he worked in a great variety of styles. As a young man Chambers travelled in East Asia, visiting the great Chinese port of Canton (Guangzhou), and in 1757 he published his observations in *Designs of Chinese Buildings*. He also designed a number of Chinoiserie style buildings for Kew Gardens. The pagoda, aviary and bridge were not based on any real Chinese examples, but Chambers did aim for accurate imitations which contrast with the rather fanciful creations of his contemporaries.

▲ Sir William Chambers, oil on canvas by Sir Joshua Reynolds, 1751–60. Courtesy of the National Portrait Gallery, London.

▶ Page from *Designs of Chinese Buildings*. National Art Library, 65.H.26

Jean Pillement

(1728–1808)

Jean Pillement was a French artist who settled in London in 1750. He was a major designer of Chinoiserie ornament, his most influential collection of prints being *A New Book of Chinese Ornaments* published in 1755. Pillement's fanciful images of Chinese figures, pavilions, flowers and foliage were copied and adapted for all kinds of objects including ceramics, wallpaper, furniture and most especially textiles.

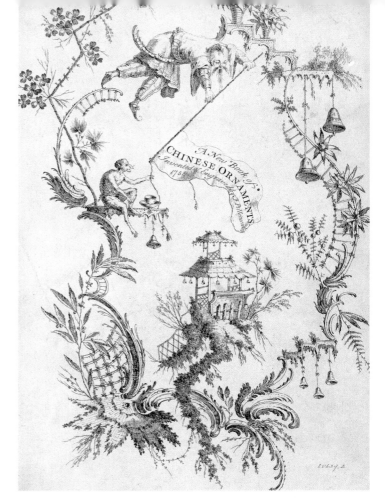

▶ Title page from A *New Book of Chinese Ornaments*. V&A: 28639a

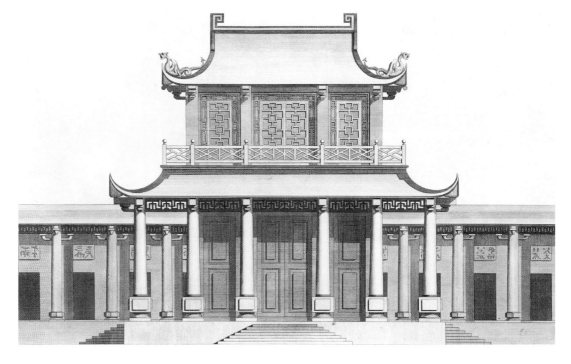

William Linnell
(1703–1763)
and John Linnell
(1729–1796)

Father and son William and John Linnell were very successful furniture manufacturers. Around 1754 they designed one of the earliest Chinoiserie interiors in Britain, the Chinese bedroom commissioned by the 4th Duke and Duchess of Beaufort for Badminton House in Gloucestershire. The most dramatic piece of furniture the Linnells made for the room was the bed. With its pagoda-like canopy embellished with dragons, its decorative latticework and its imitation lacquer surface in red, blue and gold it exemplifies the Chinoiserie style.

▶ The Badminton Bed, beechwood, japanned in red, yellow and blue and gilded. V&A: W.143-1921

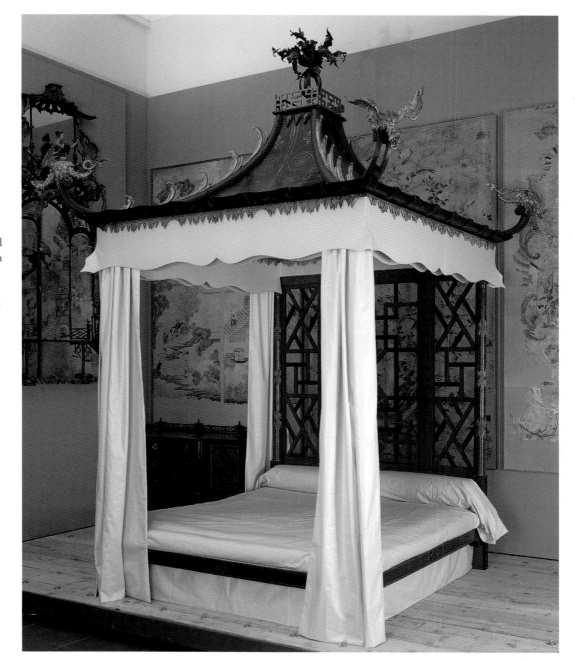

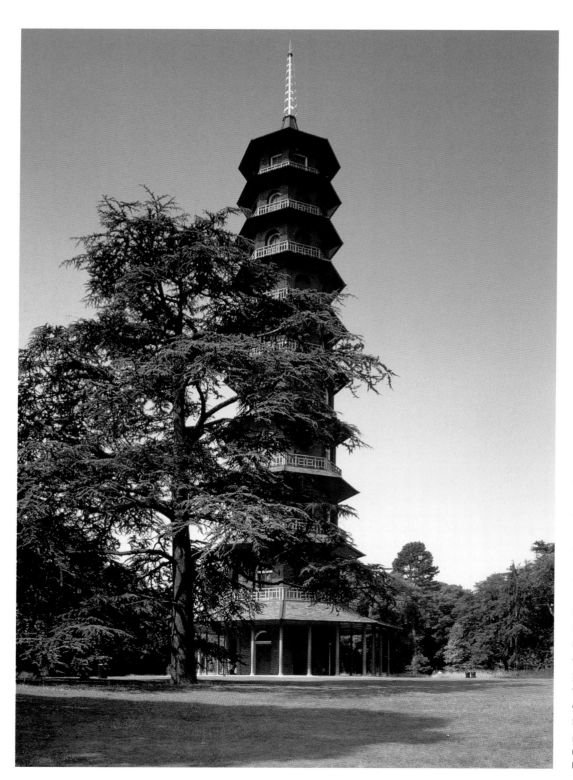

Kew Gardens

The botanic gardens at Kew, in Surrey on the outskirts of London, were established in 1759 by the Dowager Princess Augusta. She employed the architect William Chambers to create a number of exotic Chinese and Moorish style buildings. His famous pagoda, built in 1761-2, remains the most celebrated example of Chinoiserie in Britain. The publication of Chambers' plans and views of Kew in 1762 started a fashion for Anglo-Chinese gardens.

◄ The Pagoda, Kew Gardens. Courtesy of Kew Gardens Bridgeman Art Library.

The Chinese Room, Claydon House

The most elaborate Chinoiserie interior surviving in Britain is the Chinese Room in Claydon House, Buckinghamshire, which was designed by Luke Lightfoot in 1769. Above each door is a pagoda motif supported by Chinese figures. Oriental faces also appear among the flowers around the chimneypiece. The most remarkable part of the room is the tea alcove, which is painted with a latticework design and covered with bells, flowers, shells and scrolls.

► The Chinese Room, Claydon House. Courtesy of the National Trust Photographic Library, photograph by Vera Collingwood.

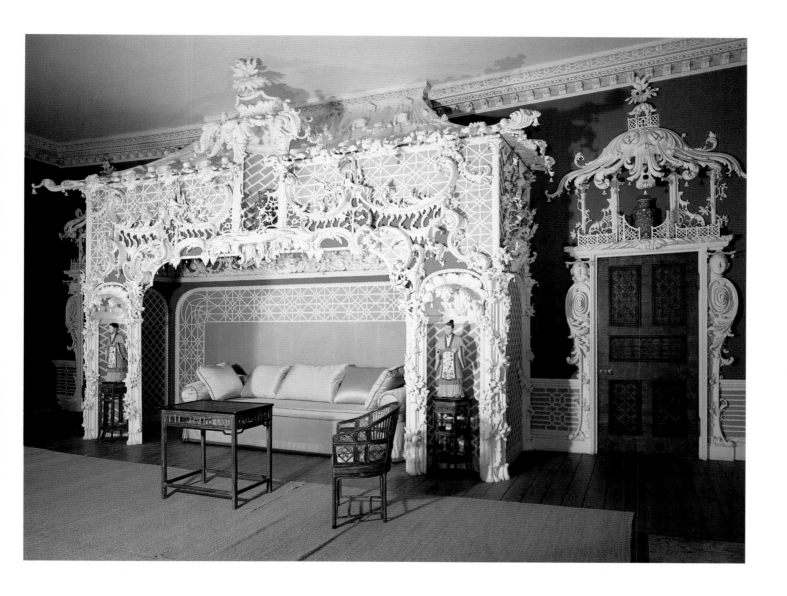

Neoclassicism
1760–1790

Neoclassicism was a style that emerged in Britain and France in the 1750s. Known to contemporaries as the 'antique manner', it was inspired by the art and design of classical Greece and Rome. A major source of inspiration came from archaeological discoveries, such as those made at Herculaneum and Pompeii in Italy, which brought the ancient world to life. Using the remains of the classical past Neoclassical artists, architects and designers sought to create a modern and eternally valid 'true style' that could be expressed across all areas of the visual arts.

Vases were the ultimate symbol of the ancient world and there was an enormous craze for them in the second half of the 18th century. The vase shape was also used for a wide range of practical objects and as a design motif. Vases and other objects were often decorated with **swags and festoons**. These hanging garlands of fabric, ribbons, flowers and bud-like motifs known as husks, were based on classical Roman ornament. Lines of small beads are another common Neoclassical motif. **Beading** was a feature of classical architecture, but in the 18th century it was also used to decorate small-scale objects.

The **classical figures** depicted in ancient Greek and Roman art provided 18th century artists and designers with sources of both subject matter and style. The cameo format, where the figure is shown in profile, was particularly popular. A wide range of both **real and imaginary animals** also appear on Neoclassical objects. Dolphins, lions, sphinxes, griffins and satyrs often form the bases or handles of objects.

This sugar bowl has been made in the shape of a classical urn. It is decorated with a band of swags and festoons, has handles in the shape of a satyr's head and is surmounted by a classically derived cherub figure.

Silver gilt with cast, chased and applied decoration. Made in London, probably by John Arnell, in 1772–3. V&A: 55-1865

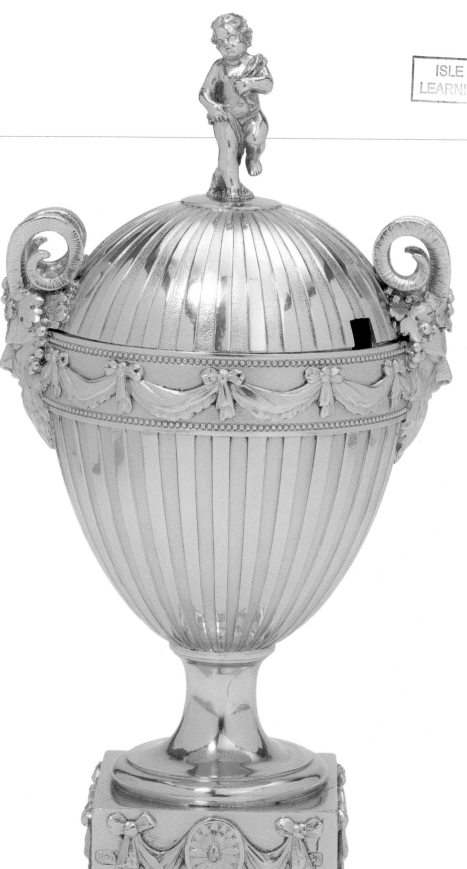

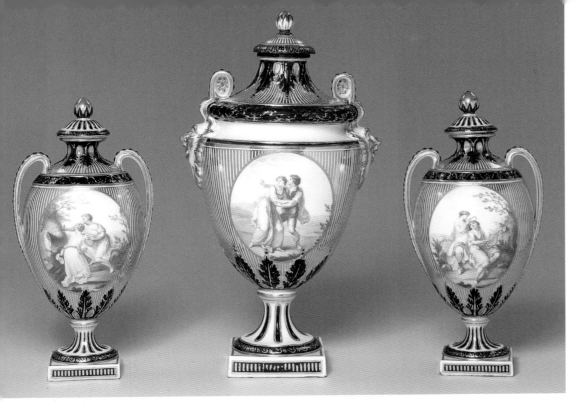

Vases

These elegant vases are typical of those produced in the Neoclassical style to satisfy the enormous desire for such objects in the late 18th century. The figures of classical mythology that adorn them are taken from paintings by Angelica Kauffmann.

Soft-paste porcelain, painted in enamels and gilt. Made at the Derby porcelain factory in 1782–5. V&A: C.263-1935

Swags and Festoons

The architect William Chambers designed this Neoclassical table for his own use. Its overall form is based on French tables, but the legs derive from ancient Greek furniture. The top is inlaid with marbles and stones and the sides are decorated with swags and festoons.

Satinwood with oak and pine carcass; inlaid with ebony veneer, jasper, onyx, lapis lazuli, quartz and serpentine. Made in London by Georg Haupt in 1769. V&A: W.38-1977

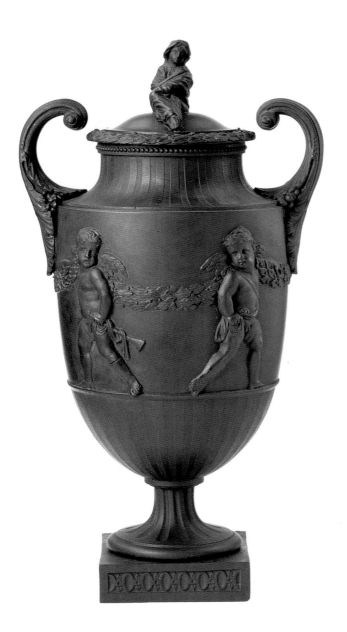

Classical Figures

The classical figures on this black basalt vase, made at Josiah Wedgwood's factory, Etruria, are loosely based on an Italian print.

Black basalt. Made at Etruria, Staffordshire in 1775. V&A: 280-1893

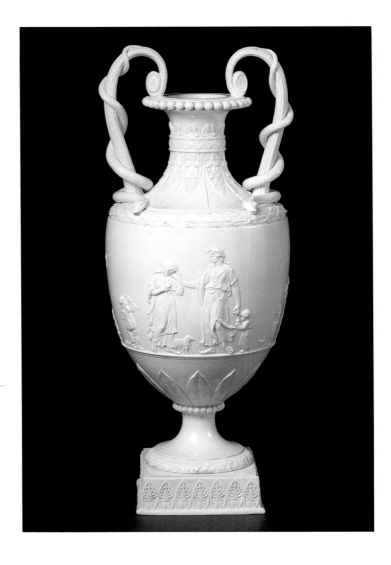

Beading

The rim of this vase is decorated with beading. The classical figures on the body are by Lady Templetown who provided Wedgwood with designs between 1783 and 1788.

Cream-coloured earthenware. Made at Josiah Wedgwood's factory, Etruria, Staffordshire in 1790–1800. V&A: C.799-1935

Real and Imaginary Animals

The handles of this Neoclassical vase are in the shape of dolphin-like creatures. Masks, lions, swags and festoons decorate the surface. The design is based on an engraving of one of the vases painted on the façade of the Palazzo Milesi in Rome in the 1520s by Polidoro da Caravaggio.

Soft-paste porcelain, painted in turquoise enamel. Made at the Derby porcelain factory in 1773–4. V&A: 414:437-1885

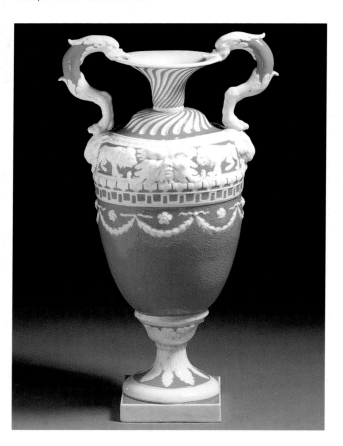

People & Places

Robert Adam
(1728–1792)

Robert Adam was one of the most eminent architects of the second half of the 18th century. He played a major role in introducing Neoclassicism to Britain, having studied ancient and Renaissance art while in Italy on the Grand Tour. Adam developed a distinctive and highly individual style that was applied to all elements of interior decoration, from ceilings, walls and floors to furniture, silver and ceramics. The 'Adam Style' was enormously popular and had a lasting influence on British architecture and interior design.

▲ Ceiling of 5 Royal Terrace, Adelphi, London, the home of the actor David Garrick, designed by Robert Adam in 1771. V&A: W.43-1936

◤ Robert Adam, moulded opaque white glass, mounted on glass, by James Tassie, 1782. V&A: 414:1323-1885

James Stuart
(1713–1788)

James Stuart was an architect and archaeologist. He found fame as the author, with Nicholas Revett, of *The Antiquities of Athens,* published in 1762. This pioneering work was the first accurate survey of classical Greek remains. It became a major source of forms and motifs for British designers. On his return to Britain from Greece, James 'Athenian' Stuart, as he had become known, found steady employment from those wishing to have houses and park buildings created in the latest and most authentic classical style. He also designed Neoclassical silver and furniture.

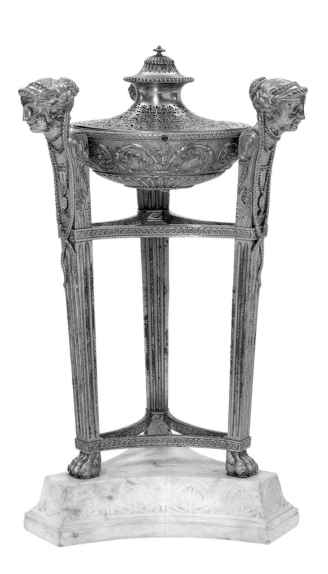

◄ Cast ormolu perfume burner, probably by Diederich Nicolaus Anderson after a design by James Stuart, around 1760. V&A: M.46-1948

Josiah Wedgwood
(1730–1795)

Josiah Wedgwood, the famous Staffordshire potter, was a leading producer of Neoclassical ceramics. He was introduced to the style by a number of collectors and architects who allowed him to copy designs from their books and antiquities. Wedgwood did much to broaden the appeal of Neoclassicism by introducing new materials and new types of pottery goods. One of his most celebrated works was the copy of the Portland Vase. At the time the original glass vase, in the British Museum's collection, was the most famous object to have survived from ancient Rome.

◥ Josiah Wedgwood, mezzotint by S.W. Reynolds, after Sir Joshua Reynolds, 1841. V&A: 22931

► Jasper ware copy of the Portland Vase by Josiah Wedgwood, 1790. V&A: 2418-1901

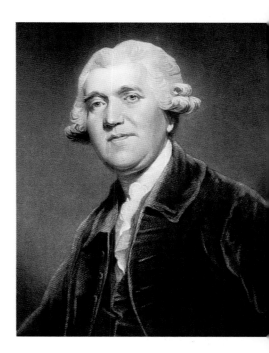

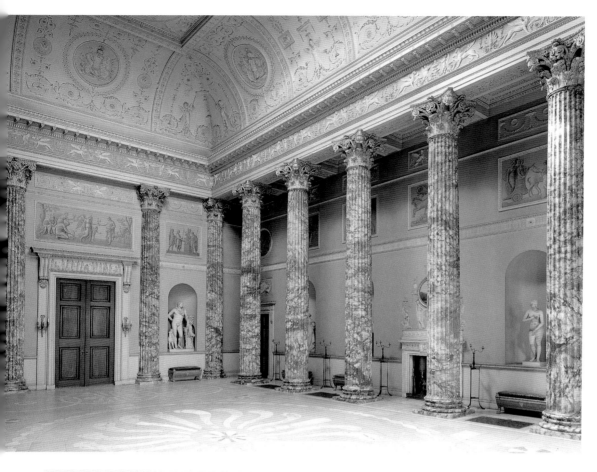

Kedleston Hall

Kedleston Hall in Derbyshire, built for Sir Nathaniel Curzon, later Lord Scarsdale, is one of the earliest and greatest Neoclassical houses in Britain. It was designed by Robert Adam, who took over from the original architects in 1760. He worked on the house over a 20 year period and it reflects the development of his Neoclassical style. The grandeur of the exterior of Kedleston is matched by the Marble Hall of the interior which features 20 enormous Corinthian columns and wall decorations of classical and fantastic creatures, swags and festoons.

◀ The Marble Hall, Kedleston. Courtesy of the National Trust Photographic Library, photograph by Nadia MacKenzie.

▼ Kedleston Hall. Courtesy of the National Trust Photographic Library, photograph by Matthew Antrobus.

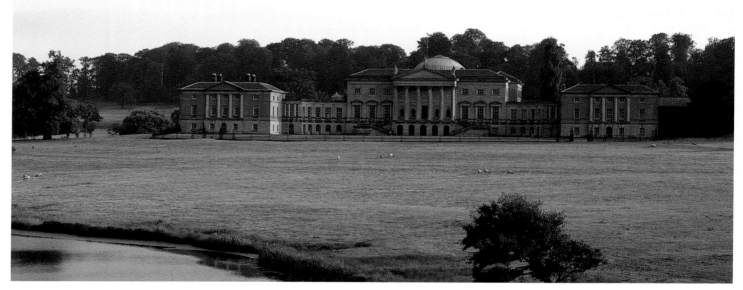

Somerset House

Somerset House on the Strand in London was built to accommodate various civil service departments and learned societies. It was designed by William Chambers, the Royal Architect, who received the commission in 1775. It was the biggest project of his career and the first, and largest, government building in the classical style. It was constructed around a grand courtyard, with a terrace on the Thames. Somerset House was recently restored and is now open to the public.

▶ The Courtyard, Somerset House. Courtesy of Somerset House Trust, photograph by Alex Orrow.

Edinburgh New Town

Edinburgh New Town is one of the largest and most unified examples of 18th and early 19th century classical town planning in Europe. The proposal for the development, north of the existing city, was put forward in 1752. The area was constructed in seven stages with various architects, including Robert Adam, contributing to the scheme. The grand terraces of houses, built in spacious squares and crescents, contrasted greatly with the medieval Old Town. The Neoclassical style buildings of the New Town led Edinburgh to be dubbed 'the Athens of the North'.

▶ Heriot Row, Edinburgh New Town. © Crown Copyright reproduced courtesy of Historic Scotland.

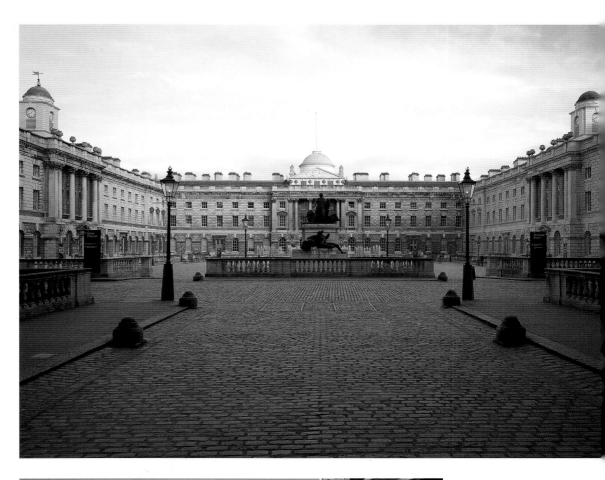

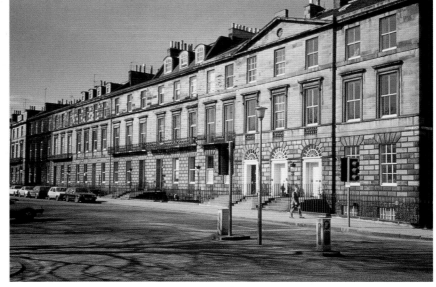

Medieval Revival
1780–1830

The Medieval Revival was inspired by the Gothic art and architecture of the Middle Ages. It first developed in the mid 18th century and by the 1790s had become an important alternative to classical styles. The scope of the revival also widened to include pre-Gothic, Norman styles and later Elizabethan, Jacobean and Restoration styles. The interest in the styles of the 11th-17th centuries reflected a romantic nostalgia for Britain's past. This was coupled with an increasingly serious study of actual medieval buildings and furnishings.

Many stylistic features of the Medieval Revival were derived from Gothic architecture. The pointed **arch** was the most recognisable characteristic, with the rounded arches of 11th century Norman architecture also used occasionally. The **tracery**, or ornamental openwork patterns, and the clustered **columns** found in medieval buildings provided other important elements. Another common decorative motif was the **quatrefoil**, a flower-like ornamentation with four lobes. The interest in 17th century styles is reflected in furniture, where the wood is elaborately turned or carved into **spiral-twist forms**.

This wrought iron chair was made for use in a garden. The Medieval Revival style was often seen in such settings, being considered particularly suitable for the wilder parts of the garden. The simple construction of the chair suggests that it was made by a rural blacksmith, presumably for a wealthy landowner. The back of the chair is in the shape of a pointed arch with three lancets surmounted by a quatrefoil.

Wrought iron. Made in 1815–30.
V&A: W.11-1977

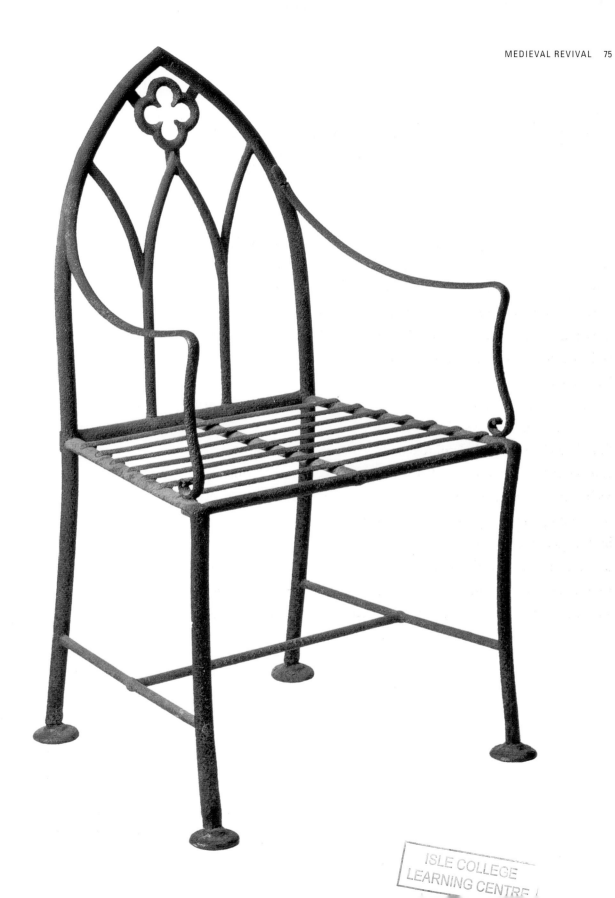

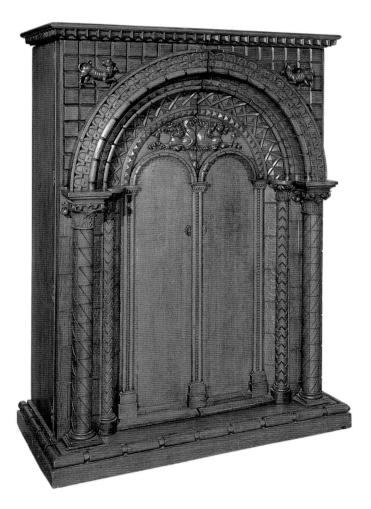

Tracery

This chair, one of eight commissioned by Horace Walpole for his home Strawberry Hill, is an early example of the Medieval Revival style. The design of the chair back is based on Gothic window tracery.

Beech, painted black to imitate ebony, with a rush seat. Designed by Richard Bentley and made by William Hallett in St Martin's Lane, London in 1755. V&A: W.29-1979

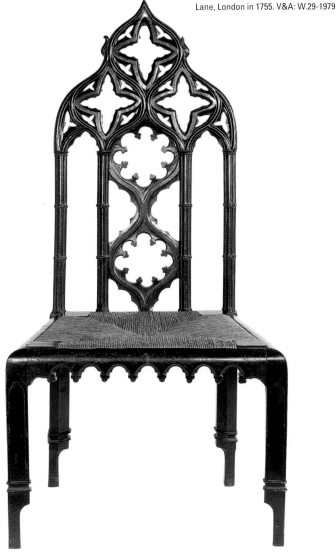

Arches

This unusual wardrobe has been designed to look like a Norman doorway. It was probably designed by the architect Thomas Hopper for Gosford Castle, Co. Armagh, Northern Ireland which was the first Norman Revival castle built in the British Isles.

Carved oak. Made in 1820–30.
V&A: W.35-1980

Columns

The clustered columns of Gothic cathedrals are here transformed into a candelabrum. The monumental stand was made for the Gothic conservatory of Carlton House, the London residence of the Prince Regent. It is made from coadestone, a hard-wearing ceramic that imitates stone.

Cast coadestone. Designed by Thomas Hopper and made by Coade & Sealy in Narrow Wall, Lambeth, London in 1810.
V&A: A.92-1980

Quatrefoils

This side table, which features quatrefoil motifs, was designed by Sir John Soane for the new Gothic library at Stowe, created to house the Marquess of Buckingham's collection of medieval manuscripts.

Ebonised mahogany and ivory. Probably made in London around 1805.
V&A: W.32-1972

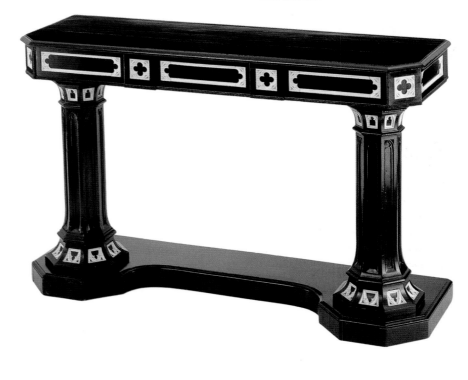

Spiral Twist Forms

Until the 1970s this elaborately turned chair was thought to be 17th century. In fact it was made in the 1830s and is an exact copy of a 17th century chair in the Bishop's Palace at Wells, Somerset.

Turned oak and ash. Probably made by Mr Kensett of Mortimer Street, London in 1830–40. V&A: W.24-1913

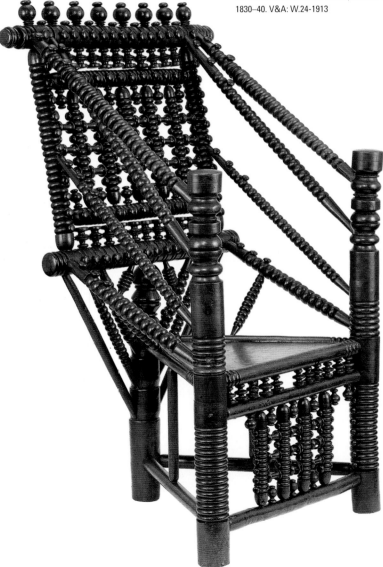

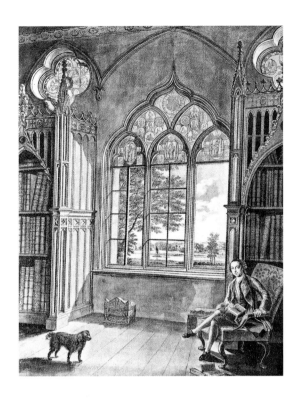

People & Places

Horace Walpole
(1717–1797)

Horace Walpole was the youngest son of Sir Robert Walpole, the first British Prime Minister. He also entered politics, but devoted most of his time to his artistic, architectural and literary interests. Walpole was an early and passionate advocate of the Gothic style and his love of the medieval was reflected in his own home, Strawberry Hill, and in the important collection he amassed. In 1764 he published the first Gothic novel *The Castle of Otranto.* Set in a labyrinthine Italian castle, it tells a fantastical and frightening story intended to excite the imagination.

▲ Horace Walpole seated in his library at Strawberry Hill, etching after a watercolour by J.H. Muntz, from *The Strawberry Hill Accounts,* 1927. National Art Library, 241.C.26

James Wyatt

(1746–1813)

James Wyatt was one of the leading architects of his day. He worked in a number of styles, but it was his achievements as a Gothic designer that brought him most fame and notoriety. Wyatt combined the use of accurate details adapted from medieval churches with picturesque effects designed to stir the emotions. His most famous building was Fonthill Abbey. Wyatt also restored a number of important medieval cathedrals, but his schemes often caused controversy and earned him the nickname 'Wyatt the Destroyer'.

▼ James Wyatt, mezzotint after Charles Turner, 1809. V&A: 22941

Thomas Rickman

(1776–1841)

Thomas Rickman was a church architect. His great importance to medievalism lies not in his designs, however, but in a book he published in 1817. *An Attempt to Discriminate the Styles of Architecture in England, from the Conquest to the Reformation* methodically describes architectural features such as windows, doors and arches as they appeared at different times in the Middle Ages. Rickman devised a chronology and terminology for medieval architecture that was rapidly adopted and is still in use today: Norman (1066–c.1190), Early English (c.1190–c.1300), Decorated (c.1300–c.1390) and Perpendicular (c.1390–c.1540).

▶ Plate from *An Attempt to Discriminate the Styles of Architecture in England, from the Conquest to the Reformation.* National Art Library, 4.6.75

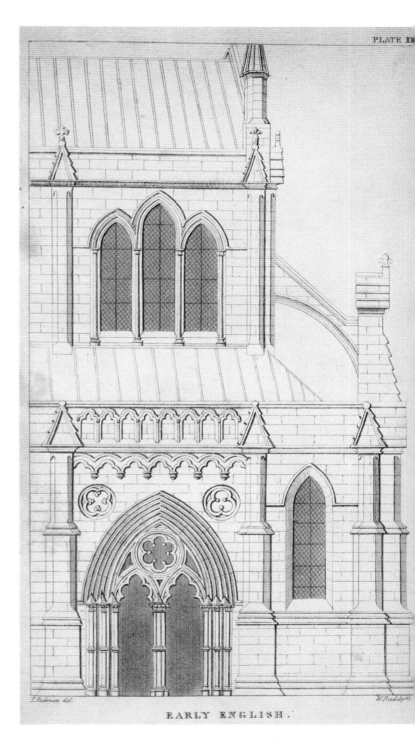

PLATE XI

T. Rickman del. *W. Radclyffe*

EARLY ENGLISH.

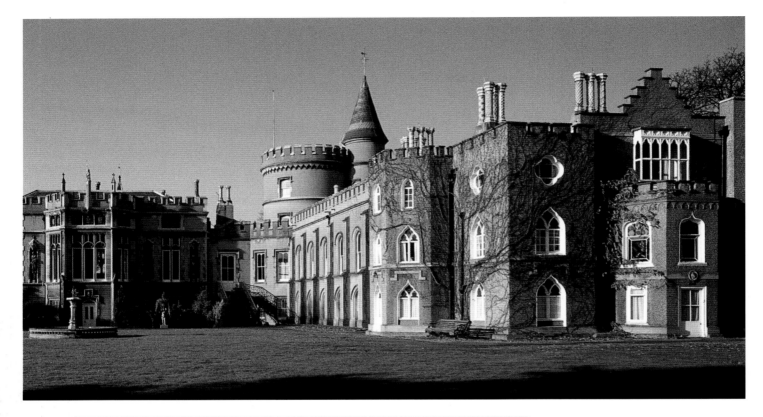

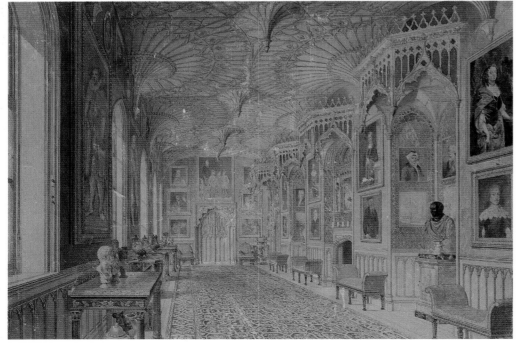

Strawberry Hill

Strawberry Hill in Twickenham, Middlesex was the home of Horace Walpole. In 1753 Walpole set about turning it into 'a little Gothic castle' with the help of amateur architects John Chute and Richard Bentley and later two professionals, Robert Adam and James Essex. The overall character of the design was very theatrical, but at Walpole's insistence all the features of the house – such as the traceried bookcases, the carved woodwork, the canopied alcoves and fan-vaulted ceilings – were based on specific medieval sources.

▲ Walpole House, Strawberry Hill.
© St Mary's College.

◀ The Gallery at Strawberry Hill, by Thomas Sandby, watercolour, 1781.
V&A: D.1837-1904

Fonthill Abbey

Fonthill Abbey in Wiltshire was built in 1796–1812 by James Wyatt for William Beckford, one of the richest men in Britain. Fonthill was the ultimate statement of the romantic vision of a medieval monastery. It was a vast cruciform structure with long galleries and an octagonal central hall surmounted by an 83-metre (273-foot) tower. In 1825 this tower collapsed taking much of the building with it. Today only a fragment survives.

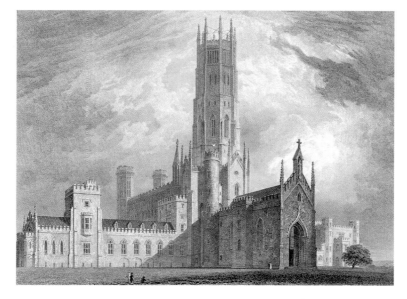

▶ View of the west and north fronts of Fonthill from *An Illustrated History and Description of Fonthill* by John Rutter, 1823. National Art Library, CLE.M13

Windsor Castle

Windsor Castle is the world's largest medieval castle, its origins dating back to the time of the Norman Conquest. It is also the greatest example of the Medieval Revival, having been completely altered and enlarged by Sir Jeffrey Wyattville between 1824 and 1840. Wyattville raised the height of the Round Tower, added turrets, towers and battlements and remodelled the interior, transforming the castle into the great symbol of British history and monarchy that it remains today.

▶ Windsor Castle. The Royal Collection, © 2001, Her Majesty Queen Elizabeth II.

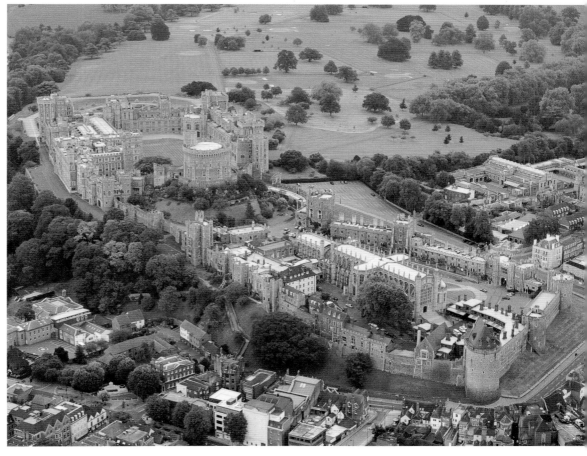

Regency Classicism
1800–1830

Regency Classicism was the most fashionable style in Britain during the period 1800–30. Forms and motifs from ancient Greece and Rome formed the basis of the style and to these were added elements taken from nature, from the arts of ancient Egypt and from French design of the mid 18th century. The combination of different patterns and colours made Regency Classicism a visually rich style.

Interest in ancient **Greece** was stimulated by the publication of a number of important illustrated books. Designers and manufacturers copied or adapted ancient examples or created objects using classical shapes. Greek motifs, such as the flower-like anthemion, were very popular. The influence of the grand architecture and sculpture of imperial **Rome** was reflected in the use of heavy forms and by ornate decoration featuring scrolling leaves, flower heads and drapery. The sculptural **friezes** found on ancient Greek and Roman architecture provided particular inspiration in the early 19th century. They featured on buildings and were used as a decorative motif on a wide range of objects. Wallpaper borders designed to look like classical friezes were also popular.

Egyptian designs had been used occasionally in the earlier Neoclassical style, but it was the archaeological surveys and discoveries that accompanied Napoleon's campaign in Egypt that led to a craze for the **Egyptian style**. Ancient Egyptian art and architecture provided designers with a whole new range of motifs.

Another stylistic ingredient of Regency Classicism was based on French designs of the period 1740 to 1770. This revival of the **Rococo** style was characterised by the use of curved forms and decoration in the shape of rocks and shells. A further feature of Regency Classicism that emerged in the 1830s was the use of nature as a source for designs. This was seen particularly in the brightly coloured ceramics of the period. In some cases **naturalism** provided the whole form of the object as well as the decoration.

Chairs with this type of curved leg and shaped back were called 'Trafalgar' chairs in commemoration of Lord Nelson's famous naval victory over the French in 1805. The outward curving front leg derives from an ancient Greek chair-type – called 'klismos' from the Greek for chair – seen on classical vases and stone carvings. The anthemion motif is used on the chair back. The black and gold decoration was very fashionable in the Regency period.

Beech, japanned black and gilt, with gilt bronze parts to the back; cane seat, modern upholstery. Made around 1810.
V&A: W.27-1958

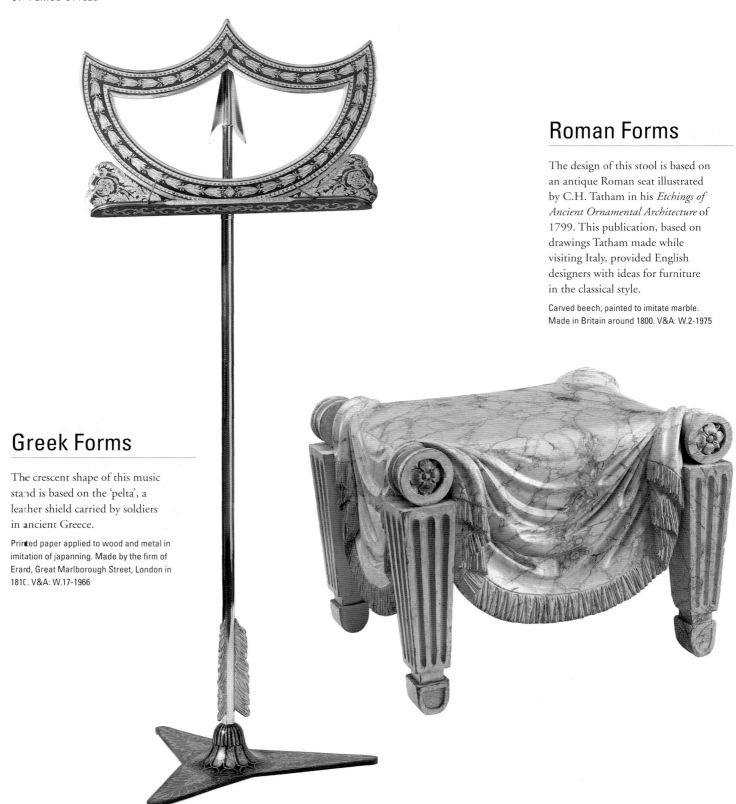

Roman Forms

The design of this stool is based on an antique Roman seat illustrated by C.H. Tatham in his *Etchings of Ancient Ornamental Architecture* of 1799. This publication, based on drawings Tatham made while visiting Italy, provided English designers with ideas for furniture in the classical style.

Carved beech, painted to imitate marble. Made in Britain around 1800. V&A: W.2-1975

Greek Forms

The crescent shape of this music stand is based on the 'pelta', a leather shield carried by soldiers in ancient Greece.

Printed paper applied to wood and metal in imitation of japanning. Made by the firm of Erard, Great Marlborough Street, London in 1810. V&A: W.17-1966

Friezes

This wallpaper border is designed to look like a plaster frieze. The swan, acanthus leaves and flower heads are all based on classical motifs.

Colour print from wood blocks on paper. Made around 1830. V&A: E.66-1939

Egyptian Style

Sphinxes, serpents and the figure of Horus, the sun god, decorate this mantle clock. It was made by Benjamin Lewis Vulliamy, whose firm used such Egyptian motifs on a wide range of objects.

Black marble, with mounts of ormolu and patinated bronze with a gilt dial. Made in London in 1807–8. V&A: M.119-1966

Rococo Revival

The curving forms, shell motifs and white and gold colour of this chair derive from French furniture of the 1750s. This type of chair is called a fly chair, reflecting the ease with which it could be moved around a room. It is one of a set of 18 designed by Philip Hardwick and made by W. & C. Wilkinson for the Court Drawing Room of Goldsmiths' Hall in London.

Carved beech, painted and gilded, with replacement upholstery. Made in London in 1834–5. V&A: W.1-1964

Naturalism

This dish combines naturalistic modelling of fruit and flowers with vivid colours and gilding. Such characteristics are typical of the highly decorative designs that were fashionable in the Regency period alongside the more restrained classical forms.

Porcelain, painted in enamels and gilt. Made at the Coalport porcelain factory, Shropshire around 1830. V&A: 3372-1901

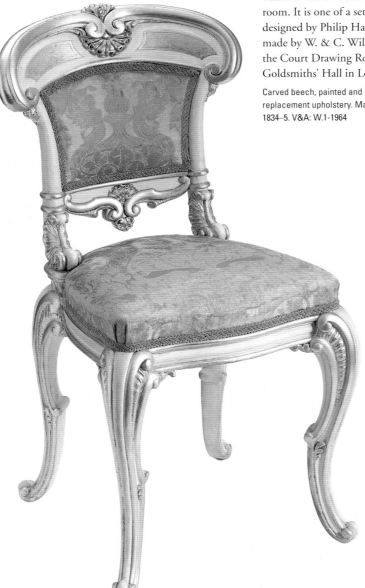

People & Places

Prince Regent
(1762–1830)

George, Prince of Wales, became Regent in 1811 following the prolonged illness of his father, George III. The Prince Regent was a leader of fashion. As a major patron and collector he helped establish the taste for Regency Classicism. He spent lavish sums on his residences, commissioning works from the major painters, architects, designers and interior decorators of his day. The Prince Regent was notorious for not paying the bill, however, and his extravagances embroiled him in a number of financial crises.

▼ The Prince Regent, oil on canvas after Sir Thomas Lawrence, 1815. Courtesy of the National Portrait Gallery, London.

Thomas Hope
(1769–1831)

Thomas Hope had a major influence on taste in the Regency period. He was born in Holland, but fled to England after the French invasion of 1795. After going on the Grand Tour, Hope began to collect classical art. He was also a designer and patron. Hope believed in creating a total stylistic environment, an idea he put into practice in the innovative designs for his own London home which was open to the public. He recorded this work in a book, *Household Furniture and Decoration* of 1807, which became a major source for designers. It also introduced the phrase 'interior decoration' into the English language.

▲ Thomas Hope in Turkish dress, oil on canvas by Sir William Beechey, around 1799. Courtesy of the National Portrait Gallery, London.

◄ The Aurora Room in Thomas Hope's house illustrated in *Household Furniture and Decoration*. National Art Library, 57.Q.1

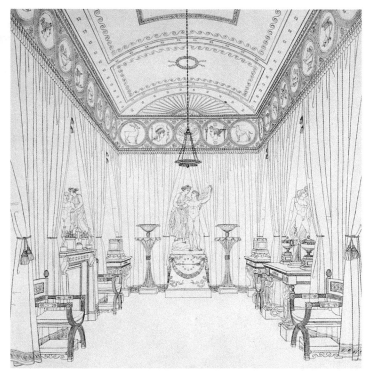

Rundell, Bridge & Rundell

The royal goldsmiths Rundell, Bridge & Rundell dominated the market for fine silver in the Regency period. The partnership was set up by Philip Rundell and John Bridge. Neither were silversmiths themselves and the work was contracted out to a network of suppliers. The partners, joined by Philip's nephew Edmond in 1805, kept close control of the designs, however. The firm made a range of objects, but was most celebrated for its high-quality, elaborate, classical style plate which adorned the grandest dining rooms of the day.

▶ Silver desert stand, made by Paul Storr in 1812–13 and sold by Rundell, Bridge & Rundell in 1812–13. The design was adapted from an illustration in Hope's *Household Furniture and Decoration*. V&A: M.49-1960

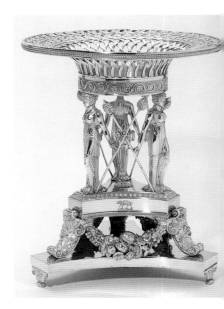

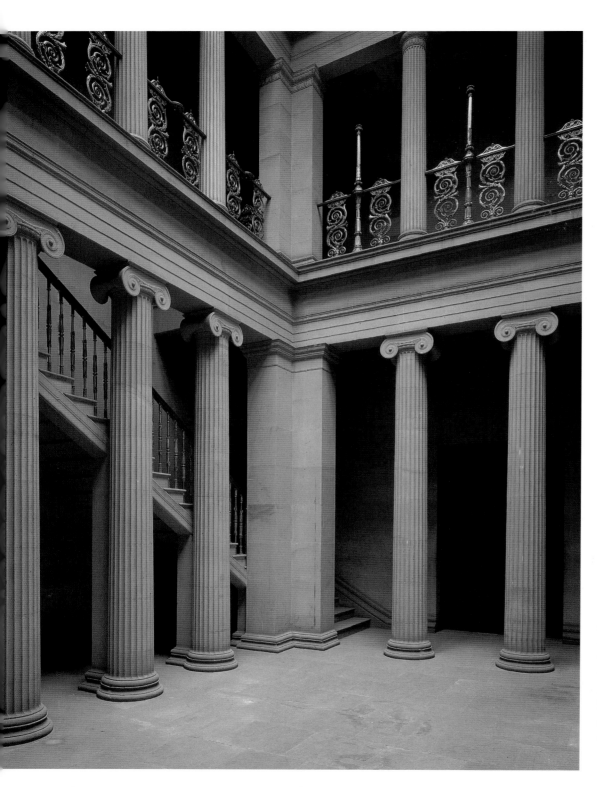

Belsay Castle

Belsay Castle, near Jedburgh in Northumberland, was built by Sir Charles Monck Middleton. The baronet had studied classical architecture while on honeymoon in Greece. His new home, constructed in 1807-15, was the first country house in Britain to be modelled entirely on Greek examples. The exterior is Doric, the earliest and plainest of the classical orders. The interior has a simple plan based on Graeco-Roman buildings with rooms grouped around a peristyle – a columned courtyard. Here both Doric and Ionic columns – the latter with their distinctive scrolling capitals – were used.

◄ The Pillar Hall, Belsay Castle. Courtesy of English Heritage Photographic Library.

► The east front of Belsay Castle. Courtesy of English Heritage Photographic Library.

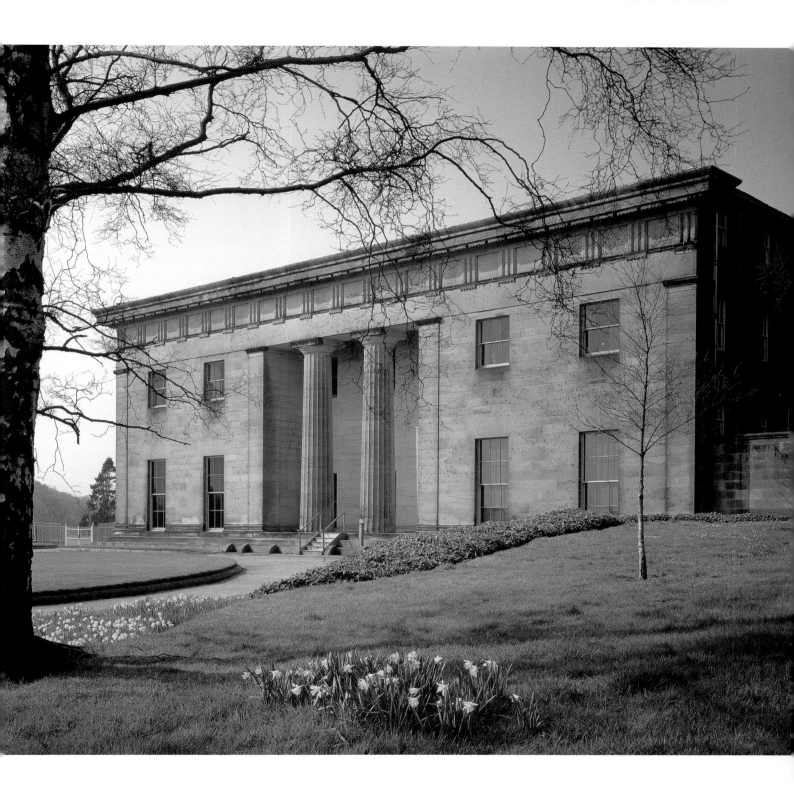

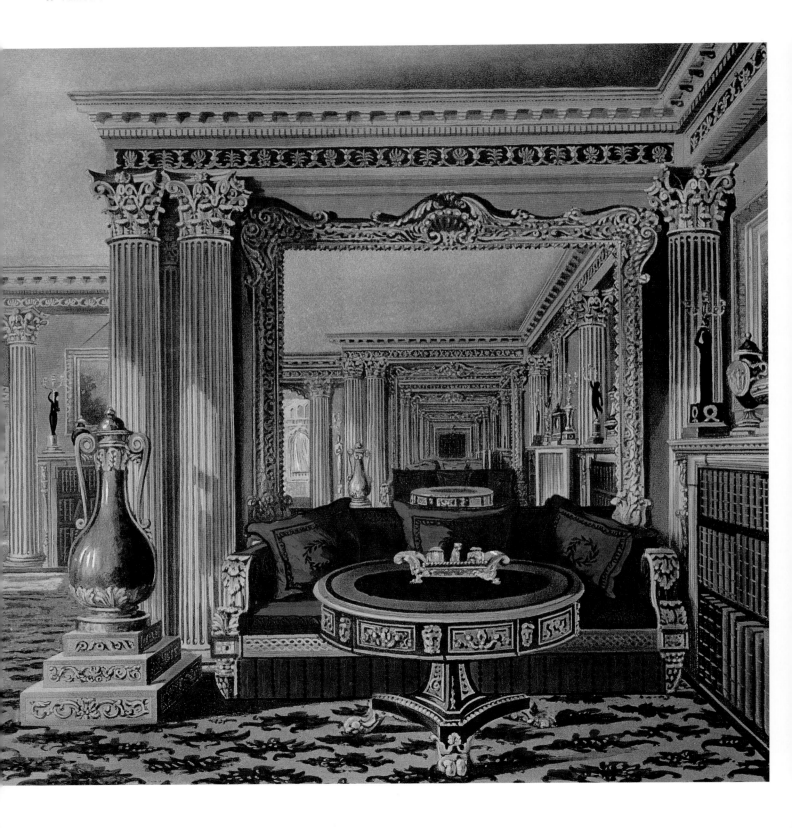

Carlton House

Carlton House, in Pall Mall, was given to the Prince Regent as his official London residence in 1783. The Prince transformed the fairly modest property into a luxurious palace. He frequently altered the interiors, making them more and more opulent. The changes he made in the early 19th century reflect his taste for the style of Regency Classicism that he had done so much to popularise. Once king, George became bored with Carlton House and it was demolished in 1827. The classical columns from the exterior were used on the front of the National Gallery.

◄ The Golden Drawing Room in Carlton House illustrated by W.H. Pyne in *The History of the Royal Residences of Windsor Castle, St James Palace, Carlton House, Kensington Palace, Hampton Court, Buckingham Palace and Frogmore*, 1819. National Art Library, RC.LL.70

The Egyptian Dining Room, Goodwood House

The Egyptian Dining Room at Goodwood House in Sussex was created in 1802–6 for the 3rd Duke of Richmond. It was the first interior in Britain to be based on the illustrations of ancient Egyptian monuments by Baron Vivant Denon, who had accompanied Napoleon on his campaigns in Egypt. A variety of Egyptian motifs appeared on the chimneypiece, curtain pelmets and door furniture, while the dining chairs had bronze crocodiles inserted into their backs. The dining room was dismantled in the early 20th century, but has recently been restored to its former glory.

▲ The Egyptian Dining Room, Goodwood House. Courtesy of the Trustees of the Goodwood Collection, photograph by Christopher Simon Sykes.

Chinese & Indian Styles
1800–1830

Designs influenced by Chinese and Indian art and architecture were extremely popular in the early 19th century. The renewed interest in the East was stimulated by objects imported from Asia and by newly published books on India and China. The scenes illustrated in these volumes provided British designers and manufacturers with fresh sources of inspiration.

Chinese blue and white ceramics had always been much admired and emulated in the West. By the early 19th century British potters were producing large quantities of inexpensive transfer-printed earthenware to satisfy the growing market for **blue and white ceramics**. Many of the **Indian scenes** that decorate the ceramics were taken from popular topographical prints of the country. **Chinese scenes** of landscapes, people and pavilions were also very popular subjects for ceramics and other objects. One of the most famous British ceramic designs is the **Willow Pattern**. The scene of a temple with bridge, boat and willow tree was inspired by images found on Chinese ceramics, but was the creation of British manufacturers. The love story it is said to depict was invented later as a clever marketing tool.

The design of this cabinet was inspired by Chinese furniture made for the export market. It has been skilfully 'japanned' in black and gold to imitate lacquer and the doors are decorated with scenes of Chinese buildings and people. These are flanked by two elaborate twisting dragons. The cabinet was probably designed by Frederick Crace for the Royal Pavilion at Brighton, Sussex.

Rosewood veneer on a carcase of oak, lime and chestnut; exterior japanned in black and gold. Probably made in Brighton or London around 1815. V&A: W.1-1966

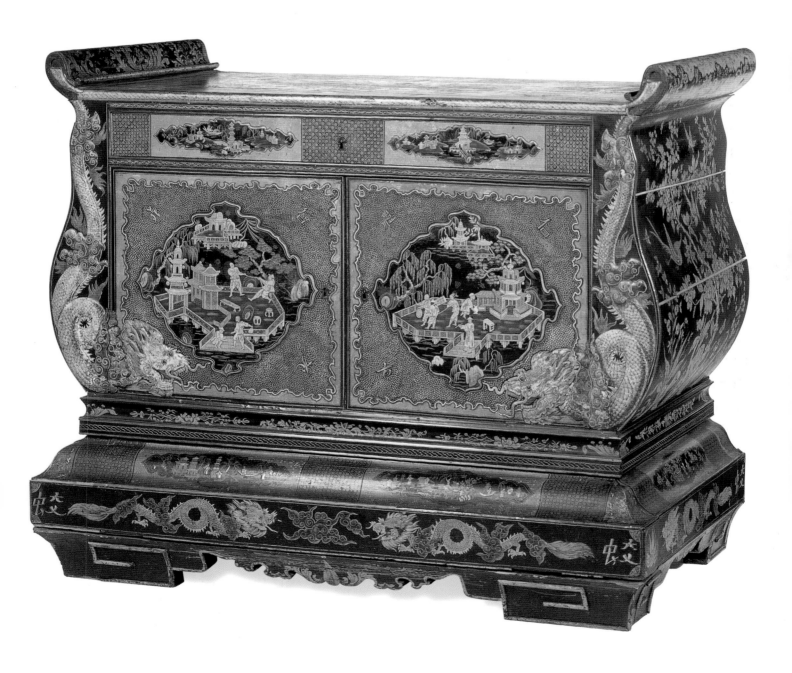

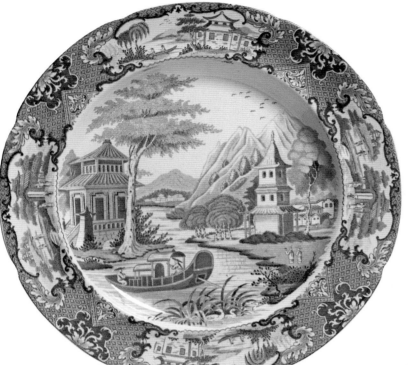

Blue and White Ceramics

The craze for blue and white ceramics exemplifies the Regency Chinese style. Plates are the most common form but other objects such as teapots were also popular.

Earthenware, transfer-printed in underglaze blue. Possibly made in Stoke-on-Trent, Staffordshire, by Robert Trent, in 1811–26. V&A: Circ.336-1974

Indian Scenes

The design of this plate is taken from Thomas and William Daniell's *Oriental Scenery*. Two engravings called 'Gate leading to a Musjed (mosque) at Chunar Ghur' and 'The Western Entrance' were used.

Earthenware, transfer-printed in underglaze blue. Made in Staffordshire by the Rogers factory around 1820. V&A: Circ.50-1959

Chinese Scenes

The pattern on this plate was one of the earliest to become popular in Britain in the late 18th century. It derives from Chinese export plates and depicts the Chinese philosopher Lao-Tzu.

Earthenware, transfer-printed in underglaze blue. Probably made in Staffordshire around 1800. V&A: Circ.371-1950

The Willow Pattern

This is the earliest known dated example of the Willow Pattern design. The plate was made for the Willey family of Cornwall who supplied cobalt, from which the blue glaze is obtained, to the Staffordshire potteries in the early 19th century.

Earthenware, transfer-printed in underglaze blue. Possibly made at the Spode factory, Staffordshire in 1818. V&A: C.231-1934

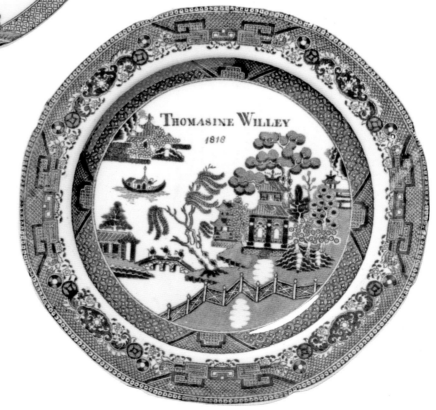

People & Places

Frederick Crace
(1779–1859)

Frederick Crace was a member of the most important family of interior decorators in 19th century Britain. His work at Carlton House, the official residence of the Prince of Wales, so impressed the prince that from 1794 he worked almost exclusively for him. From 1815 to 1823 Crace designed some of the spectacular Chinese style interiors of the Royal Pavilion in Brighton. In the Music Room he decorated the walls with Chinese scenes in red and gold and designed golden dragons to support the blue satin window draperies.

▶ The Music Room, Royal Pavilion. Courtesy of the Royal Pavilion, Libraries and Museums (Brighton and Hove) 2001.

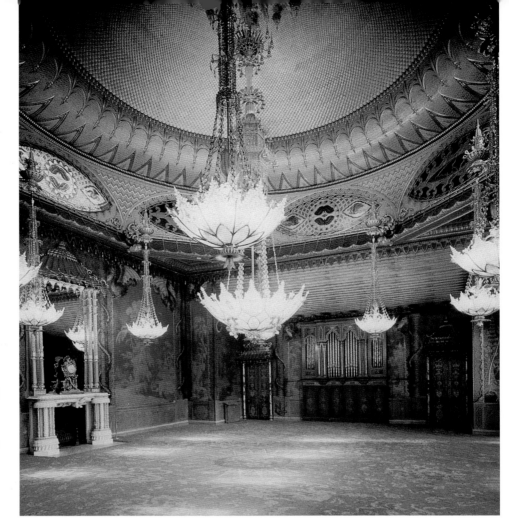

Thomas Daniell
(1749–1840)
and William Daniell
(1769–1837)

The artist Thomas Daniell and his nephew William travelled throughout India between 1785 and 1793 recording its people, buildings and scenery. On their return to Britain they worked up many of the thousands of drawings they had made into aquatints. One hundred and forty four of these were published in the six-volume *Oriental Scenery*. The illustrations provided a rich source of designs for British ceramic manufacturers.

◀ 'View of the Chitpore Road, Calcutta' from *Oriental Scenery*, 1795–1808. V&A: 14894:76

George Chinnery
(1774–1852)

The painter George Chinnery sailed to India in 1802. He settled first in Madras and then in Calcutta, making his living by painting portraits. He also produced many informal drawings and watercolours of landscapes and village life. He was forced to leave India to escape his creditors and in 1825 he moved to Macao on the Chinese coast. Here and in Canton (Guangzhou), the only other Chinese port open to foreigners in the early 19th century, he painted sketches of local life and portraits of European and Chinese merchants.

▲ *A Chinese River with a Figure on the Bank,* watercolour by George Chinnery, mid 19th century. V&A: P.46-1928

▶ George Chinnery, oil on canvas self portrait, around 1840. Courtesy of the National Portrait Gallery, London.

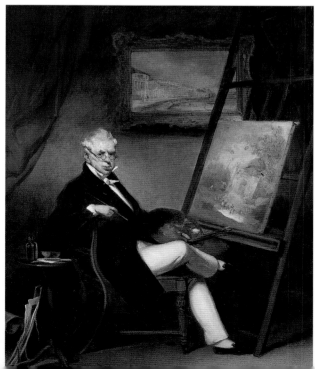

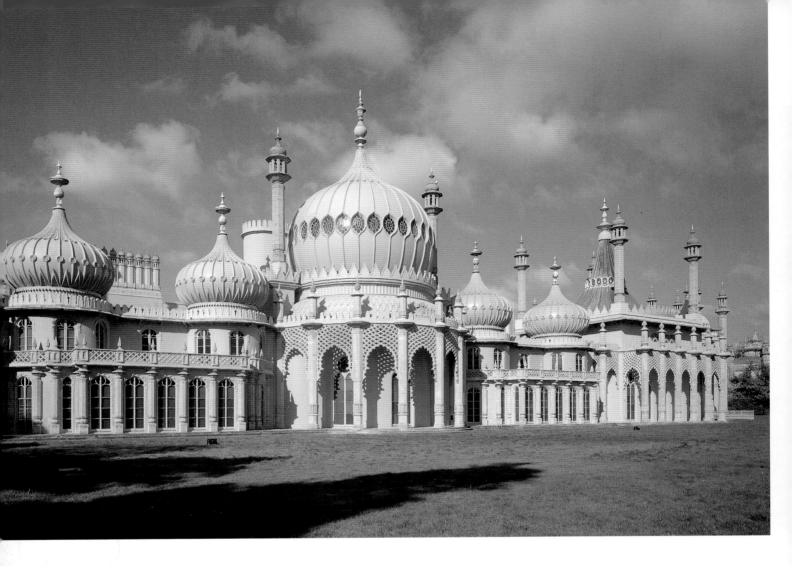

The Royal Pavilion

The Royal Pavilion in Brighton was built between 1787 and 1823 for George, Prince of Wales. The original Neoclassical design by Henry Holland was transformed from 1815 by John Nash who created an extravagant oriental fantasy. The exterior of the pavilion was based on Indian Mughal architecture. The domes, minarets, pinnacles and pierced stonework created by Nash were inspired by illustrations in William and Thomas Daniell's *Oriental Scenery*.

▲ The east front of the Royal Pavilion by John Nash. Courtesy of A.F. Kersting.

Interior of the Royal Pavilion

The spectacular Chinese-inspired interiors of the Royal Pavilion in Brighton were the work of Frederick Crace and Robert Jones, who worked on the building from 1815 to 1823. Crace was responsible for the Music Room, the Banqueting Room Galleries and the Long Gallery, and Jones for most of the other major rooms. The latter include the Banqueting Room that is one of the most magnificent parts of the Pavilion. The walls are hung with paintings of Chinese scenes and a profusion of dragons fly around the ceiling, support the chandeliers and curtains and wrap themselves around the lamps and furniture.

▶ The Banqueting Room, the Royal Pavilion, from *Views of the Royal Pavilion*, by John Nash, 1826. National Art Library 47.X.205

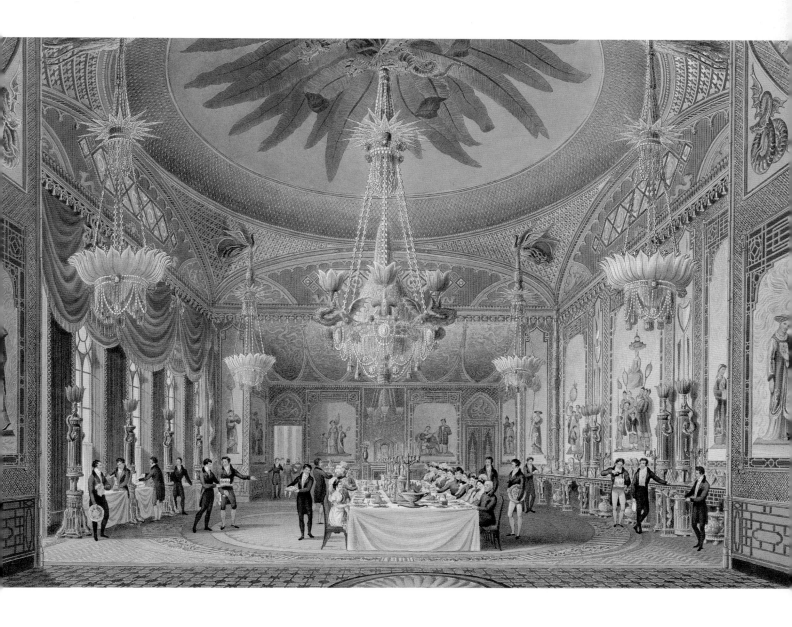

Gothic Revival
1830–1900

In the 19th century the increasingly serious study of the art, architecture and design of the Middle Ages led to the development of the Gothic Revival, the most influential style of the Victorian period. Medieval buildings were the main design source. **Architectural elements** such as pointed arches, steep-sloping roofs and decorative tracery were applied to a wide range of objects. Some pieces even looked like miniature buildings. The bold forms were combined with bright colours, elaborate **painted furniture** being one of the characteristics of the Gothic Revival.

A wide range of religious, civic and domestic buildings were built and furnished in the Gothic style which, until the 1870s, battled with classicism and the Renaissance Revival for stylistic supremacy. Supporters of the Gothic promoted the style as the true expression of British history and national identity. Major exponents of the style believed it embodied a set of medieval ideals and values that could serve as a model for 19th century society and culture. Such serious moral concerns were combined with a more romantic vision of the past, epitomised by the many stories of medieval chivalry published in the 19th century. The Victorians were fascinated with historical costume, particularly that of the Middle Ages and fancy dress events and parties were extremely popular. Figures in **medieval clothing** are often included in Gothic Revival designs. The interest in the chivalry led to the incorporation of **heraldic motifs**, such as coats of arms, into designs. **Gothic script** also featured frequently.

This cabinet is painted with imaginary scenes of the medieval French king René of Anjou. These were inspired by *Anne of Geierstein*, a novel by the popular writer Sir Walter Scott. The smaller panels illustrate different arts and crafts. The cabinet was designed and made by J.P. Seddon and the panels painted by leading artists of the day including Ford Maddox Brown, D.G. Rossetti and William Morris.

Oak inlaid with various woods, painted metalwork and painted panels. Made in London in 1860–2. V&A: W.10-1927

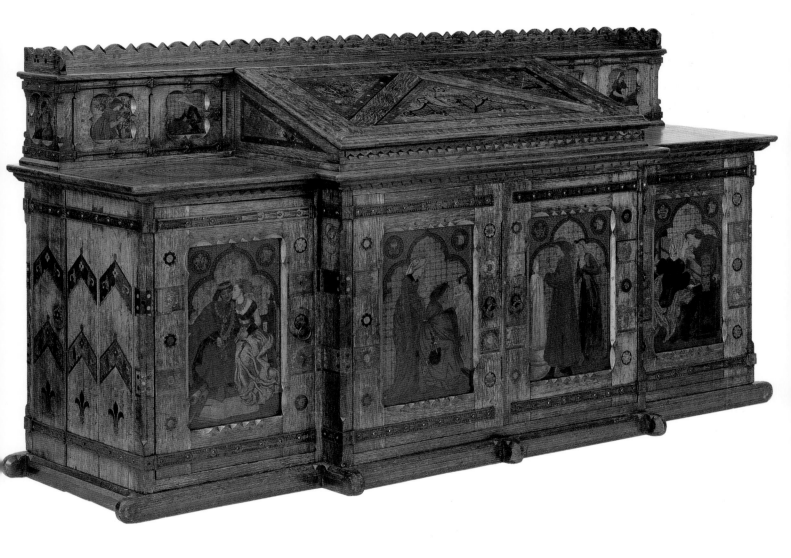

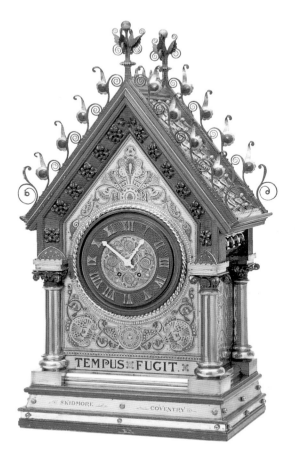

Architectural Elements

With its steep, pointed roof and corner pillars this highly decorated clock looks like a miniature building.

Painted wood, wrought iron, painted ironwork and enamelled brass. Designed by Bruce Talbert and made by Skidmore's Art Manufacturers, Coventry around 1865.
V&A: W.2-1985

Painted Furniture

William Burges based the design of this cabinet on the medieval armoires he had seen in the cathedrals of northern France. Despite its Gothic form the cabinet is painted with scenes taken from classical history.

Pine and mahogany, painted, stencilled and gilded with metal leaf; lock and hinges of iron. Made in London in 1858.
V&A: Circ.217-1961

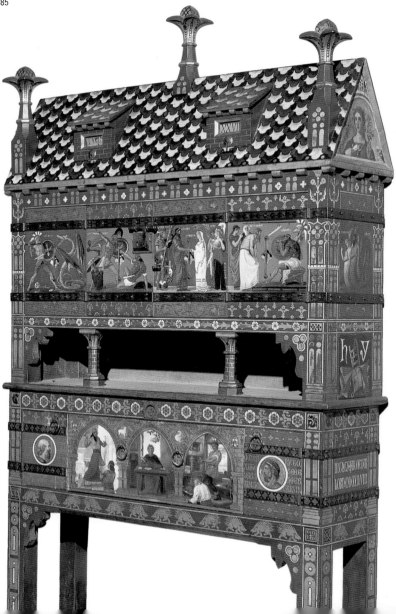

Medieval Clothing

The figures depicted on this bottle are clothed in the style of the Middle Ages. The bottle was made by Minton, the leading ceramic manufacturer of the 19th century, and decorated after a design by the artist Henry Stacey Marks who based much of his work on literary and humorous subjects.

Painted earthenware. Made by Minton & Co. in Stoke-on-Trent, Staffordshire in 1877. V&A: C.54-1915

Heraldic Motifs

A.W.N. Pugin designed this wallpaper for the new Palace of Westminster, though it was never produced as a finished printed paper. The unusual colour combinations and the arched framework are typical of his work. The symbols represent Edward the Confessor and Richard II, kings connected with the history of the Palace.

Pencil and wash on paper. Designed by A.W.N. Pugin in 1851. V&A: D.733-1908

Gothic Script

This bread plate is one of the most famous designs by A.W.N. Pugin. The use of the proverb underlines Pugin's belief that art and design should serve a moral purpose. The plate was made by Minton using a process of inlaying with coloured clays revived from medieval tile making techniques.

Earthenware inlaid with coloured clay and decorated with coloured glazes.
Made by Minton & Co. in Stoke-on-Trent, Staffordshire around 1850.
V&A: C.46-1972

People & Places

▲ A.W.N. Pugin, oil on canvas by J.R. Herbert, 1845. Courtesy of the Palace of Westminster.

◢ Carved and chamfered oak table designed by A.W.N. Pugin, 1852–3. V&A: W.26-1972

Augustus Welby Northmore Pugin
(1812–1852)

The writings of architect and designer A.W.N. Pugin, particularly *Contrasts* (1836) and *True Principles of Pointed or Christian Architecture* (1842), had a major influence on the style and theory of the Gothic Revival. Pugin believed that Gothic was the only 'true style'. He urged architects and designers to work from the fundamental principles of medieval art and to banish features 'not necessary for convenience, construction or propriety'. Pugin's own work included many Catholic churches, the Palace of Westminster and numerous designs for furniture, metalwork, ceramics, textiles, stained glass and wallpaper. He also organised the Medieval Court at the Great Exhibition of 1851. Pugin died a year later aged only 40, but his ideas continued to be very influential. The principles of truth to structure, function and material became crucial tenets of the Arts and Crafts movement later in the century.

John Ruskin
(1819–1900)

John Ruskin was the most influential art critic of his day. His interest in medieval architecture was aroused by travels in Europe, during which he made detailed watercolour studies. Ruskin was particularly interested in the decoration and colour of buildings. Two of his most important books, *The Seven Lamps of Architecture* (1849) and *The Stones of Venice* (3 volumes, 1851–3), had an enormous impact on the Gothic Revival. Ruskin advocated a return to the spiritual values of the Middle Ages which he felt had been lost in the mechanised and materialistic age in which he lived.

▲ John Ruskin, watercolour by Sir Hubert von Herkomer, 1879. Courtesy of the National Portrait Gallery, London.

▶ A Gothic window in Venice by John Ruskin, pencil and watercolour, 1845. V&A: D.1726-1908

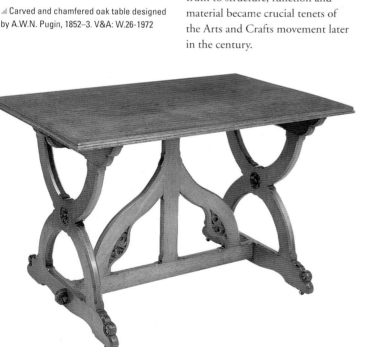

William Burges

(1827–1881)

William Burges was one of the most original and exuberant designers of the Victorian period. His work drew on a number of sources, including the arts of the Middle Ages, the Islamic world and East Asia. From 1865 until his death Burges worked for the 3rd Marquess of Bute, creating two of the most opulent Gothic Revival buildings, Cardiff Castle and Castell Coch. The exteriors of both are inspired by French medieval castles, while the interiors are radiant with coloured carvings, panelled walls and painted ceilings. Burges's designs for furniture and metalwork are equally inventive and elaborate.

▲ William Burges, self portrait on a cabinet designed by him in 1858, painted pine and mahogany. Circ.217-1961

▶ Summer Smoking Room, Cardiff Castle. © Cardiff County Council.

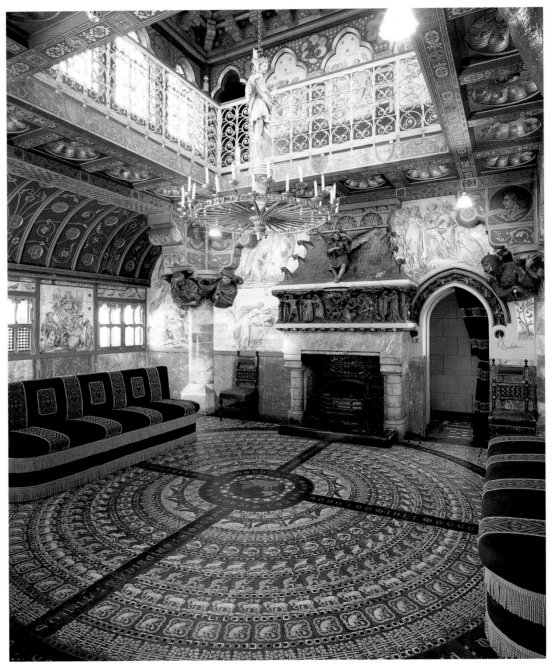

The Palace of Westminster

In 1834 a fire destroyed much of the old Palace of Westminster, the British Parliament building. It was decided that the new buildings should be built in the Gothic Revival style, which was considered particularly British and thus appropriate for the nation's Parliament. The buildings and interiors of the new Palace of Westminster, constructed between 1837 and 1867, were designed by Charles Barry. His assistant Augustus Pugin provided much of the Gothic detail. It is the largest, and most dramatic, Gothic Revival building in the world.

▶ Victoria Tower, Palace of Westminster. Photograph by Stephen Ayling, 1867. V&A: 61.115

▼ The throne and canopy in the House of Lords. © Crown copyright NMR.

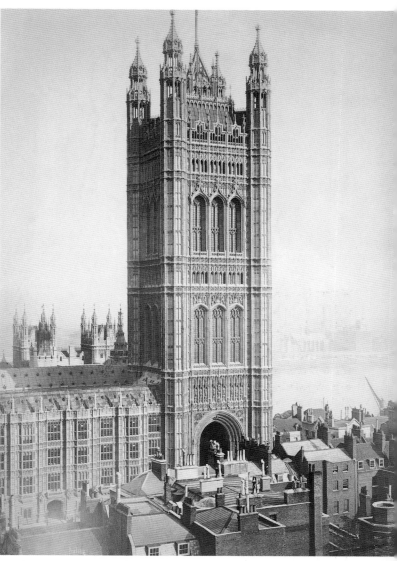

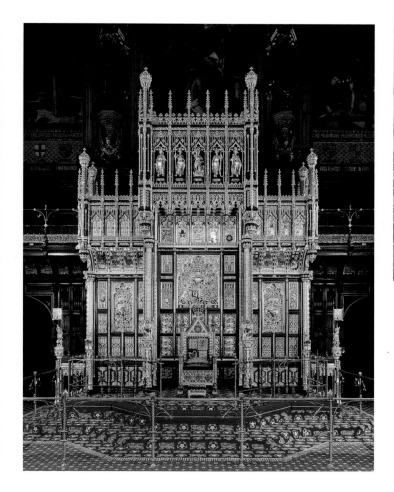

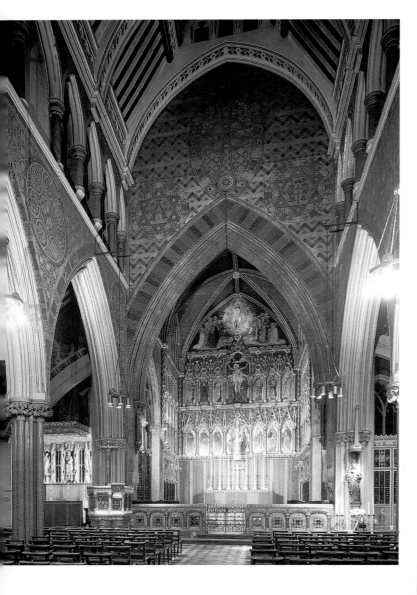

All Saints, Margaret Street

The 19th century saw a great religious revival. Old churches were restored and many new ones built, the majority in the Gothic Revival style. All Saints in Margaret Street, London was designed by William Butterfield. Built in 1850–9, it was the first High Victorian Gothic building, a development of the style that was less dependent on medieval sources. The exterior of the church is of differently coloured bands of bricks and the interior is of polished coloured stone and richly patterned walls and floors. This 'structural polychromy' had first been suggested by John Ruskin who had studied its use in Italy. The introduction of such foreign Gothic ideas gave the High Victorian style its varied character.

◄ The interior of All Saints Church. Courtesy of RIBA Library Photographs Collection.

▼ All Saints Church. Courtesy of RIBA Library Photographs Collection.

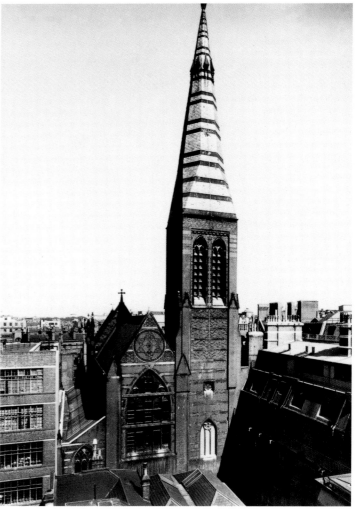

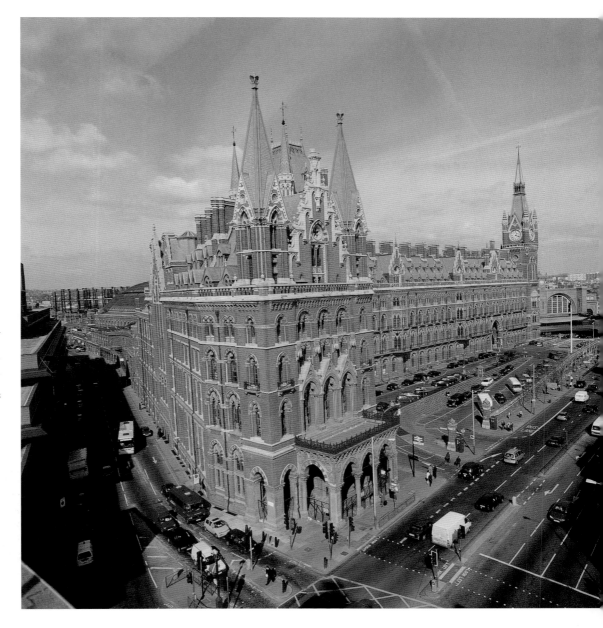

St Pancras Station

The Victorian period was the great age of railway construction. St Pancras was the London terminus of the Midland Railway, a company noted for using bold architecture and luxurious interiors to attract passengers. The great hotel which stands in front of the train shed was designed by George Gilbert Scott, one of the most prolific Gothic Revival architects. It was built in 1866-76 and has a curved brick façade, arcaded windows with polished granite shafts and an elaborate skyline and clock tower. Inside there are lavish staterooms and a dramatic staircase supported by exposed iron beams.

▶ St Pancras Chambers, photograph by John Goss.

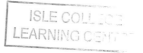

French Style
1835–1880

In the early 19th century there was a revival of the styles that had been fashionable in France between 1660 and 1790. The taste for the arts of this period was fuelled by the arrival in Britain of works of art dispersed after the French Revolution of 1789. The French style represented luxury and glamour and was the most popular commercial style in Britain for much of the Victorian period.

French style was very **ornate**. Objects were highly decorated and interiors richly furnished. Grand room settings often combined modern objects in the French style with antique French pieces. Comfort was an important consideration in the 19th century and **elaborate upholstery** augmented the historic elements of the French style. Curtains were fringed, swagged and decorated with tassels, while chairs were frequently deep-buttoned and trimmed with equally elaborate fringes, braids and tassels. Rooms were furnished with the **rich colours** essential to the style. Brightly painted porcelain was also extremely fashionable. **Gilding** was an important ingredient and was applied to many different kinds of objects. This use of gold exemplified the wealth and luxury associated with the style.

The various French styles revived in the 19th century were identified by the name of the French king who ruled when they were first used. By the 1840s the Louis XV style was predominant. It was characterised by the use of **curving C- and S-shaped scrolls**.

French style became the mainstay of production for the growing numbers of middle class customers in the 19th century. By the 1870s its association with the 'nouveaux riches' led to the style being dismissed as vulgar. It was also severely criticised by design reformers for its over elaborate decoration. Despite this, French style retained its prominent position in the market place.

This vase is a copy of one first made at the French royal porcelain factory at Sèvres in 1761. The scrolling, curved shape, bright colours and gilding are typical of the French style.

Bone china, painted in enamels and gilt. Manufactured by Minton & Co., Stoke-on-Trent, Staffordshire around 1855.
V&A: 4323-1857

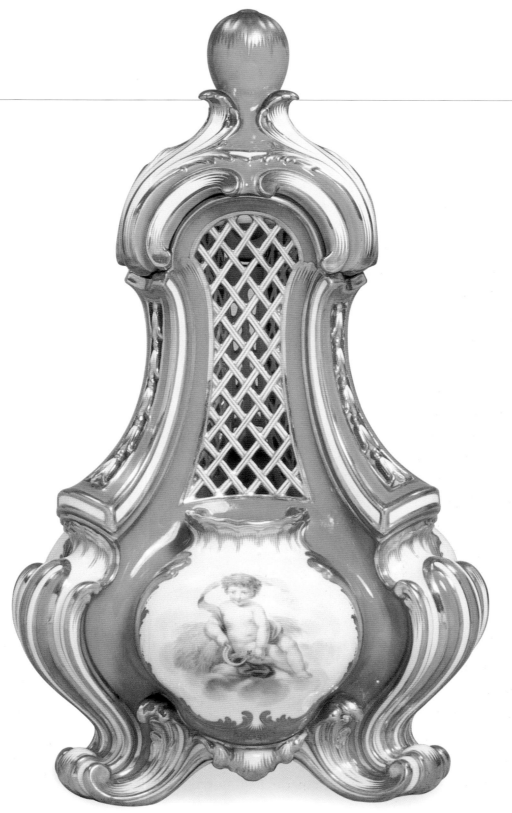

Ornate Decoration

This highly decorative candlestick is characteristic of ceramics made in the French style. It has an elaborate curving form and is painted in brightly coloured enamels and gilt.

Bone china, painted in enamels and gilt.
Made in England in 1830-40.
V&A: C.22A-1985

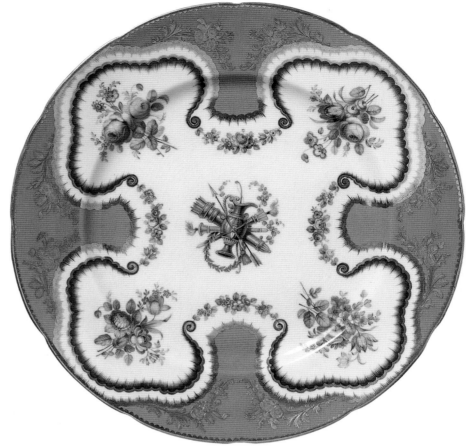

Rich Colours

The rich pink ground of this plate was very popular in the 19th century. The colour was called 'Rose Pompadour' or 'Rose du Barry' and imitates that used at Sèvres in the 18th century. The 'feuilles de choux' (cabbage leaf) decoration of rounded leaf edges tipped with blue also derives from Sèvres porcelain.

Porcelain, painted in enamels and gilt.
Made in Coalport, Shropshire in 1850.
V&A: 3381-1901

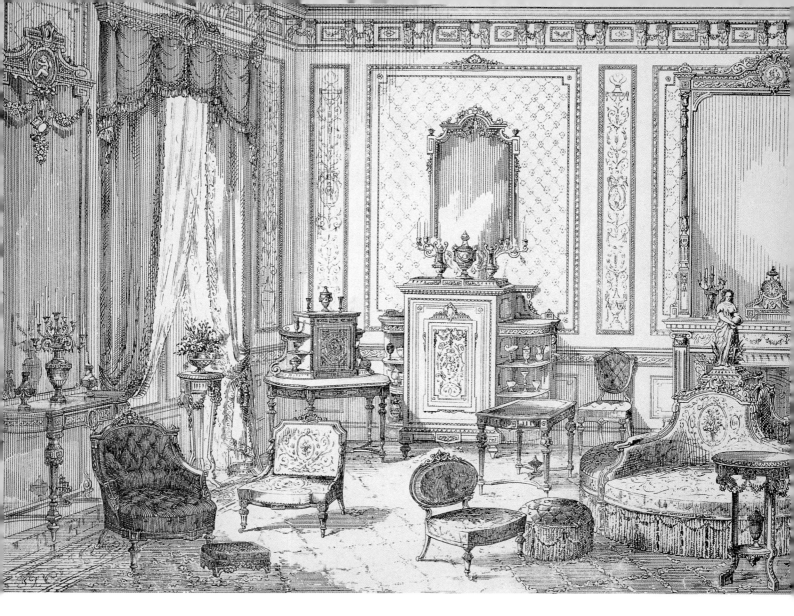

Elaborate Upholstery

J. Shoolbred's catalogue shows that the firm could provide everything needed for a French style drawing room. This design illustrates a room crowded with ornate furniture and furnishing including deep-buttoned armchairs, a fringed sofa and swagged and tasselled curtains.

Page from *Designs of Furniture Illustrative of Cabinet Furniture and Interior Decoration*, 1876. National Art Library, 25.11.76

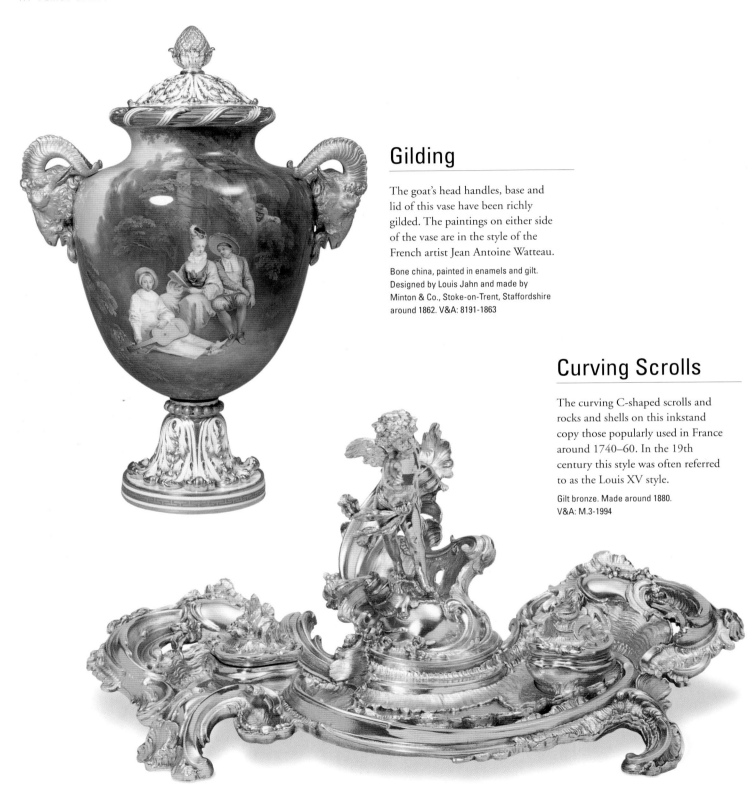

Gilding

The goat's head handles, base and lid of this vase have been richly gilded. The paintings on either side of the vase are in the style of the French artist Jean Antoine Watteau.

Bone china, painted in enamels and gilt. Designed by Louis Jahn and made by Minton & Co., Stoke-on-Trent, Staffordshire around 1862. V&A: 8191-1863

Curving Scrolls

The curving C-shaped scrolls and rocks and shells on this inkstand copy those popularly used in France around 1740–60. In the 19th century this style was often referred to as the Louis XV style.

Gilt bronze. Made around 1880.
V&A: M.3-1994

People & Places

George IV
(1762–1830)

George IV, formerly the Prince Regent, was the founding father of the French style. The king, who reigned from 1820 to 1830, commissioned many objects in the style and led the aristocratic taste for collecting historic French pieces. It was this fashion that led to the 19th century production of furniture, textiles, ceramics, silver and all kinds of luxury products in the French style.

▲ George IV sitting on a French style sofa, pink wax modelled by J. Cave, 1830.
V&A: A.73-1965

Minton & Co.

The Minton ceramic factory in Staffordshire was established by Thomas Minton in 1796. By the Victorian period the company had become one of the largest and most successful in Britain. It produced a wide range of goods, but was particularly famed for its French style pieces that emulated the luxury porcelains made at the famous French royal porcelain factory at Sèvres in the 18th century. Minton & Co. produced many spectacular items for display at the International Exhibitions. These were guaranteed to catch the eye of visitors and were often awarded prizes.

▶ Centrepiece of glazed porcelain with Parian ware figures made by Minton & Co., 1851. This is the same model as a piece shown at the Great Exhibition of 1851.
V&A: 454-1854

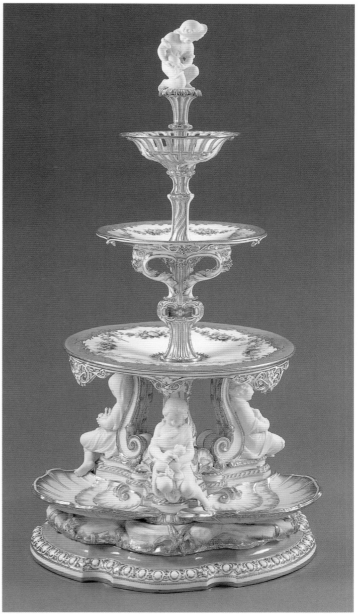

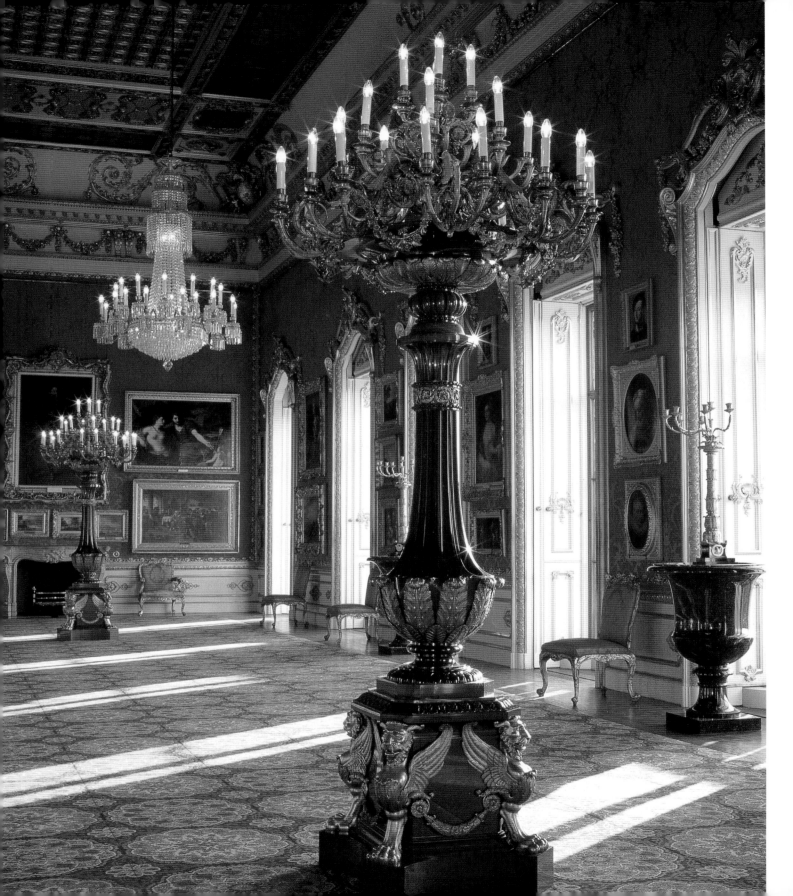

Benjamin Dean Wyatt

(1775–1855)

The architect Benjamin Dean Wyatt visited France briefly in 1815, but most of his knowledge and inspiration came from drawings and engravings. Wyatt was particularly interested in the art and architecture of the reign of Louis XIV (1643–1715). This is seen in his famous commission of 1822, the Waterloo Gallery at Apsley House, London, the home of the Duke of Wellington. With the richly coloured silk hangings, ornate plaster ceilings, white and gold woodwork, marble fireplace and marquetry floor, Wyatt sought to recreate the grandeur of Louis XIV's palace at Versailles.

◀ The Waterloo Gallery at Apsley House. Courtesy of Apsley House.

Wrest Park

In Britain the French style was used primarily for interior decoration rather than architecture. One early exception to this was Wrest Park in Bedfordshire, rebuilt in 1843–9 to the designs of its owner, the 1st Earl de Grey. He was inspired by Parisian buildings and French 18th century engraved designs. Inside, the rooms were also in the French style with carved wooden panelling, elaborate plaster ceilings picked out in gold, and walls set with panels of brightly coloured silk. In some of the rooms the earl fitted authentic 18th century French panelling.

▼ Exterior and garden of Wrest Park. Courtesy of English Heritage Photographic Library.

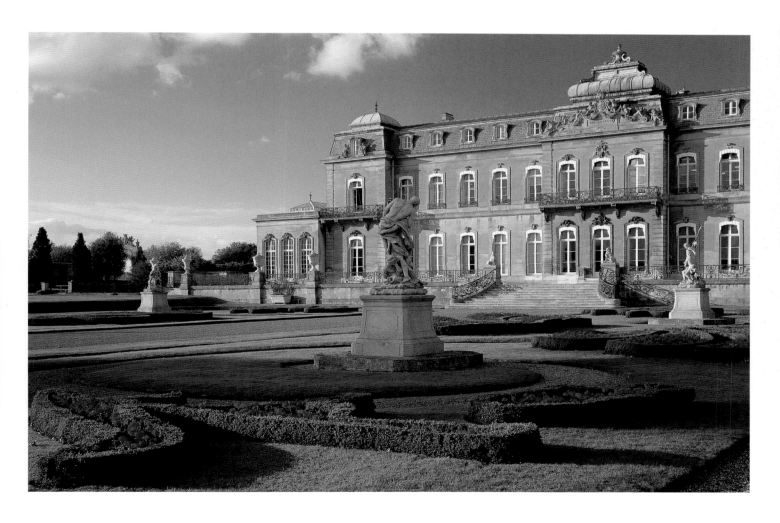

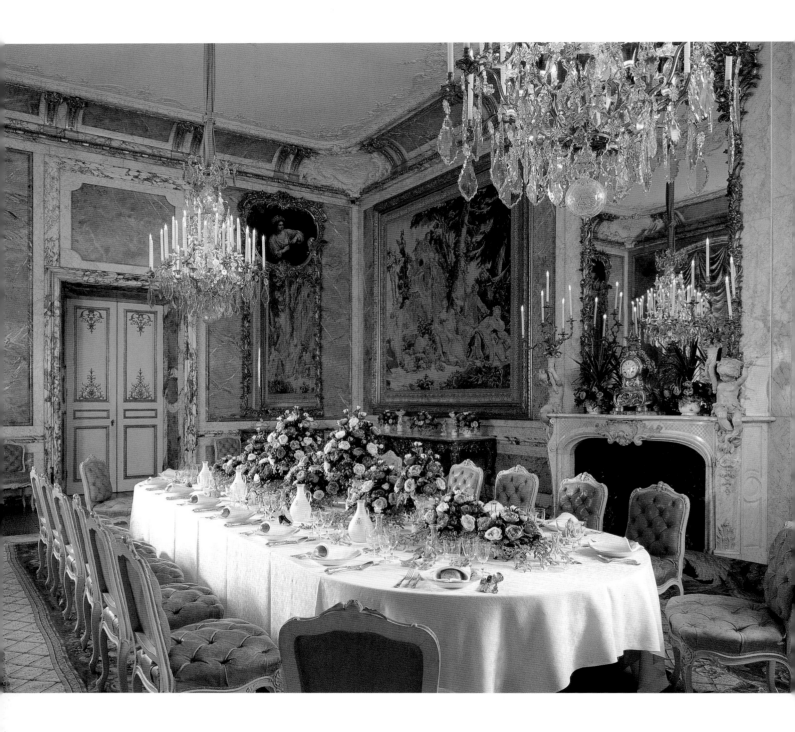

Waddesdon Manor

Waddesdon Manor, Buckinghamshire was built between 1874 and 1889 for Baron Ferdinand de Rothschild, a member of the successful banking family. He, like many of his relatives, was an enthusiastic collector of 18th century French works of art. Most of the interiors at Waddesdon were in the French style. The Louis XV style dining room featured richly coloured marbles, tapestries, carved and gilded furniture and large expanses of mirror glass. The mirror frames had come from an 18th century house in Paris, but the rest of the furnishings were newly made.

◄ The dining room at Waddesdon Manor. © National Trust, Waddesdon Manor, photograph by Tim Imrie.

Cliffe Castle

Cliffe Castle, near Keighley, West Yorkshire, was built for the woollen manufacturer Henry Isaac Butterfield. His great business success allowed him to spend lavishly on the French style interiors of his new house, constructed between 1875 and 1884. The four interconnecting drawing rooms were richly decorated with silk hangings, white and gold woodwork, and mirrored doors. The sense of opulence was enhanced by the heavy, swagged pelmets of the curtains and the deeply buttoned upholstery of the chairs. These features were typical of French style interiors of the Victorian period.

▼ Henry Isaac Butterfield at Cliffe Castle, around 1880. V&A: ISAAC.1

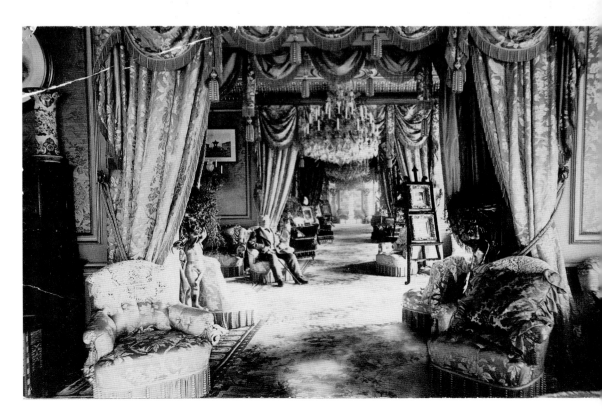

Classical &
Renaissance Revival
1850–1900

From about 1850 there was an enormous revival of interest in classical art as new archaeological discoveries in Greece and Italy fuelled the imagination of designers. Renaissance art and architecture of the 15th and 16th centuries, itself inspired by ancient Rome, also had a great influence. Classical and Renaissance pieces were sometimes copied quite closely, but often a variety of forms and motifs were combined or reinterpreted.

The style employed **architectural elements**, such as columns, capitals and pediments, taken from classical Greek and Roman buildings. The distinctive **shapes** of various classical objects were also used. Ancient Greek vessels were usually copied directly, while the forms of other objects were adapted for different materials. Artists and designers often took their subjects from classical history and mythology. The Elgin Marbles, brought to Britain from the Parthenon in Athens in 1812, provided particular inspiration. Renaissance bronze sculptures of **classical figures** were also much admired and emulated.

The **scrolling decorative forms** of the Renaissance were revived in the second half of the 19th century. Classical figures or mythical creatures were often shown surrounded by an abundance of garlands and foliage. Italian Renaissance tin-glazed pottery, known as maiolica, was particularly popular in the 19th century. The brightly **painted ceramics** were widely imitated by British potters.

Ancient **Egyptian motifs and forms** were used alongside those from classical Greece and Rome. The interest in Egypt was stimulated by the many important excavations that took place in the 19th century. The Egyptian Hall at the Great Exhibition of 1851 and the displays of antiquities at the British Museum inspired many designers.

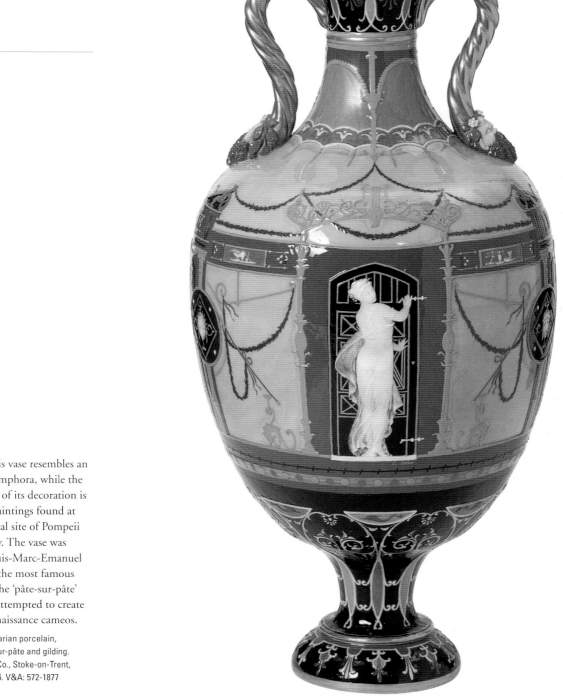

The shape of this vase resembles an ancient Greek amphora, while the style and colour of its decoration is based on wall paintings found at the archaeological site of Pompeii in southern Italy. The vase was designed by Louis-Marc-Emanuel Solon who was the most famous practitioner of the 'pâte-sur-pâte' technique that attempted to create the effect of Renaissance cameos.

Tinted and glazed Parian porcelain, polychrome pâte-sur-pâte and gilding. Made by Minton & Co., Stoke-on-Trent, Staffordshire in 1876. V&A: 572-1877

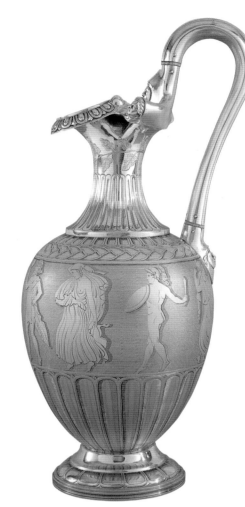

Classical Shapes

The shape and decoration of this silver jug are adapted from a Greek pottery 'oenochoë' or wine jug from the collection of Sir William Hamilton. The catalogue of his collection was used as a source of design in the 19th century.

Silver with engraved decoration. Made by Reily & Storer, London in 1840–1.
V&A: M.18-1971

Architectural Features

This grand cabinet is surmounted by a classical pediment with a central panel of a peacock. This bird is the symbol of the Roman goddess Juno whose portrait is shown in the panel below.

Mahogany carcass veneered in ebony, decorated with ivory stringing and beading; marquetry panels of box wood, myrtle, ivory and mother-of-pearl; cast and chased bronze mounts. Designed by Bruce Talbert and made in London in 1878. V&A: W.18-1981

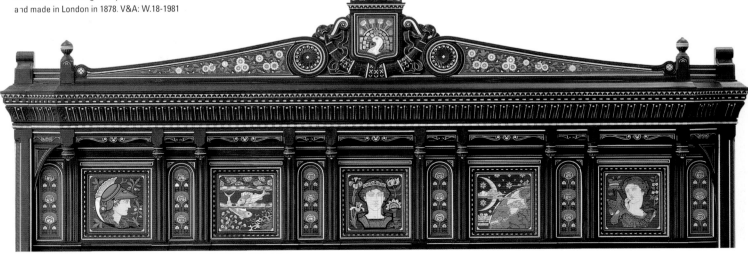

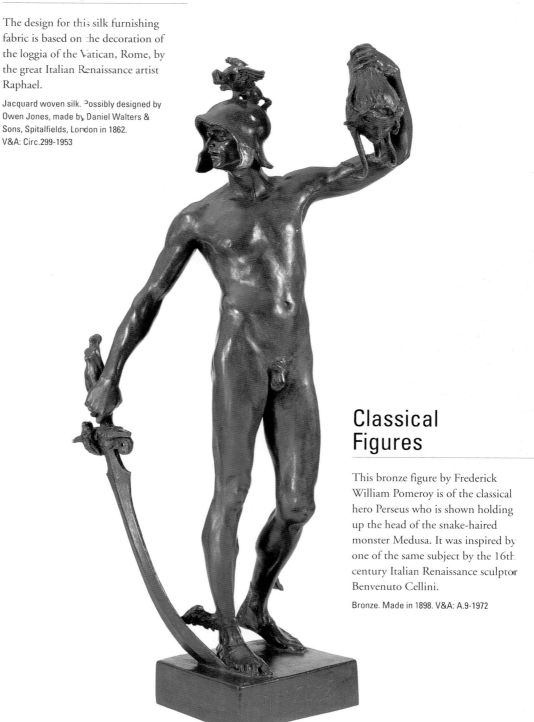

Scrolling Forms

The design for this silk furnishing fabric is based on the decoration of the loggia of the Vatican, Rome, by the great Italian Renaissance artist Raphael.

Jacquard woven silk. Possibly designed by Owen Jones, made by Daniel Walters & Sons, Spitalfields, London in 1862.
V&A: Circ.299-1953

Classical Figures

This bronze figure by Frederick William Pomeroy is of the classical hero Perseus who is shown holding up the head of the snake-haired monster Medusa. It was inspired by one of the same subject by the 16th century Italian Renaissance sculptor Benvenuto Cellini.

Bronze. Made in 1898. V&A: A.9-1972

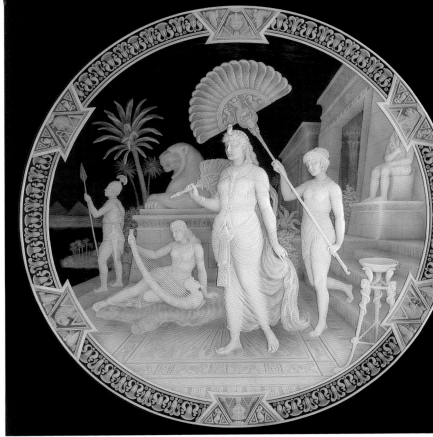

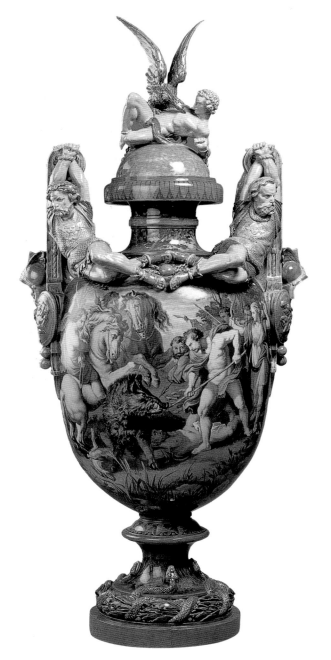

Painted Ceramics

The elaborately painted decoration
of this vase imitates maiolica and
draws on a mixture of Italian,
Flemish and French sources for its
subjects. The body of the base is
painted with scenes of a boar hunt,
taken from prints by the great
Baroque artist Peter Paul Rubens.
The captive warriors, who include
the mythical figure of Prometheus
on the lid, are derived from 16th
century Florentine models. The
snakes on the base are in the style of
the 16th century French ceramicist
Bernard Palissy.

Earthenware, painted in enamels and
majolica glazes. Designed and modelled by
Victor Etienne Simyan, painted by Thomas
Allen and made by Minton & Co., Stoke-on-
Trent, Staffordshire in 1867. V&A: 1047-1871

Egyptian Forms and Motifs

From the 1860s glass manufacturers
such as Thomas Webb & Sons, the
producers of this plaque, employed
cameo techniques that imitated
those used in ancient Rome.
The image of Cleopatra and her
attendants was designed and cut by
George Woodall, the best cameo
carver of the day. He was inspired
by engraved illustrations in
magazines of imaginary Egyptian
scenes.

Carved glass. Made in Stourbridge, West
Midlands around 1885. Anonymous loan.

People & Places

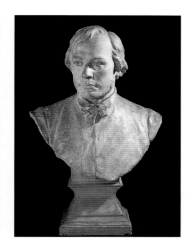

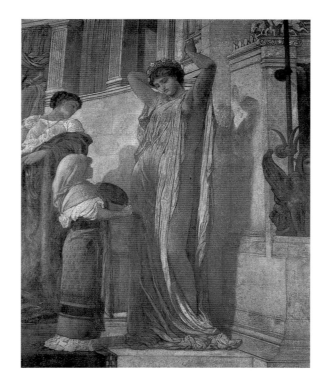

Alfred Stevens
(1817–1875)

The painter, sculptor and designer Alfred Stevens was one of the leading figures of the Classical and Renaissance Revival. In the 1830s he went to Italy to study Renaissance painting, working in Florence and Rome before returning to Britain. Stevens produced designs in many fields including silver and ceramics. His sculptural work in particular reveals his admiration for Renaissance artists such as Michelangelo.

▲ Alfred Stevens, plaster bust by Edward Lanteri, 1911. V&A: A.6-1912

▶ Earthenware vase, painted in enamels. Designed by Alfred Stevens and made by Minton & Co., Stoke-on-Trent, Staffordshire in 1864. V&A: 184-1864

Frederic, Lord Leighton
(1830–1896)

Frederic Leighton was one of the most celebrated artists of the 19th century. His paintings and sculptures of classical and mythological subjects reflected his interest in Greek and Renaissance art. In 1868 Leighton was commissioned by the Victoria and Albert Museum to paint two frescoes celebrating artistic achievement. *The Arts of Industry as Applied to Peace* is set in the classical world of order and plenty, while *The Arts of Industry as Applied to War* portrays the princes and courtiers of an Italian Renaissance city setting out for battle.

◤ Detail of The Arts of Industry as Applied to Peace by Frederic, Lord Leighton.

▽ Frederic, Lord Leighton wearing Renaissance costume, photograph by David Wilkie Wynfield, 1863. V&A: 133-1945

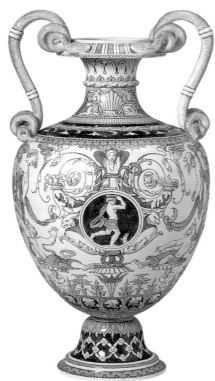

Sir Lawrence Alma-Tadema
(1836–1912)

Lawrence Alma-Tadema was a painter and designer of Dutch birth who settled in London in 1870. His fascination for the ancient world was aroused by visits to Pompeii and Herculaneum and by his study of Greek and Egyptian antiquities at the British Museum. Alma-Tadema was renowned for his ability to create seemingly accurate classical interiors. This reputation was gained though his highly popular paintings of ancient Greek, Roman and Egyptian scenes. He was also famed for his London home, which he designed and decorated in a Graeco-Roman style.

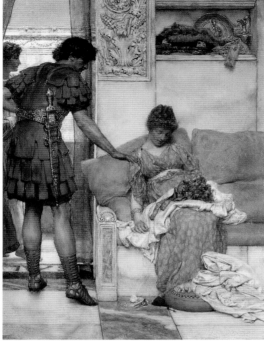

◣ A Silent Greeting, oil on wood by Lawrence Alma-Tadema, 1889. © Tate, London 2001.

◤ Sir Lawrence Alma-Tadema, photograph by Frederick Hollyer, 1892. V&A: 7737-1938

The Wellington Monument

In 1856 the British Government announced a competition for a monument to the Duke of Wellington. The commission was awarded to Alfred Stevens, the leading sculptor of his day. His design was felt to be particularly in keeping with the Baroque interior of St Paul's Cathedral, London, where the monument was to be positioned. The 12-metre (40-foot) high monument was designed in the form of a Roman triumphal arch. It was adorned with Michelangelo-inspired sculptures and crowned by the figure of Wellington on a horse.

▶ Plaster and wax model for the Wellington Monument by Alfred Stevens, 1857. V&A: 44-1878

Marquand Music Room

In 1884 the American art collector Henry Gurdon Marquand commissioned Lawrence Alma-Tadema to create a Greek style music room for his New York house. The suite of furniture Alma-Tadema designed was made by Johnstone, Norman & Co. Before being shipped to America it was exhibited in their London showrooms were it received much attention and acclaim. The ceiling of the music room was painted by Frederic Leighton, another leading figure in the Classical and Renaissance Revival. Leighton also helped Marquand acquire ancient Greek and Roman vases and statues to display in the room.

▲ The Marquand Music Room. Courtesy of The Metropolitan Museum of Art, New York.

◀ Mahogany chair, with cedar and ebony veneer, carving and inlay of several woods, ivory and abalone shell. Designed by Lawrence Alma-Tadema for the Marquard Music Room. V&A: W.25-1980

Influences from beyond Europe
1840–1900

In the Victorian period the British Empire expanded greatly and there was a dramatic increase in overseas trade and travel. This generated a far greater awareness of countries and cultures outside Europe. British designers, seeking a fresh approach that was free from existing historical styles, began to draw on artistic examples from Asia, north Africa and southern Spain.

By the mid 19th century British trade with **China** had been established for about 160 years. The Chinese, or Chinoiserie, style also had a long history and was in still in use for objects made for the popular market. Images of **Chinese people** were produced on a wide range of goods. Many of the scenes depicted were purely British inventions, but some designers took their inspiration directly from Chinese watercolours made for the European market. An enormous range of **bamboo furniture** was also available in Britain, the poles and panels being imported mainly from Japan. Manufacturers combined British, Chinese and Japanese elements to produce items that satisfied a desire for the 'exotic' but were relatively inexpensive.

British expansion into China in the 1850s and 1860s re-awakened people's interest in the 'Celestial Empire' and brought previously unknown examples of Chinese art to the attention of British collectors and designers. Growing knowledge of Chinese pottery and porcelain had a great influence as British and European potters sought to understand and recreate the brilliant **glazes** found on these ceramics.

India had a special significance in Victorian Britain. It was the key

The striking design and decoration of the palace of the Alhambra in Granada, Spain, had a great influence on British designers in the Victorian period. Information on the palace was made available through illustrated books, photographs and plaster casts. Architectural models such as this were sold as souvenirs in Spain.

Painted stucco and marble. Made in Spain around 1865. V&A: Repro.1890-52

possession of the Empire and many goods were made there for the British market. The rich displays of Indian art and design shown at the Great Exhibition of 1851 and at subsequent exhibitions influenced a number of British designers and commentators.

Indian textiles were much admired for the way in which 'patterns and colours ...diversify plain surfaces without ...disturbing the impression of flatness'. British textile and wallpaper manufacturers were particularly influenced by the **flat patterns** of Indian chintzes and embroidery. **Flowering plant designs**, a dominant theme in Indian art since the reign of the 17th century Mughal emperor Shah Jahan, were a major source of inspiration. The elongated leaf motif was a commonly used pattern on British shawls. The design became known as **'paisley'** as one of the leading manufacturing centres of such shawls was Paisley in Scotland.

In the 19th century the complex religious and historical factors influencing the appearance of objects from Iran, Turkey, north Africa and southern Spain were seldom understood, but such works were deeply admired for their technical and aesthetic brilliance. Colours, patterns and motifs from a variety of sources were used by British designers to create a composite **'Islamic'** style.

Patterns of **intertwining flowers and leaves** were incorporated into various 19th century designs, particularly those for ceramic vessels and tiles. The distinctive **turquoises, blues, greens and reds** found ceramics from Iznik (Turkey) were also an important source of inspiration as were the **lustrewares** of 13th–15th century Iran and southern Spain. The characteristic iridescent surfaces and striking patterns of these ceramics were emulated by British potters.

Chinese Glazes

This vase was made by Pilkingtons Tile and Pottery Company and reflects the 19th century admiration for Chinese ceramics. The mottled turquoise colour is inspired by so-called 'duck's egg' glazes and the shape by vessels known as 'gu'.

Earthenware, blue mottled glaze. Made in Clifton Junction, near Manchester in 1903–4. V&A: 68-1905

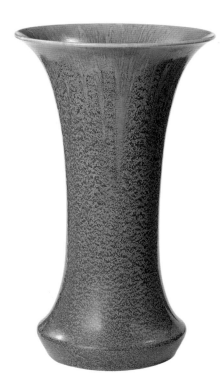

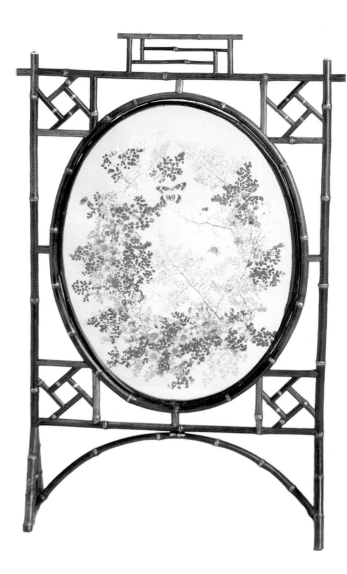

Bamboo Furniture

Model & Co., who made this fire screen, were one of the leading manufacturers of bamboo furniture in the 1880s and 1890s. Here Chinoiserie style bamboo frames a very British design that incorporates actual ferns and butterflies.

Bamboo, glass, ferns, butterflies. Made in London in 1881. V&A: W.62-1981

Images of Chinese People

This tin was made for Huntley & Palmer to promote their range of 'Orient' biscuits. The imaginary scenes of Chinese life would have appealed to the British market.

Offset-litho printed tin. Made in 1887. V&A: M.211-1983

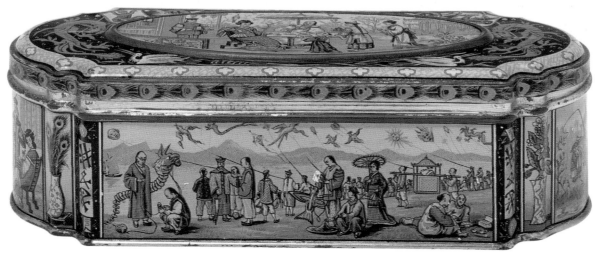

Flat Patterns

The flat pattern of this wallpaper, designed and printed for Morris & Co., was inspired by an example from the early 18th century which in turn was based on an Indian chintz.

Block-printed in distemper colour on paper. Made in 1868–70. V&A: E.3706-1927

Flowering Plant Designs

This is an example of 'Leek embroidery', a technique of embroidering over ready-printed panels manufactured by Thomas Wardle & Co. in Leek, Staffordshire. The design draws on a variety of styles but the chief model was a type of printed chintz made in southern India in the 18th century.

Embroidery in silk by Frances Mary Templeton over a printed silk manufactured by Thomas Wardle & Co. Made in Leek in 1892. V&A: T.38-1853

Paisley

The elongated pine leaf forms that decorate this shawl are based on Indian models, but the complex all over pattern and floral motifs are distinctly European.

Woven in wool on a Jacquard loom. Probably made in Paisley, Scotland in 1851–5. V&A: T.111-1977

Intertwining Flowers and Leaves

The design of this tile produced by Minton & Co. is inspired by Turkish examples.

Dust-pressed earthenware, printed in black and hand-painted in various colours. Made in Stoke-on-Trent, Staffordshire around 1875. V&A: C.202-1976

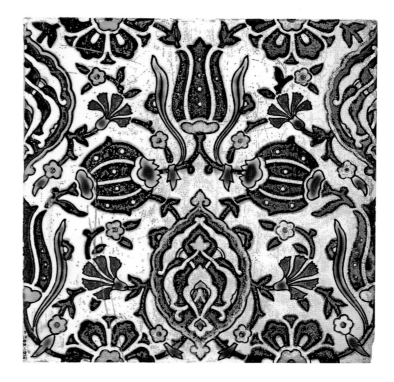

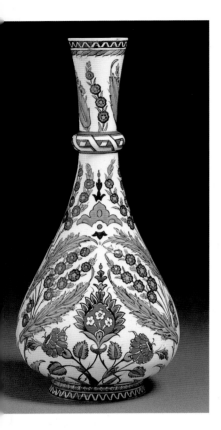

Strong Colours

In the Victorian period large manufacturers such as Minton & Co. produced ceramics in the fashionable Turkish style. Shapes, colours and decoration were taken directly from historic examples. The floral pattern and turquoise, blue, green and red colours of this vase were based on Iznik pottery.

Bone china, painted in underglaze and overglaze colours. Made by Minton & Co., Stoke-on-Trent, Staffordshire around 1862. V&A: 8098-1863

Lustreware

William De Morgan was famed for lustrewares such as this dish. The glaze and motif, of an antelope standing by the water's edge, were inspired by Iranian ceramics of the 13th century, but the overall design illustrates the ceramicist's own distinctive style.

Earthenware painted in ruby and yellow lustres on a white slip. Probably made at Merton Abbey, Wandsworth, London around 1880–5. V&A: 832-1905

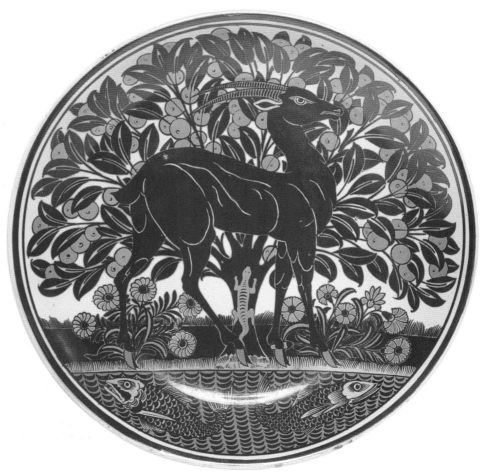

People & Places

Bernard Moore
(1850–1935)

Bernard Moore took over his father's pottery factory in Loughton, Staffordshire in 1870. Moore was particularly interested in Chinese glaze technology and his own experiments in the field led to the creation of some technically remarkable pieces. He is best remembered for his highly accomplished red flambé glazes on Chinese inspired shapes. Moore acted as a consultant to other potteries and wrote a number of technical papers. He thus played an important role in the development of the ceramic industry in Britain.

 Porcelain vase with red flambé glaze by Bernard Moore, 1904. V&A: 507-1905

William Howson Taylor
(1876–1935)

William Howson Taylor established the Ruskin Pottery in 1895. He experimented with Chinese glaze technology with the aim of pushing forward the boundaries of ceramic knowledge. He often used Chinese vessel forms, feeling that the elegant shapes would best enhance the effect of the glazes. Unfortunately Taylor's research notes do not survive. He destroyed them himself on retirement as he feared that they would pass into unscrupulous hands and cheap imitations would flood the market.

▲ Stoneware vase with Chinese inspired glaze by William Howson Taylor, 1909. V&A: C.68-1972

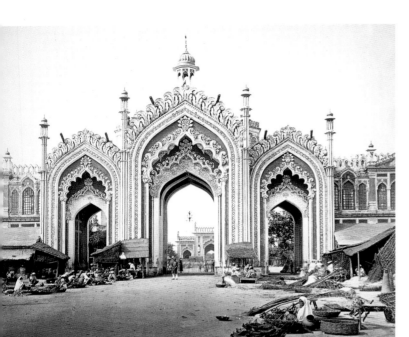

Thomas Wardle
(1831–1909)

Thomas Wardle, the son of a silk dyer in Leek in Staffordshire, entered the family business on leaving school. By 1880 he owned two textile print works; one for commercial dyeing and printing and the other for experimental work. Wardle was an avid traveller. His particular fascination for India lasted all his career and many of the textiles he produced show his interest in Indian patterns. He imported silk from India onto which he printed designs. He also perfected the dyeing and printing of tussore, the wild silk of India.

▼ Cotton velveteen cushion cover block-printed by Thomas Wardle, around 1885. V&A: T.269-1979

Queen Victoria
(1819–1901)

Queen Victoria became Empress of India in 1876. In the minds of the British public the queen was particularly associated with India, though she never travelled there. She did, however, declare great interest in the country and even learnt Hindustani with her Indian secretary Abdul Karim. In 1890 Victoria commissioned an Indian style banqueting hall for one of her residences, Osborne House on the Isle of Wight. The Durbar Room was designed by John Lockwood Kipling, father of the famous novelist Rudyard Kipling and Principal of the School of Art at Lahore, and Sardar Ram Singh, who taught wood carving at the school.

▶ Queen Victoria as Empress of India, oil on canvas by H. Macbeth after Heinrich von Angeli, 1885. Courtesy of the Government Art Collection.

◢ The Durbar Room, Osborne House, 1890. Courtesy of English Heritage Photographic Library.

Samuel Bourne
(1834–1912)

In 1863 Samuel Bourne gave up his job as a bank clerk and moved to India, establishing a photographic firm in Simla, near Delhi. Bourne's detailed studies of the architecture and peoples of India proved very popular. The photographer also made a number of expeditions to the Himalayas, the many dramatic pictures he produced being some of the first ever of the region. Bourne's visual documentation of the expanding British Empire appealed to people at home eager to see images of 'exotic' India.

▲ Albumen print of the gateway to Hooseinabad Bazaar, Lucknow, India by Samuel Bourne, 1863–6. V&A: 7-1972

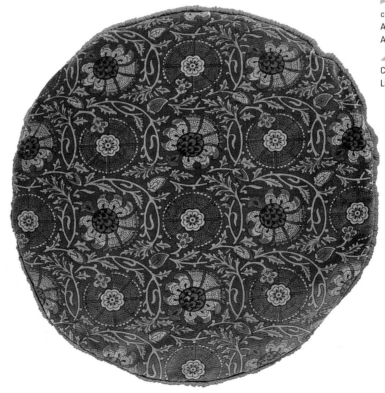

Owen Jones
(1809–1874)

The architect and designer Owen Jones played a key role in introducing and popularising the arts of the Islamic world. Jones particularly admired the Moorish art and architecture of northern Africa and southern Spain. In 1842–5 he published a detailed study of one of the most famous Moorish buildings, the Alhambra Palace in Granada. Jones' most important and influential work *The Grammar of Ornament* of 1856, which illustrated examples of historic styles, featured 'Arabian', 'Turkish', 'Persian' and 'Moresque' decoration. Jones used such stylistic sources in many of his own designs.

▶ Page of 'Moresque' ornament from *The Grammar of Ornament.* National Art Library, L.1625-1986

◢ Owen Jones, wood engraving after Thomas D. Scott, 1869. Courtesy of the National Portrait Gallery, London.

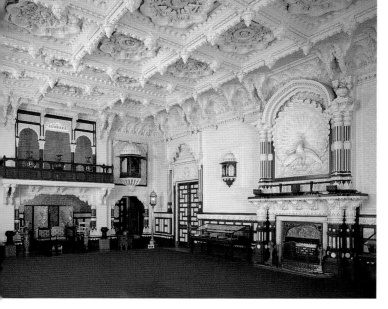

William De Morgan
(1839–1917)

William De Morgan was one of the most innovative ceramic designers of his day. His particular passion was the development of patterns and colours inspired by Spanish, Iranian and Turkish ceramics of the 15th and 16th centuries. De Morgan spent many years experimenting with techniques and created countless designs for vases, dishes and tiles. He was particularly famed for his boldly coloured lustrewares.

◄ William De Morgan, oil on canvas by Evelyn Frend de Morgan, 1909. Courtesy of the National Portrait Gallery, London.

▼ Panel of painted earthenware tiles by William De Morgan, 1888–97. V&A: 361-1905

John Frederick Lewis
(1805–1875)

The British artist J.F. Lewis lived for almost a decade in Cairo. He returned to Britain in 1851 and devoted the rest of his career to the painting of vivid and meticulously detailed scenes of Egyptian life, first in watercolour and, from 1858, in oils. Lewis's pictures of beautiful women in exotic dress and settings were very popular. Based on fantasy as much as fact they did much to generate a particularly 19th century vision of the picturesque East.

▲ Life in the Hhareem, Cairo, oil on panel by J.F. Lewis, 1863. V&A: 679-1893

▶ J. F. Lewis, oil on panel by Sir William Boxall, 1832. Courtesy of the National Portrait Gallery, London.

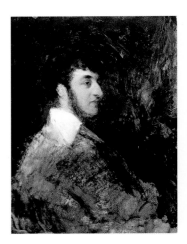

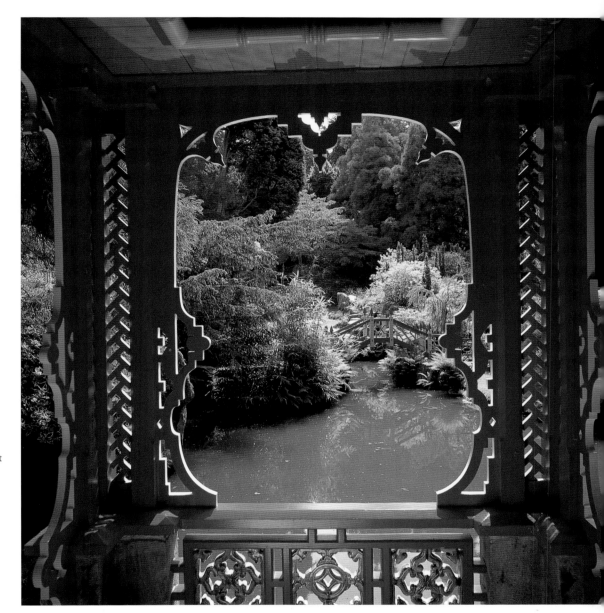

Chinese Garden, Biddulph Grange

Biddulph Grange in Stoke-on-Trent is a remarkable example of Victorian garden design. Starting in 1842, its owner James Batemen spent over 20 years creating a series of themed gardens using trees, shrubs and plants from all over the world. The Chinese garden evokes a magical Victorian vision of the East. It features a great stone gateway, an ornate wooden bridge and a temple crowned with golden dragons. Within this fanciful setting are displayed many of the plants that were brought back from China in the Victorian period.

◥ Temple in the Chinese Garden at Biddulph Grange. Courtesy of the National Trust Photographic Library, photograph by Ian Shaw.

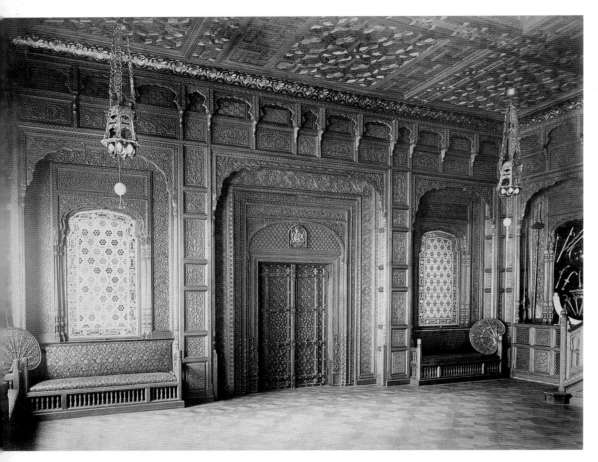

The Arab Hall, Leighton House

Leighton House in Kensington, London, was the home of the painter Frederic, Lord Leighton. The centrepiece of the house is the Arab Hall. It was created in 1877–9 by George Aitchinson as a showcase for the dazzling collection of 14th and 15th century tiles Leighton had acquired while travelling in Syria and Turkey. The scheme was completed with tile panels by William De Morgan. The room also features a marble pool, a wooden balcony, or zenana, and a gilt mosaic frieze.

▶ The Arab Hall, Leighton House. Courtesy of Leighton House Museum, The Royal Borough of Kensington and Chelsea.

The Durbar Hall

The Durbar Hall was part of an Indian palace created for the 1886 Colonial and Indian Exhibition in Kensington, London. It was not a copy of a real palace, but a representation of a 'typical Royal Residence'. It was designed by Caspar Purdon Clarke, later Director of the Victoria and Albert Museum, who brought carvers from India to execute his designs. The room was acquired by Lord Brassey who installed it in his London home and used it as a smoking room. It is now in the Hastings Museum and Art Gallery.

▲ The Durbar Hall. Courtesy of Hastings Museum & Art Gallery.

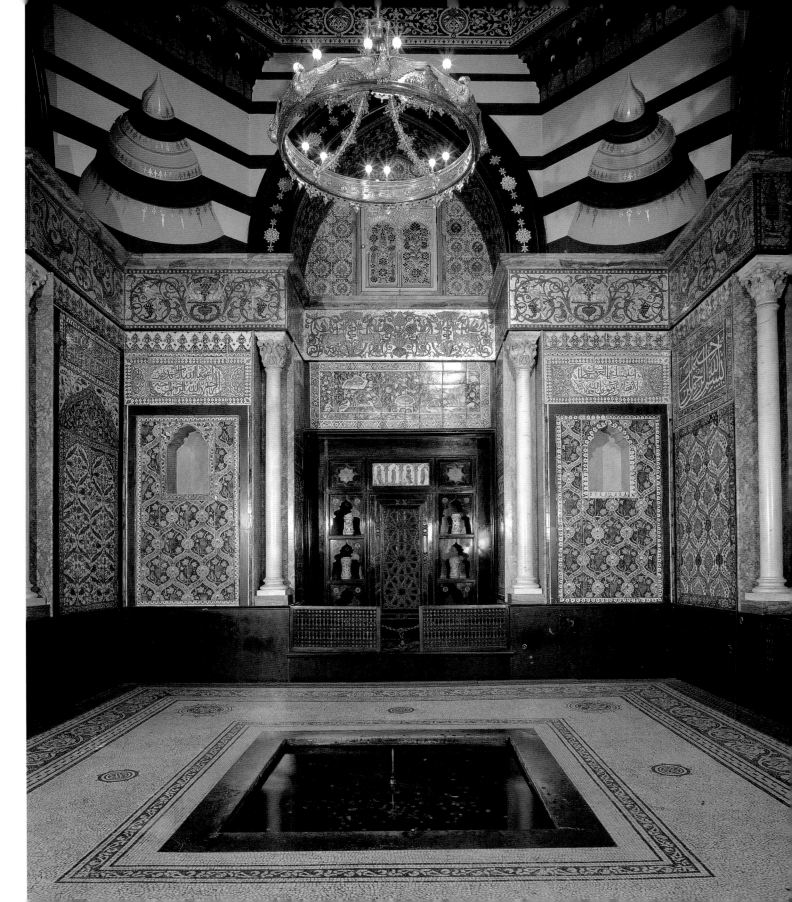

Influence of Japan
1860–1900

Of all the non-European sources available to British designers in the Victorian period, it was Japanese art and design that had the greatest impact. Interest in Japan was first aroused in the 1850s when the country was forced to open its ports to American and European powers. Large numbers of Japanese objects were subsequently imported into Britain and by the 1870s there was a craze for all things Japanese.

The art of Japan was very different to anything being produced in Britain and provided a fresh and exciting source of inspiration. Many of its distinctive patterns and motifs were eagerly adopted. **Circular motifs** were particularly popular. These derive from crests, called 'mon', that appear on many Japanese objects, sometimes in combination with geometric patterns. Japanese books illustrating mon provided another source. The stylised **natural motifs** found in Japanese art were also influential. Flowers, birds and even insects were very popular.

The art of Japan seemed to offer solutions to the various debates about the reform of British design that were taking place in the Victorian period. Japanese design was particularly admired for its 'simplicity [and] purity of form'. Such qualities inspired the creation of objects whose **geometric forms** and undecorated surfaces contrasted with much of mainstream Victorian production. Furniture in this style was sometimes stained to make the wood black. This **ebonising** was done to emulate Japanese lacquer. The style, **composition** and subject matter of Japanese woodblock prints also influenced artists working in Britain.

This screen was designed by William Eden Nesfield and made by James Forsythe, who gave it to the architect Richard Norman Shaw and his wife Agnes as a wedding present in 1867. It features a series of Japanese bird and flower paintings in a framework of ebonised wood that has been intricately carved and gilded with Japanese-inspired geometric, floral and crest-like motifs.

Painted paper panels and ebonised wood with gilt and fretted decoration. Made in 1867. V&A: W.37-1972

Circular Motifs

E.W. Godwin, the designer of this fabric, copied the circular motifs directly from a Japanese book of mon.

Jacquard woven silk and cotton brocatelle. Made by Warner, Sillett & Ramm, Bethnal Green, London around 1874. V&A: T.152-1972

Natural Motifs

The insects in the centre and flowers around the rim of this silver plate reveal the influence of Japan. The makers, Daniel and Charles Houle, were also inspired by Japanese metalworking techniques.

Silver, chased and inlaid with two colours of gold. Made in London in 1878–9. V&A M.355-1977

Ebonising

This sideboard is one of the most famous pieces of furniture designed by E.W. Godwin. The geometric form, ebonised finish and what Godwin called the 'grouping of solid and void' all come from the designer's study of Japanese artistic principles. Japanese embossed paper has been used in the doors.

Mahogany, ebonised, with silver-plated handles and inset panels of embossed paper. Made by William Watt & Co., London in 1867–70. V&A: Circ.38-1953

Geometric Forms

The simple, geometric form of this decanter reveals Christopher Dresser's interest in and admiration for Japanese design. The handle is derived from those on Japanese water containers and the engraved monogram on the lid looks like a mon.

Glass claret jug with silver mounts. Designed by Christopher Dresser and made by Stephen Smith in 1879–80. V&A: Circ.416-1967

People & Places

Christopher Dresser
(1834–1904)

The designer and writer Christopher Dresser was a great advocate of Japanese style design. Like many of his contemporaries, Dresser began to collect Japanese objects after seeing them displayed at the London International Exhibition of 1862. Dresser set up his own import companies and promoted Japanese art through exhibitions, lectures and publications. In 1876 he travelled to Japan, visiting numerous artists and manufacturers. In his work Dresser sought to express the 'breadth of treatment, simplicity of execution and boldness of design' that he admired in Japanese art.

▲ Christopher Dresser, photograph taken around 1861. Courtesy of the Linnean Society.

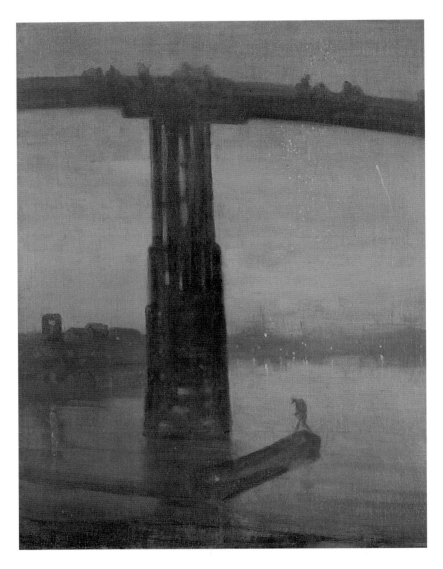

Composition

The artist James McNeill Whistler was particularly interested in the composition of Japanese painting and prints. This atmospheric painting *Nocturne: Blue and Gold, Old Battersea Bridge* was inspired by the work of Japanese print artists such as Utagawa Hiroshige.

Oil on canvas, painted in London in 1872–5.
© Tate, London 2001.

Edward William Godwin
(1833–1886)

The architect, designer and critic E.W. Godwin was a great admirer of Japanese art and design. Its influence can be seen in his architecture and his designs for textiles, wallpapers and the theatre. He was particularly famous for his 'Anglo-Japanese' furniture. Godwin did not seek to imitate Japanese art. Instead he sought to combine the general principles of simplicity and elegance that he admired in the art of Japan with the needs of the Victorian home.

▼ Japanese doors and furniture. Pencil, pen and ink and watercolour by E.W. Godwin, late 1870s. V&A: E.280-1963

Patterns of Door (panelled) from Jap. Books.

Door nagasaki

Wall.

Arthur Lasenby Liberty
(1843–1917)

Arthur Lasenby Liberty was the founder of the famous Liberty's shop in London's Regent Street. Opened in 1875, the store specialised in goods imported from Asia and did much to foster the Victorian craze for all things Japanese. From the 1880s Liberty began to commission works from designers such as Christopher Dresser and E.W. Godwin. A great enthusiast of the art of Japan, Liberty visited the country in 1889.

▲ Arthur Lasenby Liberty, oil on canvas by Arthur Hacking, 1914. Courtesy of the Liberty Archive, Liberty plc.

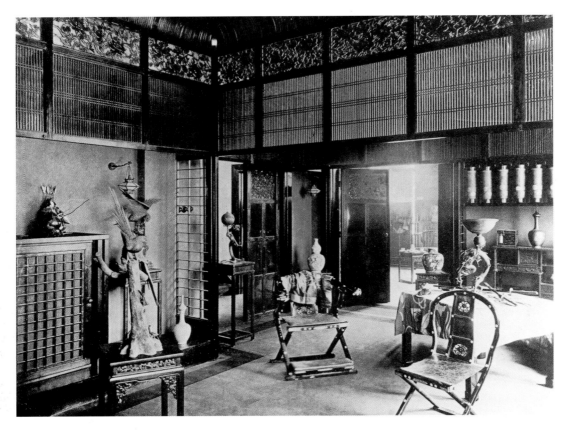

The White House

E.W. Godwin designed the White House, in Chelsea, for his friend James McNeill Whistler in 1877–8. No photographs survive, but the architectural drawings suggest a Japan-inspired interior. The latticework of the staircase derived from Japanese architecture and the fireplace was decorated with circular crests. Shelved areas were designed to display Whistler's collection of Chinese and Japanese blue and white porcelain.

▲ Design for the White House, pen, ink, watercolour and pencil by E.W. Godwin. V&A: E.542-1963

25 Cadogan Gardens

25 Cadogan Gardens, London, was the home of the artist Mortimer Menpes. Designed by Arthur Mackmurdo the house was completed in 1895. Menpes was not content with merely filling his new home with Japanese objects. He had interior fittings made for him in Japan by a craftsman he met on his second visit to the country in 1896.

▲ The interior of 25 Cadogan Gardens, c.1876, photograph published in *The King*, 29 March 1902. Courtesy of the Royal Borough of Kensington and Chelsea.

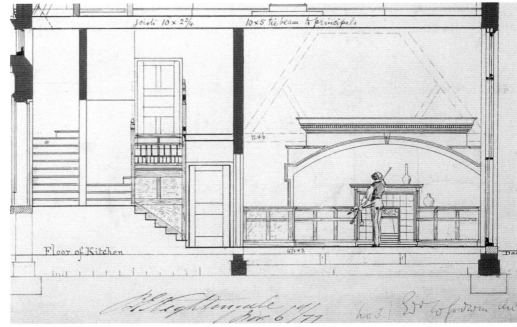

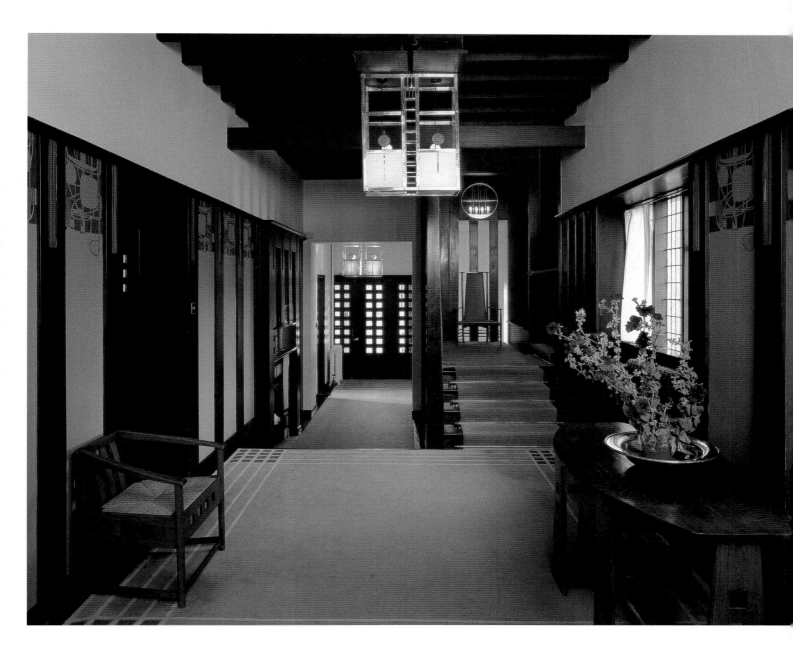

The Hill House

The Hill House in Helensburgh, near Glasgow, was designed by Charles Rennie Mackintosh for the publisher Walter Blackie. The house was completed in 1904. The uncluttered open plan, the geometric form of the furniture and fittings, and the use of dark wood against light-coloured, plain walls all reveal Mackintosh's interest in Japanese interior design.

▲ The entrance hall of The Hill House.
© The National Trust for Scotland, photograph by Allan Forbes, 1996.

Aestheticism
1870–1900

Aestheticism was an approach to life based on the philosophy of 'art for art's sake'. It emphasised the importance of art above everything else and the pleasure to be found in beautiful things. Aestheticism was a complex mixture of a number of sources of inspiration including Greek, Roman and Gothic styles and the arts of Asia. Japan was particularly important and Aesthetic interiors were often decorated with Japanese prints, screens, fans and other objects. Chinese and Japanese blue and white porcelain were avidly collected by members of the Aesthetic movement. British designers and manufacturers followed this fashion, producing a variety of **blue and white ceramics**, some of which featured oriental motifs such as fans.

The **peacock feather**, previously thought to be a symbol of bad luck, became an icon of the Aesthetic style. Its use as a motif confirmed the movement's reputation for decadence. **Sunflowers** were another popular Aesthetic motif. With their simple, flat shape and bold colour the flowers had great appeal. The Aesthetic style particularly favoured **strong, simple colours**. Popular colours for the home included bright blues, greens and especially yellow highlighted with black and gold. In **Aesthetic dress**, however, dull browns and sage greens were preferred. Women dressed in loose, flowing garments modelled on medieval styles while fashionable men favoured velvet suits with knee breeches.

This clock combines Japanese-inspired ebonised wood, Chinese-inspired blue and white porcelain with the characteristic Aesthetic sunflower motif. It shows the extent to which the Aesthetic style was adopted for everyday objects by commercially popular and versatile designers such as Lewis F. Day.

Ebonised birch wood case, porcelain face. Designed by Lewis F. Day and made by Howell, James & Co., London around 1880. V&A: Circ.662-1972

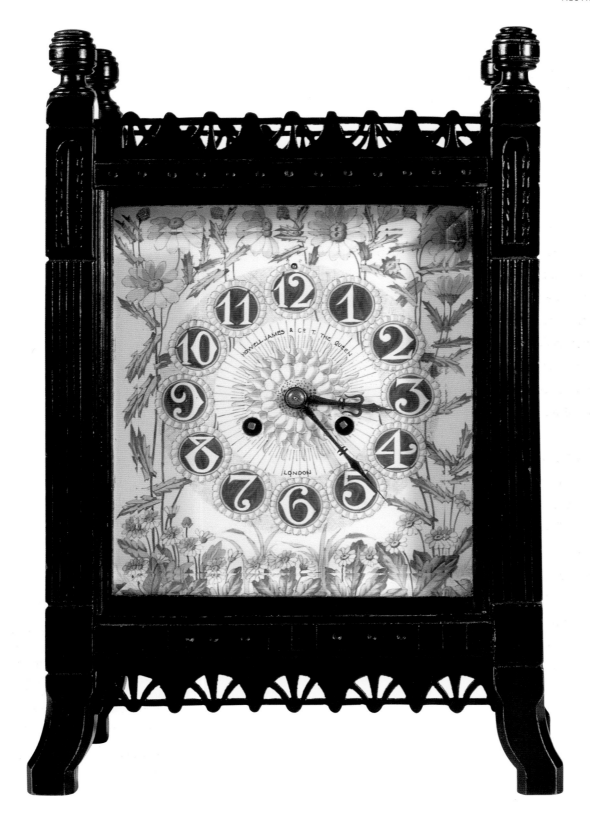

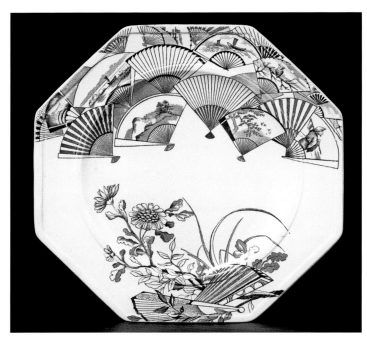

Blue and White Ceramics

Although inexpensively made for everyday use, this plate was highly fashionable in style. The blue and white asymmetric pattern of fans and chrysanthemums was influenced by East Asian motifs.

White earthenware, printed. Made by Brown, Westhead, Moore & Co., Hanley, Staffordshire in 1875–85. V&A: C.216-1984

Peacock Feathers

This famous printed cotton helped establish Liberty & Co. as the leading supplier of Aesthetic style furnishings.

Roller-printed cotton. Designed by Arthur Silver of the Silver Studio, printed by the Rossendale Printing Co., Rossendale, Lancashire for Liberty & Co. of Regent Street, London in 1887. V&A: T.50-1953

Sunflowers

Thomas Jeckyll, one of the leading designers of the Aesthetic style, created a number of influential decorative schemes. This iron sunflower was part of the railing from an ornamental Japanese pavilion he designed for the International Exhibitions in Philadelphia (1876) and Paris (1878).

Wrought iron. Made by Barnard, Bishop & Barnard, Norwich, Norfolk around 1876.
V&A: Circ.530-1953

Strong, Simple Colours

The bright yellow, green and red of this furnishing fabric, designed by Bruce Talbert, would have suited an Aesthetic interior.

Woven silk and wool double-cloth. Made by J.W. & C. Ward around 1880.
V&A: T.210-1969

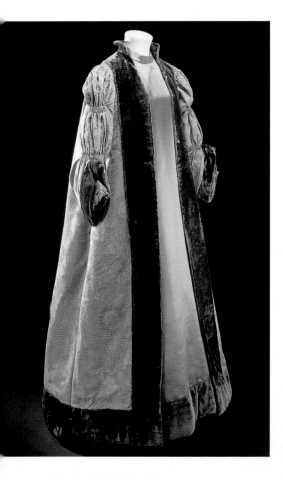

People & Places

James McNeill Whistler
(1834–1903)

American-born artist James McNeill Whistler was an important figure in the Aesthetic movement. In his paintings Whistler did not seek to be true to nature, but to express mood and atmosphere through simple shapes, fluid brushstrokes and subtle colours. Like his fellow Aesthetes he believed that art was an end in itself, with no wider moral or social implications. Whistler's attitude, and his artistic style, angered John Ruskin and those involved in the Arts and Crafts movement who thought that art and morality were fundamentally connected. In 1877

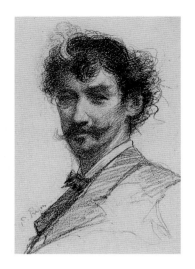

Ruskin reviewed one of Whistler's paintings, accusing the artist of 'flinging a pot of paint in the public's face.' Whistler sued for libel and won, but received damages of only a farthing.

▲ James McNeill Whistler, lithograph by P. Rajon, 1870–80. V&A: E.2671-1908

▼ Nocturne: Blue and Silver, Cremorne Lights, oil on canvas by James McNeill Whistler, 1872. © Tate, London 2001.

Aesthetic Dress

This robe combines references to historic dress with the characteristic Aesthetic sunflower motif. It was made in the 'Artistic Costume Studio' of Liberty & Co., London, for a member of the Liberty family. Liberty's had opened their dress department in 1884 under the guidance of the Aesthetic designer E.W. Godwin. From this time they took a leading role in setting artistic fashions.

Silk and cotton brocade with a silk-satin front panel, silk-plush edgings and a taffeta lining. Made in London in 1885–1900. V&A: T.57-1976

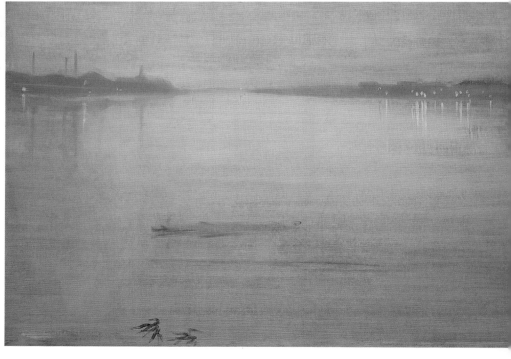

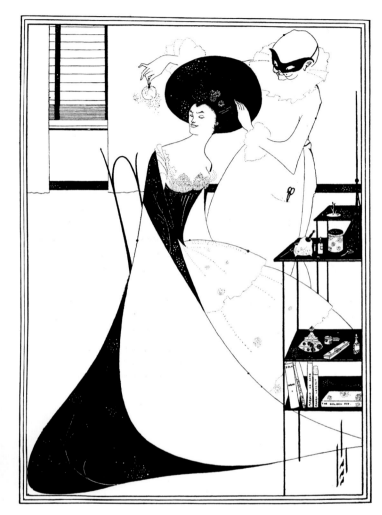

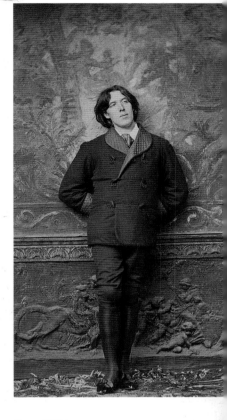

Aubrey Beardsley
(1872–1898)

Aubrey Beardsley was one of the most original artists of the late 19th century. Principally a book illustrator, Beardsley created striking black and white drawings in pen and ink. His expressive use of line and lack of shading show the influence of Japanese prints. In 1894 Beardsley illustrated Oscar Wilde's play *Salome* and became the art editor of *The Yellow Book*. These socially and sexually provocative publications shocked the public and added to Aestheticism's decadent reputation. Beardsley suffered from tuberculosis for most of his life and died in 1898. He was only 25.

The Toilette of Salome, line block print by Aubrey Beardsley, published in 1894.
V&A: E.433-1972

◄ Aubrey Beardsley, photograph by Frederick Evans, around 1893.
V&A: PH.29-1972

Oscar Wilde
(1854–1900)

The poet and writer Oscar Wilde was the leading personality of the Aesthetic movement. He promoted the philosophy of 'art for art's sake' in a series of lectures in America and Britain. A famous dandy and wit, Wilde is best known for plays such as *The Picture of Dorian Gray*, which was later turned into a novel, *Lady Windermere's Fan* and *The Importance of Being Earnest*. In 1895, at the height of his success, Wilde was tried and imprisoned for homosexuality. With his downfall the Aesthetic movement lost its popularity.

▲ Oscar Wilde, photograph by Napoleon Sarony, 1882. Courtesy of the National Portrait Gallery, London.

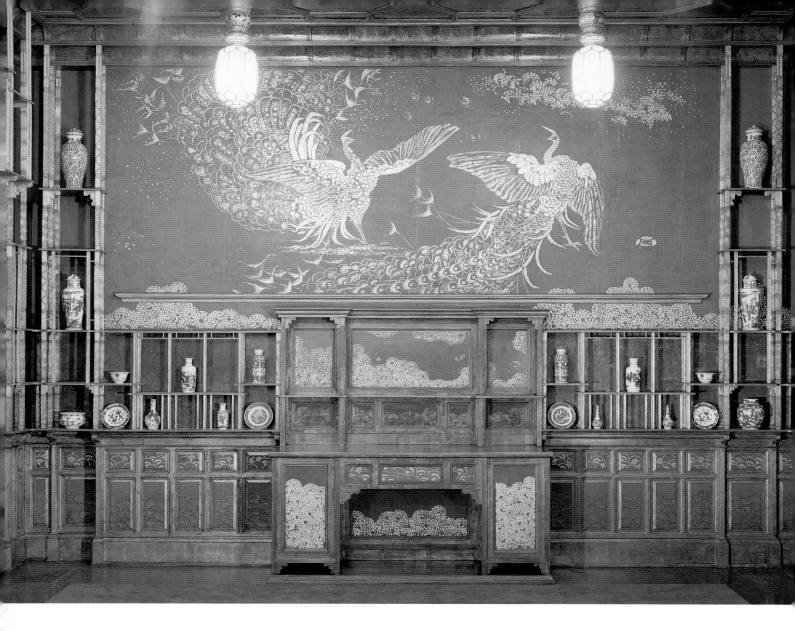

The Peacock Room

The Peacock Room was created in 1876-7 for the London home of F.R. Leyland, a wealthy ship-owner. The architect and designer Thomas Jeckyll adapted a dining room in the house to accommodate Leyland's collection of blue and white porcelain and a painting by James McNeill Whistler. Whistler felt that the décor of the room did not suit his painting so without his patron's knowledge he painted the entire room deep blue and gold and covered the window shutters with glorious peacocks. Whistler's audacity, and a dispute over payment, caused a breech between artist and patron. Despite his anger, however, Leyland kept the room as Whistler had left it.

▲ The Peacock Room. Courtesy of the Freer Gallery of Art, Washington.

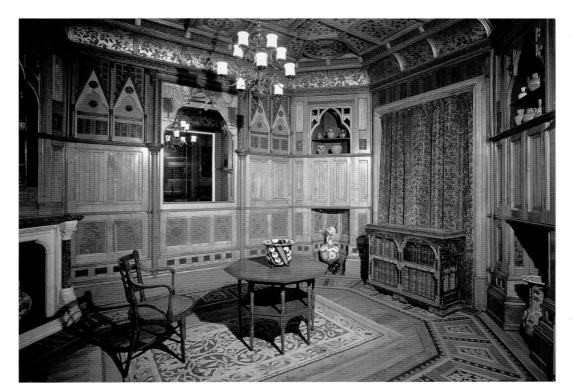

The Grove

The Grove, Harborne, Birmingham, was designed in 1877–8 by J.H. Chamberlain for William Kendrick, a prominent Birmingham businessman. The anteroom of the dining room, which was acquired by the V&A just before the house was demolished, reflects the classical and Gothic elements of the Aesthetic style. It is richly decorated with inlaid, painted and gilded wood. The room was used to display Kendrick's collection of blue and white ceramics.

◥ Room from The Grove. V&A: W.4-1964

Design for a drawing room

This illustration of a drawing room comes from William Watt's *Art Furniture* catalogue of 1877 which featured designs by E.W. Godwin, one of the leading members of the Aesthetic movement. The catalogue contained 'hints and suggestions' to help middle-class customers create a tastefully decorated and furnished home. This interior shows Godwin's Anglo-Japanese furniture.

▶ Page from *Art Furniture from Designs by E.W. Godwin and Others; With Hints and Suggestions on Domestic Furniture and Decoration.* National Art Library, 57.D.19

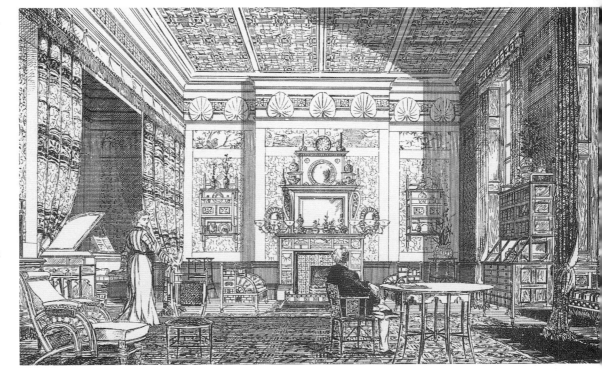

Arts and Crafts
1860–1910

The Arts and Crafts movement developed in the 1860s as a reaction against the growing industrialisation and commercialisation of Victorian Britain. It took its name from a society formed by a group of artists, designers and craftspeople who wanted to exhibit their work and exchange ideas. Those involved believed in the equality of all the arts and the importance and pleasure of work.

The distinctive appearance of Arts and Crafts objects resulted from the strong principles that developed around the making process. First and foremost was the idea of **truth to materials**. Makers insisted on preserving and emphasising the natural qualities of materials. Wood, for example, had to be used in a way that was sympathetic to wood. **Simple forms** were also a hallmark of the Arts and Crafts style. There was no unnecessary decoration and the actual construction of the object was often exposed.

Nature was an important source of Arts and Crafts motifs. Inspired by plants that grew naturally in Britain, designers created flat, organic shapes and patterns. The bold forms of the **vernacular**, or domestic, architecture and design traditions of the British countryside provided another vital influence on the Arts and Crafts movement. Many of those involved set up workshops in rural areas and revived old techniques.

The Arts and Crafts style broke cleanly away from the historical styles that dominated the Victorian period. By the end of the century the ideals of the movement had affected the design and manufacture of all the decorative arts in Britain.

This chair epitomises the Arts and Crafts style. It is based on a traditional country design and is simple in form and traditional in structure. It was designed by Ernest Gimson, a London-based architect and designer who moved to the Cotswolds in 1892. There he set up a workshop dedicated to the idea of a community of craftsmen making good quality objects by hand.

Ash, turned on a pole-lathe with splats of riven ash; replacement rush seat. Made in Gloucestershire in 1892–1904.
V&A: Circ.232-1960

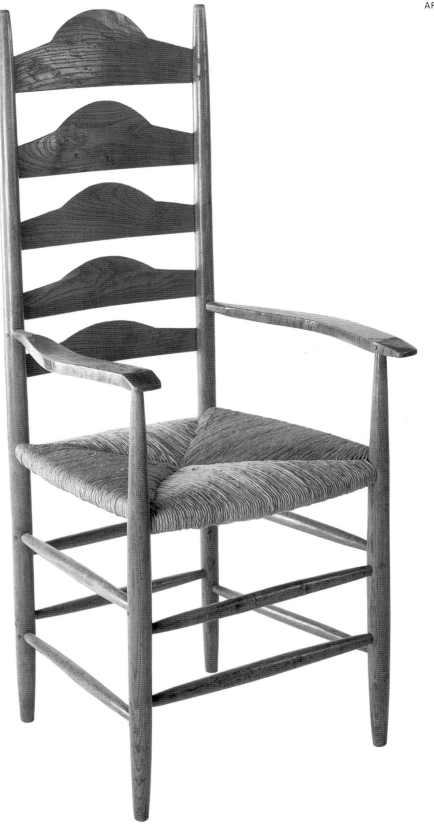

Truth to Materials

The simple form and finish of this lamp serve to emphasise the intrinsic qualities of the brass. It was designed by A.S. Dixon who set up evening classes in 1893 to teach beaten metalwork and other handicrafts. Two years later this became the Birmingham Guild of Handicrafts. Dixon gave the lamp as a wedding present to another major Arts and Crafts designer, C.R. Ashbee.

Hand-beaten brass. Made in Birmingham around 1893. V&A: Circ.277-1961

Simple Forms

This writing desk was designed by C.F.A. Voysey and is illustrative of his distinctive Arts and Crafts style. The desk is simple in appearance and the decoration is confined to practical features such as the applied copper hinges.

Oak with brass panel and copper hinges. Made around 1896. V&A: W.6-1953

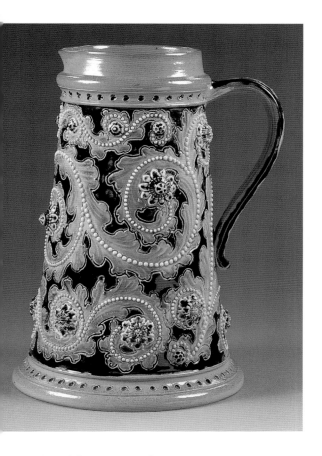

Natural Motifs

Embroidered screens were popular in Arts and Crafts interiors. This example by Morris & Co. was designed by John Henry Dearle, William Morris's assistant, and embroidered under the supervision of May Morris, who ran the embroidery section of the firm. The panels were also sold in kit form to embroider at home. The bold design of tulips, poppies and anemones is typical of the Arts and Crafts style.

Glazed mahogany frame; panels of canvas embroidered with silks in darning, stem and satin stitches. Made in London in 1885–1910. V&A: Circ.848-1956

The Vernacular

The simple shape of this tankard is based on traditional forms. It was made by George Tinworth at Doulton & Co. Art Pottery. Doulton had revived the ancient technique of making salt-glaze stoneware whereby salt is thrown into the kiln at peak temperature and combines with the clay to produce an orange peel effect. The stylised leaf and flower motif that decorates this tankard is typical of the Arts and Crafts style.

Salt-glazed stoneware, with incised and applied decoration painted in blue, grey and brown. Made in Lambeth, London in 1874. V&A: 3789-1901

People & Places

William Morris
(1834–1896)

William Morris was one of the most important and influential designers in British history. In 1861 he founded his first company, which produced a wide range of decorative objects for the home including furniture, fabrics, wallpaper and stained glass. Morris was also renowned as a poet and writer and in 1890 he set up the Kelmscott Press. His artistic skills were combined with strong political beliefs. A committed conservationist and socialist, he dedicated his life to the idea that art should improve the lives of ordinary people.

▲ Design for 'Acanthus' wallpaper, pencil, watercolour and bodycolour by William Morris, 1874. V&A: Circ.297-1955

◄ William Morris, photograph by Frederick Hollyer, 1884. V&A: 7715-1938

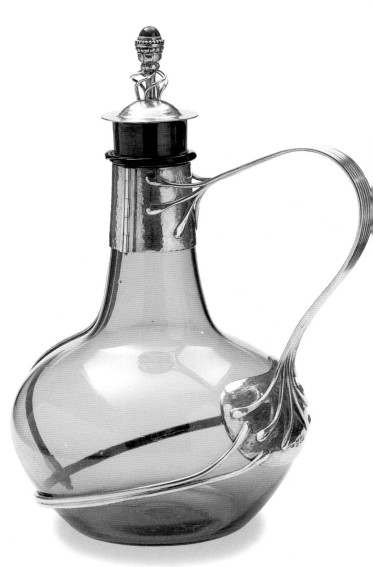

C.R. Ashbee
(1863–1942)

Charles Robert Ashbee was a major figure in the Arts and Crafts movement. He designed many important pieces of jewellery and silver tableware for the Guild of Handicraft which he established in 1888 in the East End of London. The guild's work is characterised by plain surfaces of hammered silver, flowing wirework and coloured stones in simple settings. In 1902 Ashbee moved the guild out of London to found an experimental community in Chipping Camden in the Cotswolds.

▲ C.R. Ashbee, charcoal and chalk by William Strang, 1903. Courtesy of the Art Workers' Guild Trustees Limited, London, UK/Bridgeman Art Library.

◄ Decanter designed by C.R. Ashbee, glass with silver mounts and chrysophase, 1904–5. V&A: M.121-1966

C. F. A. Voysey
(1857–1941)

Charles Francis Annesley Voysey was one of the most innovative Arts and Crafts architects. He was also a very versatile designer, responsible for wallpaper, fabrics, tiles, ceramics, furniture and metalwork. Some of his patterns were used for objects in a wide variety of materials. Voysey had a highly original style that combined simplicity with sophistication. He became particularly famous for his wallpaper designs, which feature stylised bird and plant forms with bold outlines and flat colours.

◄ C.F.A. Voysey, photograph taken around 1900. Courtesy of RIBA Library Photographs Collection.

▶ Woven wool curtain designed by C.F.A. Voysey, 1896–1900. V&A: Circ.886-1967

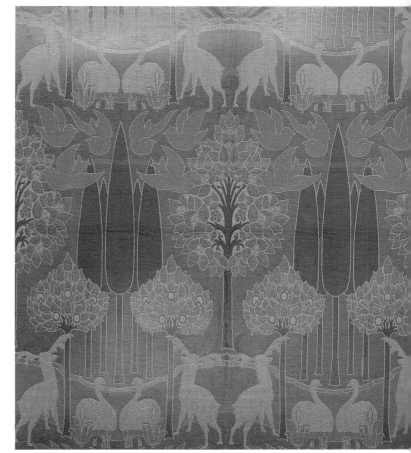

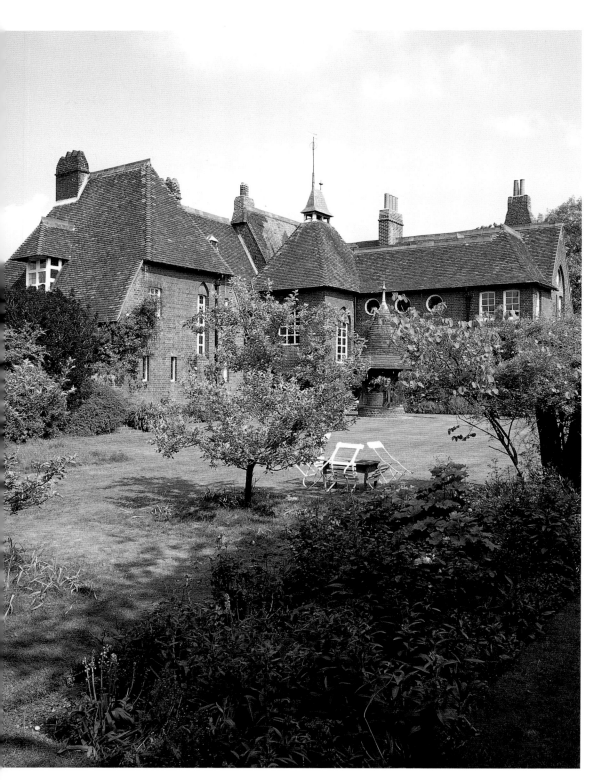

The Red House

The Red House, in Bexleyheath, was designed in 1858-60 by Philip Webb for his friend William Morris. Webb rejected the grand classical style and looked instead to British vernacular architecture. With its well proportioned, solid forms, deep porches, steep roof, pointed window arches, brick fireplaces and wooden fittings the Red House characterises the early Arts and Crafts style.

◄ The Red House. V&A Picture Library.

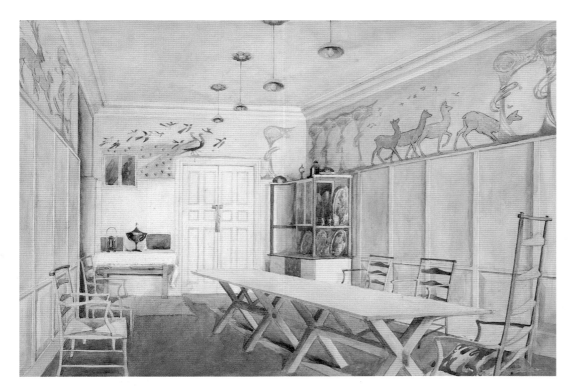

37 Cheyne Walk, London

37 Cheyne Walk was built by C.R. Ashbee in 1893–4. It was the home of his mother and sister and also contained Ashbee's architectural offices. The house was known as the Ancient Magpie and Stump after a public house that once stood on the site. This design shows the dining room. It is quite plain with a trestle table and ladder-back chairs and is decorated with a modelled plaster frieze.

◄ The dining room at 37 Cheyne Walk, pencil and watercolour by C.R. Ashbee, 1901. V&A: E.1903-1990

The Orchard, Chorleywood

C.F.A. Voysey designed The Orchard in Chorleywood for himself and his wife in 1899. In common with other Arts and Crafts designers, Voysey was interested in vernacular traditions. However, his architecture marks a radical break from the past and anticipates modern 20th century styles. With its sparse decoration and plain, simple furnishings The Orchard was very different from the usual dark and cluttered Victorian interior.

► The Orchard, photograph taken around 1900. Private collection.

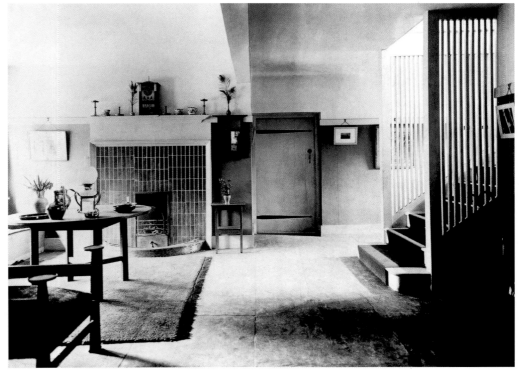

Scottish School
1885–1915

At the end of the 19th century a striking new style emerged in Scotland. Artists and designers in Glasgow and Edinburgh created unified decorative schemes in which architecture, interior design, furniture and fittings harmonised to produce an environment suitable for modern living.

The Glasgow style is characterised by its use of **geometric forms** and motifs. Straight lines predominate, but they are frequently combined with simple curved forms. These elements show the influence of Japanese art. Another unique aspect of the style is the **elongated form** of designs, something also seen in the distinctive typography employed by artists working in Glasgow. Many objects feature highly **stylised flowers** that are almost abstract in appearance. The rose was a particularly dominant motif. Artists and designers working in Glasgow tended to employ a limited colour range based on **subtle tones** of pink, purple and green, highlighted with black and white. In contrast, Edinburgh based artists used more vibrant colours

Many of the works of the Scottish School are concerned with **symbolism**. Symbolism was a reaction against the increasing materialism of the modern world. It involved an exploration of the inner world of the psyche and spirit. Artists used Celtic myths, dreams and religion to express their ideas.

The subtle colours and elongated forms of this cushion cover are typical of the Glasgow style. The words are a poem in Latin concerning the passage of time and the value of daily work.

Linen ground with linen appliqué; embroidered with coloured silks in satin stitch with borders of needleweaving. Designed and embroidered by Jessie Newbery in Glasgow around 1900. V&A: T.69-1953

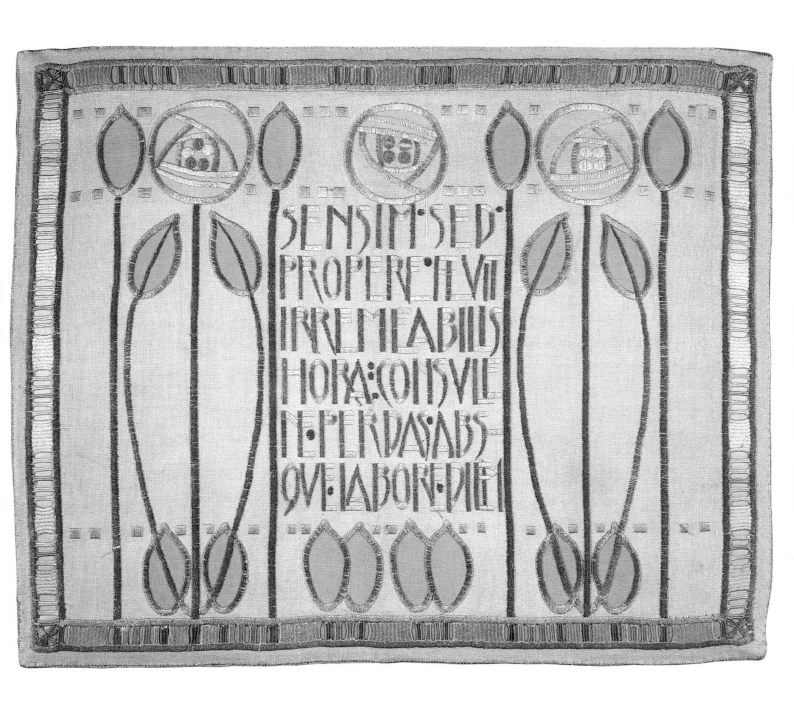

Geometric Forms

Charles Rennie Mackintosh and his
wife Margaret designed all the
furnishings and decoration for the
Willow Tea Rooms in Glasgow.
This fireplace was made for the
exclusive 'Salon de Luxe'. Its strong
blocks of colour, stylised geometry,
iron willow trees and the white
oval tile leaves reflect the theme
of the room.

Iron with ceramic tile surround. Made in
Glasgow around 1904. V&A: Circ.244-1963

Elongated Forms

This chair designed by Charles
Rennie Mackintosh has become
one of the icons of the Glasgow
style. With its extreme height and
linearity, and the combination of
the vertical elements with the oval,
it was stylistically very advanced
for its time.

Stained oak with drop-in seat; upholstery
modern. Made in Glasgow around 1900.
V&A: Circ.130-1958

Stylised Flowers

The rose and leaf motifs on this embroidered collar and belt are characteristic of the radical, almost abstract, style of the artists and designers working in Glasgow at the end of the 19th century.

Silk ground with appliqué of silk; embroidered with silk threads in satin stitch and couching; glass bead and needlelace trimmings. Made by Jessie Newbery in Glasgow around 1900. V&A: Circ.189 and 190-1953

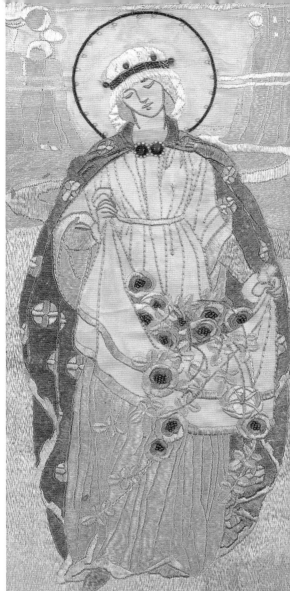

Subtle Tones

The pinks, purples, blues and greens of this embroidered picture of St Elizabeth of Hungary are typical of the embroidery executed at the Glasgow School of Art.

Silk embroidered in floss silks in stem, satin, chain and long and short stitches; with couched silver thread, gold beads and pink translucent stones. Designed by Ann Macbeth and embroidered by Elizabeth Jackson in Glasgow around 1910. V&A: T.359-1967

THE SEA VOICES

Symbolism

Jessie M. King's very individual
style led her to become one of the
most successful illustrators and
designers of her time. She had
a spiritual inner vision that
influenced her drawings of fantasy
worlds. In this watercolour book
illustration 'The Sea Voices' she
uses her linear style of drawing
to emphasise the semi-mystic
melancholy of the subject.

Watercolour on vellum. Published around
1900. V&A: E.888-1948

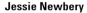

People & Places

Charles Rennie Mackintosh
(1868–1928)

An architect, designer, and painter Charles Rennie Mackintosh was one of the most innovative artists of his generation. In 1893 he and friends from Glasgow School of Art formed a group known as 'The Four'. Mackintosh, Herbert MacNair (1868–1953) and sisters Margaret (1865–1933) and Frances MacDonald (1874–1921) produced graphic work, metalwork, textiles and furniture. Margaret and Charles married in 1900. Together they designed a series of remarkable interiors for tea rooms, exhibition displays and their own homes.

▲ Design for the music room in The House of an Art Lover, colour lithograph by Charles Rennie Mackintosh, around 1902. National Art Library, L.794-1902

◄ Charles Rennie Mackintosh, photograph by James Craig Annan, 1893. © The Annan Gallery, Glasgow.

Jessie Newbery
(1864–1948)

In 1894 Jessie Newbery became head of a new department of embroidery at Glasgow School of Art. Although embroidery had been taught at the school before this time, under Newbery's direction the subject was radically transformed. Rather than copy historical examples, she encouraged her students to create more original and intuitive works. Newbery's own work is characterised by the use of textured linen and pale silk grounds, appliqué and satin stitch. Her stylised compositions often included inscriptions and the repetition of symbolic motifs such as the rose.

▶ Jessie Newbery, detail of a photograph taken around 1890. Courtesy of Glasgow School of Art Collection.

▼ Embroidered collar by Jessie Newbery, linen and silk, around 1900. V&A: T.65-1953

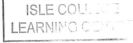

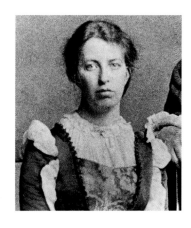

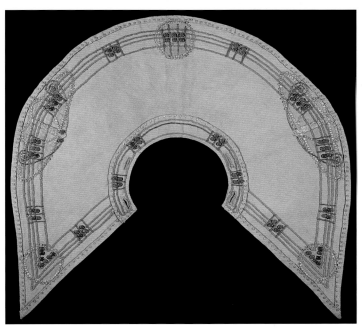

Phoebe Anna Traquair
(1852–1936)

Born in Dublin, Phoebe Anna
Traquair moved to Edinburgh in
1874. By the 1890s she had
become a major figure in the Arts
and Crafts movement that had
been established in the city.
Traquair worked in a wide variety
of media including mural
decoration, painting, book
illumination, embroidery and
jewellery. Her work is characterised
by its vibrant colours and romantic
imagery. She drew her inspiration
from medieval and Renaissance
art, Pre-Raphaelite painting and
Celtic myths and legends.

▷ Pendant by Phoebe Anna Traquair,
enamel with foil on copper set in gold with
an enamel teardop, 1902. V&A: M.192-1976

◁ Phoebe Anna Traquair, oil on panel self
portrait, around 1909–11. Courtesy of
Scottish National Portrait Gallery.

Glasgow School of Art

Glasgow School of Art is Charles
Rennie Mackintosh's most famous
work. It was built in two stages,
1897–9 and 1907–9. Mackintosh
designed every aspect of the
building with meticulous detail.
The austere façade recalls Scottish
baronial architecture, while the
strong geometric structure of the
interior design echoes Japan.
The overall effect, however, reveals
Mackintosh's own unique artistic
style.

▲ Exterior of Glasgow School of Art.
Courtesy of A.F. Kersting.

▶ The library of Glasgow School of Art.
Courtesy of Glasgow School of Art
Collection.

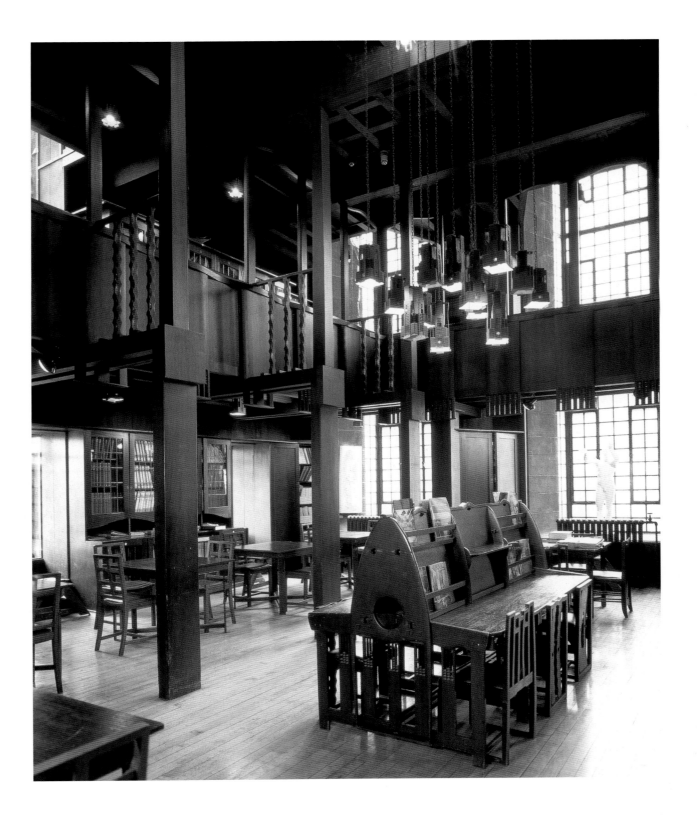

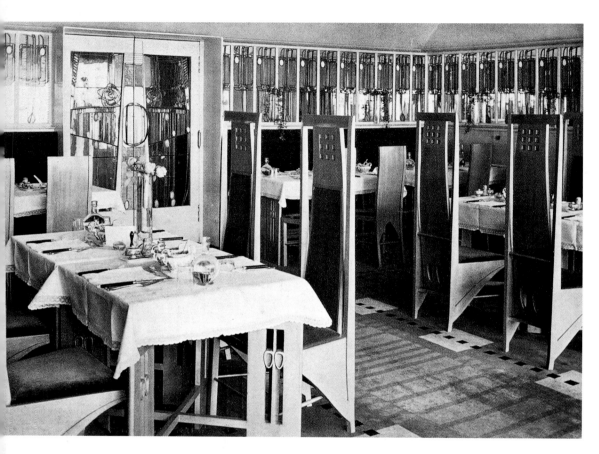

Willow Tea Rooms

The Willow Tea Rooms in Sauchiehall Street, Glasgow, were designed by Charles Rennie Mackintosh. Opened in 1903, they were one of a series of such commissions received from renowned tea room proprietor Kate Cranston. The artistic unity of the Willow Tea Rooms' decorative scheme even extended to the waitresses serving in the Salon de Luxe who wore dresses and jewellery designed by Mackintosh.

◀ The Salon de Luxe in the Willow Tea Rooms, photograph published in *Dekorative Kunst* 13, 1905. National Art Library, PP.43.C

The Catholic Apostolic Church

In 1892 the Edinburgh Social Union commissioned Phoebe Anna Traquair to decorate the interior of the Catholic Apostolic Church in Mansfield Place in Edinburgh. The murals that Traquair created on the great chancel arch and the walls and ceiling of the chancel aisles were the most important of her career. They were widely praised for their exquisite design and jewel-like colours.

▶ Detail from the murals in the Catholic Apostolic Church. © Crown Copyright, reproduced courtesy of Historic Scotland.

Acknowledgements

The authors would like to thank Michael
Snodin, Sarah Medlam and the many other
colleagues who contributed their time and
expertise towards the production of this book:
Pip Barnard, Nick Brod, Ruth Cohen, Frances
Collard, Leah Darling, Richard Davies, Joan
Dekker, Denise Drake, Martin Durrant, Joanna
Fernandes, Alun Graves, Paul Greenhalgh, Sara
Hodges, Laura Houliston, Maurice Howard,
Nick Humprey, Ken Jackson, Mike Kitcatt,
Karen Livingstone, Danny McGrath, Leela
Meinertas, Elizabeth Miller, Wendy Monkhouse,
Tessa Murdoch, Dominic Nash, Brenda Norrish,
Graham Parlett, Linda Parry, Paul Robbins,
Christine Smith, Susan Stronge, Ian Thomas,
Eleanor Tollfree, Christopher Wilk and
Hilary Young. Thanks are also due to Mary
Butler and her staff in V&A Publications,
Lucy Trench, Avril Broadley and colleagues in
the Far Eastern Department.